A Day in the Life of the American Woman

A Day in the Life of the American Woman

How We See Ourselves

Created by

Sharon J. Wohlmuth, Carol Saline, and Dawn Sheggeby

An EpiCom Media Book
in association with

Bulfinch Press
New York • Boston

Bulfinch Press

Time Warner Book Group
1271 Avenue of the Americas, New York, NY 10020
Visit our Web site at www.bulfinchpress.com

Created by Sharon J. Wohlmuth, Carol Saline, and Dawn Sheggeby
Produced by Lewis J. Korman and Matthew Naythons
Creative Director: Thomas K. Walker
Director of Photography: Acey Harper

An EpiCom Media Book
www.daywoman.com

Chairman: Lewis J. Korman
Co-Chairman: Robert Gottlieb
President: Matthew Naythons
Senior Vice President, Editorial: Dawn Sheggeby
Senior Vice President: John Silbersack

First Edition: October 2005

ISBN 0-8212-5706-4
Library of Congress Control Number 2005930593

For information regarding sales to corporations, organizations, mail order catalogs,
premiums, and other non-book retailers and wholesalers, contact:
Special Markets Department
Time Warner Book Group
1271 Avenue of the Americas, 12th Floor
New York, NY 10020-1393
Tel: 1-800-222-6747

Book and jacket design by Thomas K. Walker

PRINTED IN ITALY

Photographed on April 8, 2005,
by Fifty of the World's Leading Women Photographers

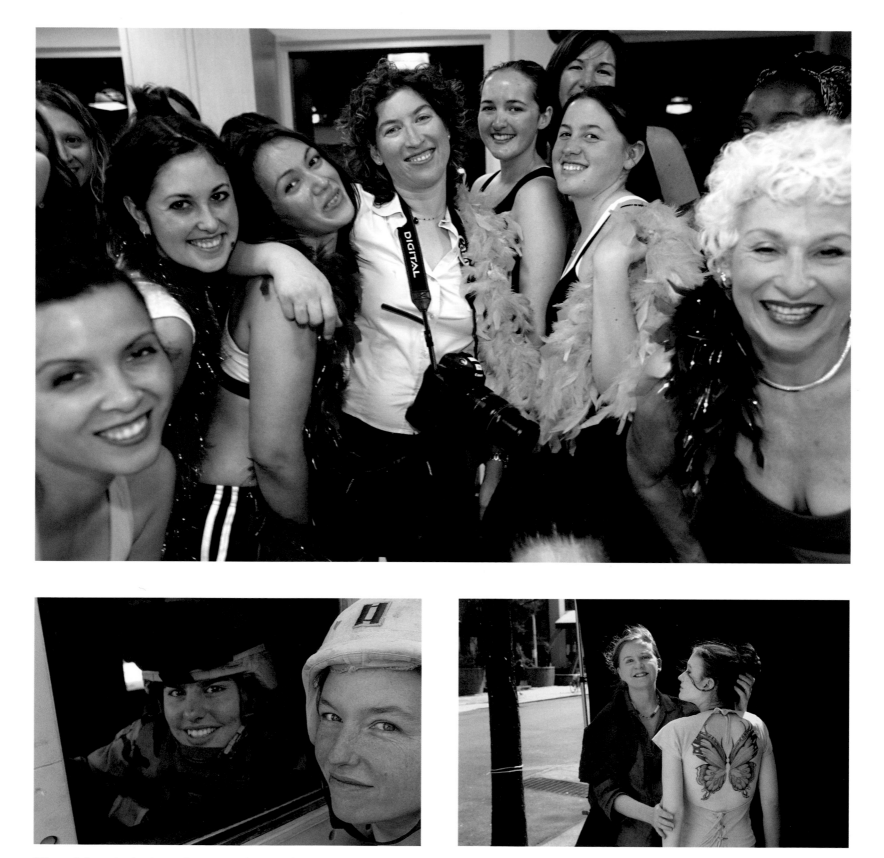

Three of the project's 50 award-winning photographers at work on April 8, 2005: Lauren Greenfield (top) with the "boa burn" aerobics class in Hollywood; Stephanie Sinclair with PFC Jennifer Lipzer in Iraq (above left); and Joyce Tenneson in Manhattan with FIT student Lindsey Cook (above right).

How We See Ourselves

Two years ago, a small group of us got together with the idea of creating a portrait of the American woman in 2005—not the superstars who fill the pages of magazines, but ordinary women going about their everyday lives with grace, optimism, and resiliency. Our vision was to show, in pictures and in words, what brings them happiness and fulfillment, and how they cope with the challenges that are an inevitable part of life.

Everybody we talked to had a "perfect woman" for us—usually someone living her life in a quietly inspirational way. Narrowing our choices was daunting because we couldn't possibly squeeze into the pages of a single book the staggering social, ethnic, religious, and geographic range of our great country. But by capturing a single moment in time, we could show a representative sample that would embody the spiritual and emotional connections that unite us as working women, caretakers, lovers, and friends.

And so on April 8, 2005, we sent out 50 of the world's most talented female photographers to document a diverse group of women over the course of a typical day. Some of our subjects came to our attention from newspaper or magazine articles; others came from a friend of a friend or someone we met on the train; and many came from the photographers themselves, who were asked to choose a person or subject that was personally meaningful to them. We wanted to see what would bubble up when they put aside their normal journalistic objectivity and allowed themselves to get involved with the women they were photographing.

Our photographers are a remarkable group of women, with outstanding credentials—including 11 Pulitzer Prizes among them. They come from varied backgrounds and locales, but share a high level of excellence in their work. Some of them ended up shooting under unexpectedly difficult conditions, with bad weather, stolen wallets, and even broken bones threatening

their assignments. But for all, the day was immensely gratifying. As photographer Anne Day said, "What a great thing, to celebrate women! I felt a complete connection in a way I'd never experienced before."

Just a week after the shoot day, we assembled our second dream-team back in our New York headquarters: nine top women photo editors from magazines including *Time, Newsweek, Life, People, Parade, More, In Style,* and *Vanity Fair.* Over seven grueling days they sifted through more than 50,000 images to come up with the 500 or so finally selected. They worked all day, and gathered each night with the project team to vote on a slide-show of their favorites. Longtime *Life* photo editor Bobbi Baker Burrows summed up the feelings of all of us when she said, "It was truly a rewarding time and the process was so supportive. Women work well together and I made some great friends."

As we looked at the pictures and gathered the stories we noticed that, while women across the land speak in many accents and languages, more and more they are finding their own voices. The idea of "having it all" seems to have faded, replaced by a sense of finding a balance, and crafting a life that is personally fulfilling. Throughout these pages you will witness the passion that they pour into work, family, relationships, and community.

Women today have learned they can write their own recipe for contentment, set their own priorities, and take control of their lives with courage and creativity. As they continue to care for their loved ones, they are finding ways to inject their own needs and desires into the equation. Why wait to find a husband before buying a house, when you can purchase one and fix it up yourself? Why not move to the countryside, or run for office, or start your own company, or preach the gospel—if that's what makes you happy?

We began this project with excitement and ended it with respect. This book celebrates the way American women, individually and collectively, navigate their sometimes rocky and often joyful journey. It is a testimony to the energy, ingenuity, determination, bravery, and tenderness that make us a unique breed. An unspoken sisterhood has always connected women to women—we instinctively know how to seek each other out for comfort, for companionship, for solace, and for support. The women we encountered in the course of this project have truly inspired us. We hope that they will also inspire you.

Dawn Sheggeby
Sharon J. Wohlmuth
Carol Saline

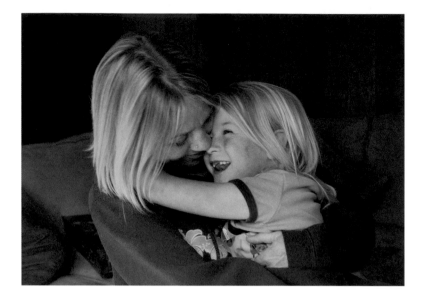

Flower Power. At 7:15 a.m., the lights come on inside Kimberly Brooks's home in the Marin County town of Tiburon, California. The 44-year-old mother of four sips coffee, feeds the cats, and puts on the hip-hop group Black Eyed Peas to begin rousing Chad, 12, Ellie, 10, Dana, 6, and Wilder, 4, as well as a school friend who has slept over. "We pick funny songs to get them out of bed," she says.

Soon, Kimberly and the children are bopping spontaneously to the music as she fixes breakfast. She kisses Peter, her husband of 18 years, good-bye as he goes off to do a job for the family's landscaping business. (Later, she'll join him to do some billing and paperwork.) Then Wilder goes to preschool and the older kids scatter to three different public schools.

In many ways, Kimberly is a traditional mom. She's warm and loving. She stays home with the kids, folds laundry, picks up *(continued on following page)*

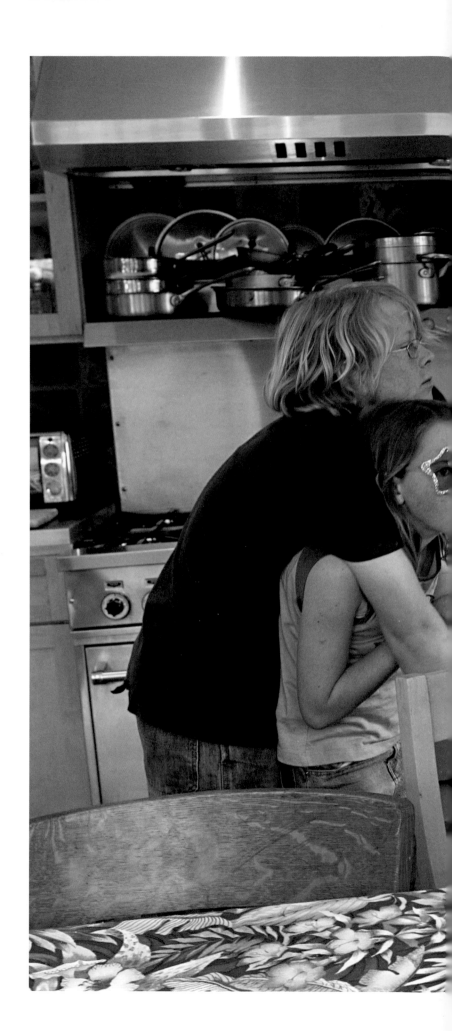

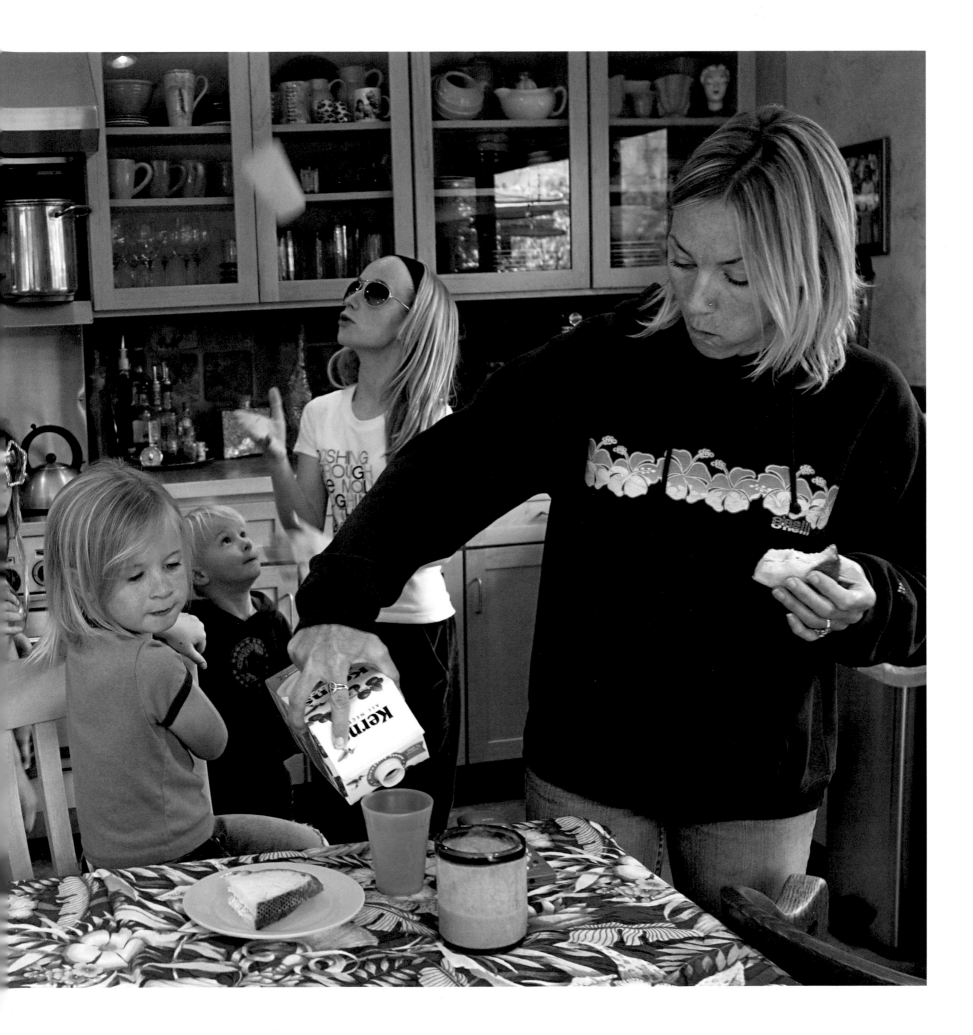

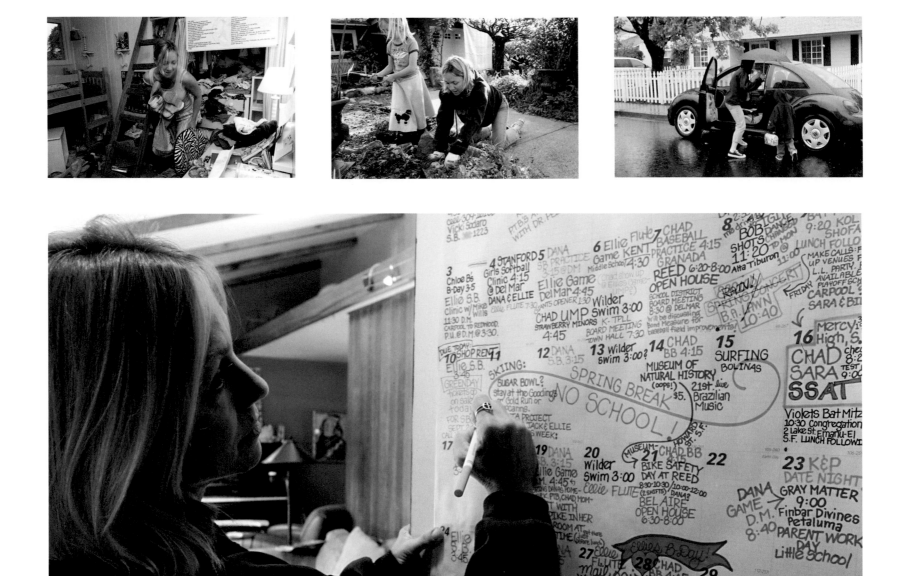

(*continued from previous page*) cluttered rooms, tracks her children's social activities on a huge color-coded calendar, and raises money for their sports teams. She also protects her clan's time together. "Sundays are our family day. The kids get invited to lots of birthday parties, but we usually don't go."

Her idea of family fun? A Green Day concert or a beach outing. Kimberly is a true California girl, with her peace sign ring, tiny nose stud, and oversized glittery brooches pinned on everyday T-shirts. When one sneaker is lost or beyond repair, she dashes about in mismatched high-tops. And forget about the SUV. Kimberly hauls her kids around in a Volkswagen bug adorned with a plastic peony, the back seat covered with a cut-up shower curtain to catch crumbs.

In rich, ultra-driven Marin, her relaxed style makes her stand out. "Here in this community, we're surrounded by super-overachievers," she says.

But she's been touched by enough tragedy—a miscarriage, a brother who went to Vietnam, a 46-year-old sister who died from breast cancer—to want her own family to enjoy living in the moment. "I count my blessings every day," she says. "Life can be difficult, but it doesn't have to be hard every day."—*Photos by Catherine Karnow*

Granny Heart. Jamilah Peters-Muhammad, 56, has always been called "Mama." The oldest of six kids growing up in New Orleans, she always had some child or another to watch. Then she raised three sons. Now she's making a home for three of her grandchildren.

Twelve years ago, illness claimed the life of her oldest son, Tevis. A few weeks later, Jamilah's grand-daughter Nzinga was born to her younger son Craig and his wife, who already had a toddler at home. "Craig thought it would be good for Nzinga to come home with me."

The girl Mama Jamilah calls her "Granny Heart" was joined four years ago by her now-10-year-old twin brothers, Tevis and Craig, when Jamilah insisted on moving them from their inner-city school to a better one close to her home. "That was in first grade, and there's been such a change in them," she says.

Now, Mama Jamilah often takes other New Orleans schoolchildren on "Imagination Tours" with Bamboula 2000, the African music and dance ensemble she co-founded. "We teach them to open their minds and travel with us to Africa. We drum and dance, and they see the magic of their traditions," Mama Jamilah says. "Dancing is the closest I've come to touching God. It led me on a path to give something back to the world."
—Photos by Kathy Anderson

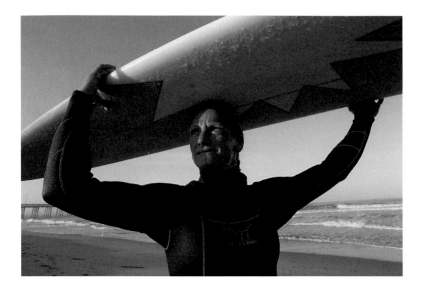

Danger Woman. Fueled by a cup of coffee and a liter of chlorophyll-enriched water, Kim Hamrock, 44, rides waves with more zeal than surfers half her age. "I surf because it's in my heart and soul," says the 2002 Women's World Longboard Champion.

Growing up in Southern California, Kim discovered surfing on TV at age 6, and by 16 was cruising the waves daily, despite heckling from male surfers who dubbed her "Danger Woman." The name stuck.

Kim starts the day by meditating at 4 a.m. "I visualize the big waves, and I see myself paddling hard, taking off, dropping in, and successfully riding them," she says. She also practices listening to her heart, a life skill she has passed on to her daughters, Nina, 20, and Margeaux, 16 (both on the beach with Kim, *right*), who surf as well, as do son Christopher and husband Marty.

"So many women lose themselves when they have kids," says Kim, who lives in Huntington Beach, California. "But if you're not true to your own heart you can't be true to anyone." Lately, for Kim that means focusing on "big-wave riding," elite invitation-only events. "I ride waves with faces up to 30 feet. That's my new realm."—*Photos by Peggie Peattie*

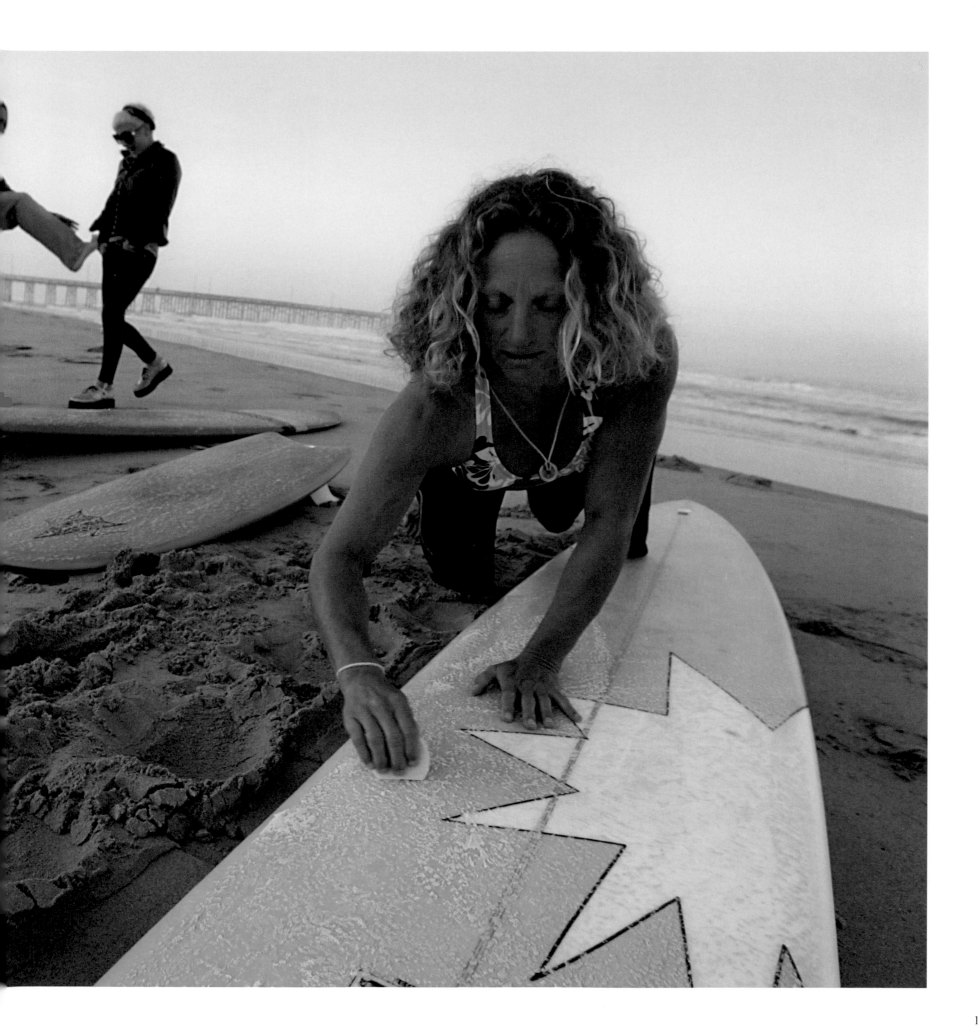

The Shape of Success

❖

Photos by Ann States

SARA BLAKELY WAS 27 YEARS OLD, LIVING IN ATLANTA, SICK OF HER DEAD-END JOB AS A sales trainer for a fax machine company. She constantly complained to her friends: "I want to do my *own* thing. I'm already past 25, and I haven't made a million dollars." All she needed was an idea—something that would land her on *Oprah*. And then she had her "aha" moment. "I'd bought this expensive pair of white slacks that hung in my closet because I couldn't find the right undergarment," explains the size-four blonde. "And I like to wear open-toed sandals." In desperation, she cut the feet off her pantyhose. "That was it," she exclaims. "I wore the footless pantyhose with my white pants. I looked fabulous. Firm. No lines. Great pair of mules. I said to myself, 'This should exist for every woman.'"

Lots of people get light-bulb notions that just burn out. Sara was determined to see hers through to reality. And she was relentless. After checking department stores and the Internet for competition (there wasn't any), she contacted hosiery mills to interest them in footless pantyhose. They thought she'd been sent by *Candid Camera*. Undeterred, she pored over hundreds of pantyhose patents at the library—none were footless—and charmed a lawyer into helping her write an application for her idea. "Everybody thought I was crazy," she admits. "Finally, I just asked the universe for a sign." One afternoon, after an early fax sales seminar, she turned on *Oprah* in her hotel room. "Right there on TV, she lifts her trouser leg to show how she'd cut the feet off her pantyhose to solve an underwear problem. I jumped off the bed, called the hosiery mills, and said, 'I'm coming down in person.'"

Finally one manufacturer, at his daughters' urging, agreed to make a prototype. Sara chose the name Spanx because it sounded saucy, and "I'd seen research that products with made-up names sell well." After two years of development, she called the hosiery buyer at Neiman Marcus in Dallas and begged for ten minutes to show her "something that would change her customers' lives." She left with the promise of a test run in seven stores. No bank would advance her the cash she needed to fulfill that first order, so her grandparents lent her $100,000—which she paid back in six months.

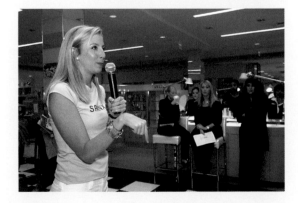

Not leaving anything to chance, she enlisted friends around the country to storm the test-run Neiman Marcus stores and snap up her product. Meanwhile, she sent Oprah a basket of samples, and in 2000 the daytime diva chose Spanx as one of her favorite products of the year, with a feature about Sara on the show. Since then, Spanx

Success hasn't spoiled Spanx founder Sara Blakely. She still colors her own hair, touching up her roots and then running out for her morning coffee (top left). She gives input into every piece that is added to the growing Spanx line, and works in her hot pink office with the zebra rug whenever she's not on the road. Her popular sales seminars to department stores where Spanx is featured (bottom left) give her a chance to showcase the talent she used in her brief time as a stand-up comic.

has exploded into a 44-piece line of hosiery, lingerie, and clothing—all with Sara's trademark slimming control—with sales last year of $75 million.

Her family isn't surprised. When Sara was a kid and her mom sent her to clean her room, she packed her old toys in a wagon and sold them in the neighborhood. At age 8 she told her father, "I don't know what I want to be when I grow up, but I'm going to make all my own money so I can marry the garbage man if I want to." Longtime friends say success hasn't altered Sara's character a bit; she remains loyal and generous, and enjoys picking up restaurant checks and taking her buddies on trips.

Beneath her breezy style is a serious woman described by a college pal as having "a brain that never shuts up." Sara confesses, "One of my favorite things to do is think— just sit for an evening without any TV or music on—and see what visions come to me."

It sounds like a charmed life, but Sara has known tragedy. A number of her

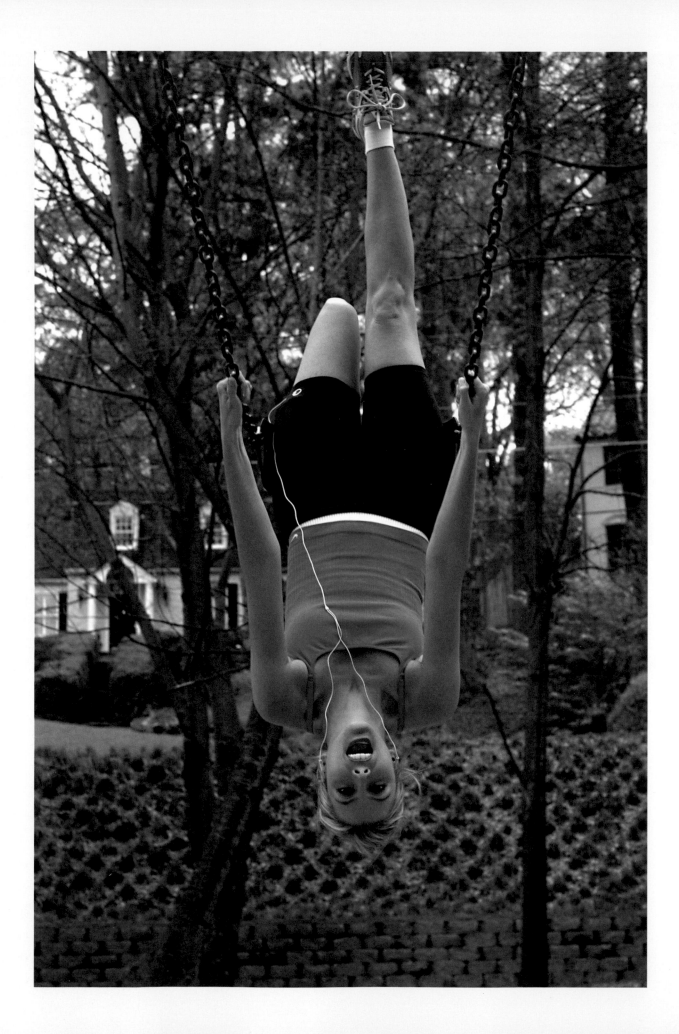

To relieve stress from her intense work life, Sara often hops on the swings at a playground near her art-filled townhouse (left), or cuts loose with her girlfriends in the private disco she designed in the basement, with its own bubble machine and Ms. Pac-Man (right).

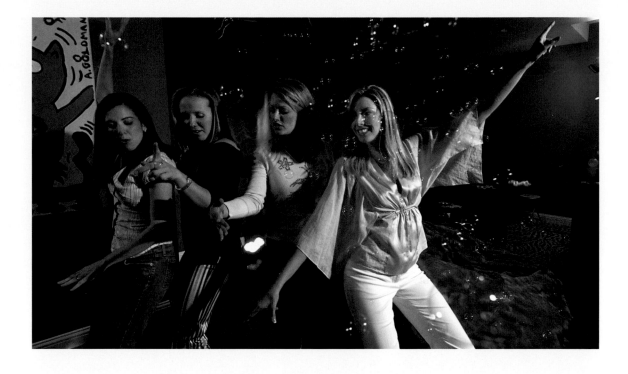

close friends have died, starting when she was in her teens and a car slammed into a girlfriend while they were bike-riding together. The most recent grievous loss was her roommate, Laura Pooley, a singer-songwriter who was killed in a horseback-riding accident. "I have been through grief that brings you to your knees," Sara says, still shaken. "It's given my life an urgency and sense of the preciousness of time that's unusual when you're 34. It's why I never let fear get in my way."

Long a devotee of motivational tapes, Sara pushes her limits by using fear as a challenge. So she's always on a plane, even though she gets anxiety attacks at takeoff. And she took part in daredevil CEO Richard Branson's TV show, *The Rebel Billionaire*, where, despite her terror of heights, she scaled the side of a hot-air balloon 10,000 feet in the air, and leaped off the 380-foot-high Victoria Falls gorge. "I don't want to be sitting in a nursing home remembering I didn't do something because I was afraid," she says. Although Sara came in second, Branson, impressed with her desire to do something to serve women in need, surprised her with a consolation check of $750,000. She plans to use it to establish a foundation that she will continue to finance from Spanx profits—one she hopes will honor her friend Laura somehow.

That she went from plugging fax machines to regular appearances on QVC, lunch with Nelson Mandela, and having Jane Fonda drop by with Gloria Steinem to brainstorm ideas for her foundation, is, Sara says, amazing. Still, she insists that what truly matters are friends and family. "I'm kind of ready to embrace the next stage, which I hope will be marriage and motherhood." She pauses. "I do occasionally have these random thoughts about what it might be like to be an archaeologist. And maybe because I'm getting older, I want to invent a comfortable stiletto. If we can put a man on the moon, why can't we come up with a comfortable pair of high heels?"—*C.S.*

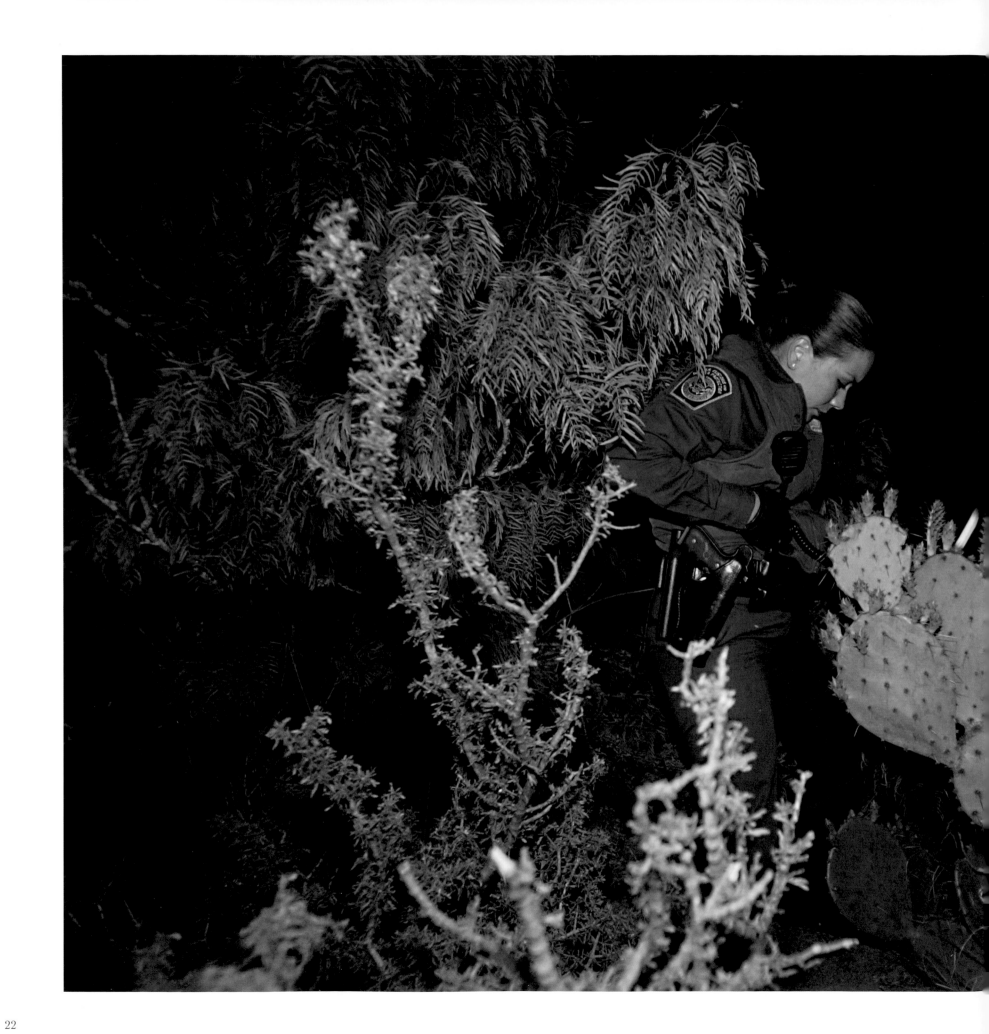

Border Patrol.

Border Patrol. At night, Adela Vazquez is tough and unflinching. She has to be. As a border patrol agent in Carrizo Springs, Texas, she stalks illegal immigrants through the pitch-black desert, following footprints and scanning for overturned rocks before pouncing, sometimes alone, on groups of illegal aliens trying to sneak into the United States from Mexico. Adela gives chase while hauling 18 pounds of gear—including a pistol, heavy boots, and night vision goggles—while avoiding rattlesnakes, venomous spiders, and, occasionally, violent drug runners.

Still, the three-year veteran of the patrol says she is rarely frightened. "Once I'm hot on the trail, nothing else matters," Adela says. (*continued on following page*)

(*continued from previous page*) "It's exciting, addicting, and time just flies. I love the rush."

In the morning, Adela, 28, is back home in the sprawling new house she bought in Laredo in early March, caring for the family she alone supports: her daughter Karla Maria, 6, son Carlos Raul, 2, and parents, Carlos and Maria. Her children's father, Raul Ugalde, is a full-time student. "There's a time to be tough, and a time not to be tough," Adela says. "I don't bring work home, or home to work. It's separate."

She makes it sound easy, but she admits the balance is a struggle. She hates saying good-bye to her children every day before her hour-long commute and 12-hour shift. And keeping her relationship with Raul on track takes extra effort. "I work all the time, make the money, and don't do the traditional wife thing," she says. "I'm so independent that it takes a toll." Still, Adela is

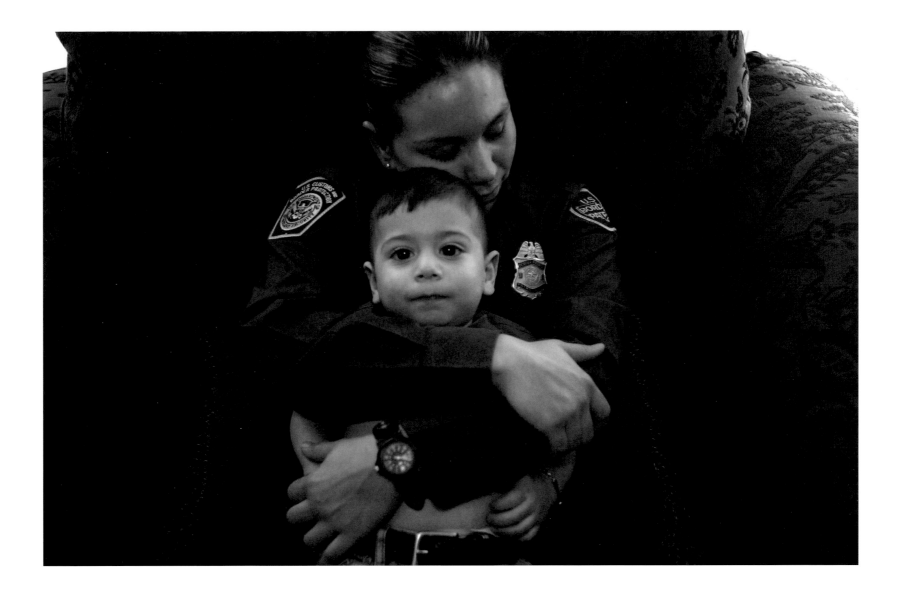

determined to stick with her plan: spend three more years on border patrol, then apply for a supervisor's job—with luck, closer to Laredo.

"I can't say, 'I'll quit my job to be home more,'" she says. "I want to do something else with my life, too. My children understand that."

—*Photos by Penny De Los Santos*

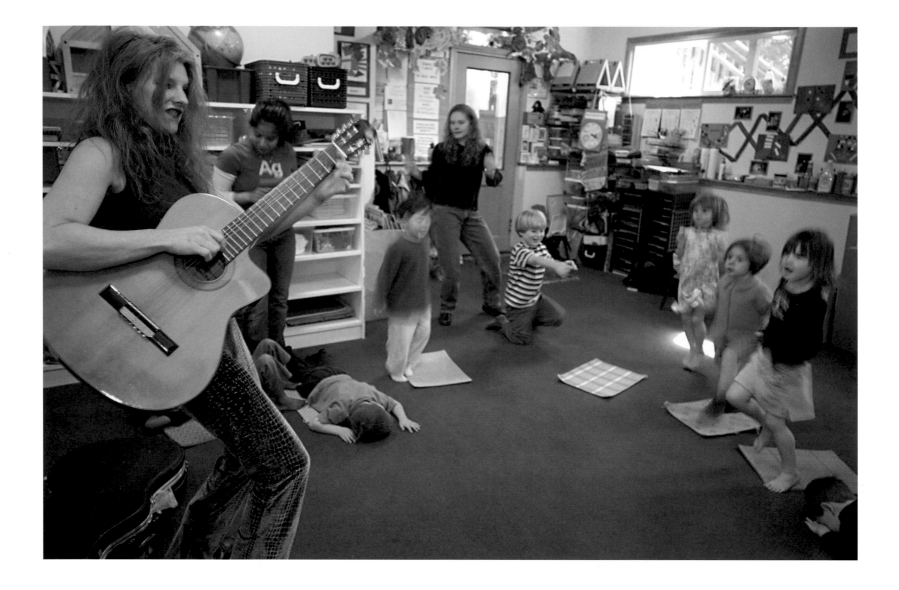

Taking Care. On any given day, some 50 percent of American women with preschool-age children go to work, placing what they love most in the world—their kids—in the hands of strangers. "Any time you leave your child with someone besides yourself or your spouse, there's a lot of concern," says photographer Natalie Fobes, who has two young daughters.

Natalie and her husband rejected many daycare options before settling on the Intergenerational Learning Center in Seattle, where teacher Dana Park, 45 (*far right*, with kids at naptime), "sealed the deal for us," says Natalie. "She is confident, caring, and she enjoys her job. She's always on the floor with the kids climbing over her.

She has loads of patience and understanding."

The children are also big fans of Sandy Buchner (*above*, at left), whom Natalie calls "a rock star for the under-7 set." The "Music Lady" teaches harmony and rhythm at daycare centers and schools around town. Natalie first saw Sandy at a festival, where, she recalls, "Fifty little girls and boys were waiting at the stage, singing and clapping and jumping around. When she started playing, it was like a mosh pit."

For Natalie, the importance of these "unsung heroes" in her daughters' lives can't be underestimated. "They shape how our children view the world."
—*Photos by Natalie Fobes*

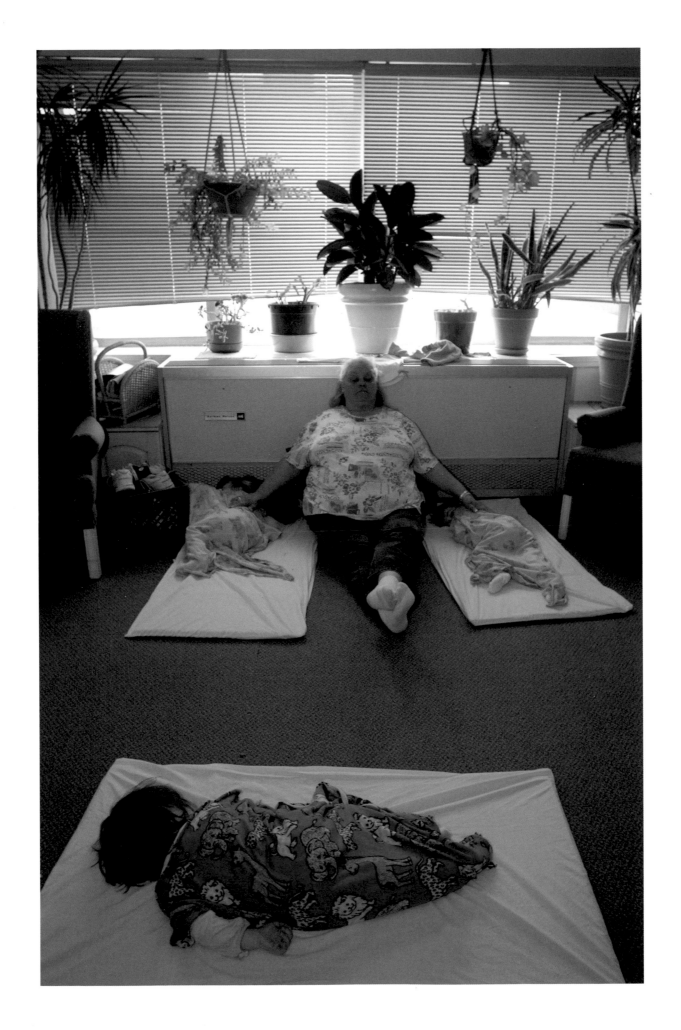

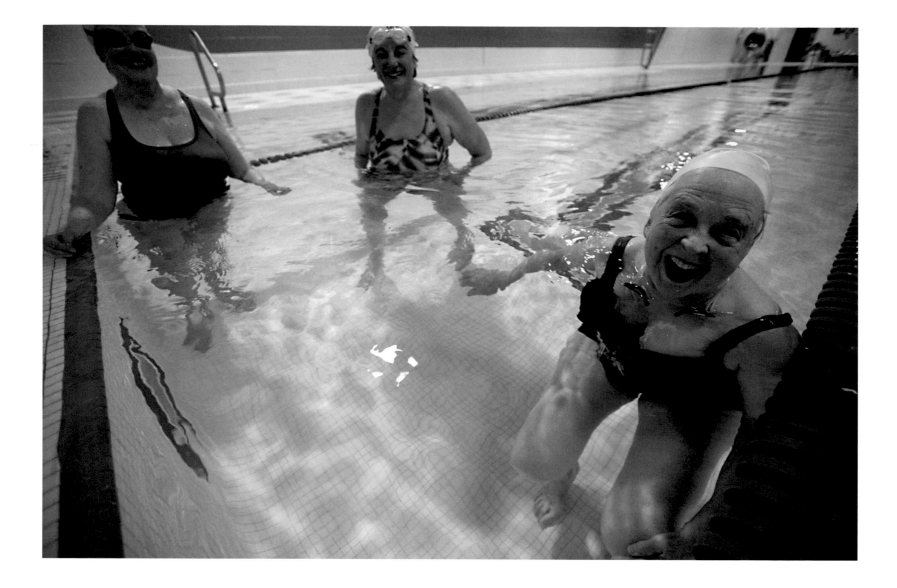

Circle of Friends. Sue. Claire. Jane. Bea. Ann. Nancy. When they started swimming 25 years ago at the Y in Andover, Massachusetts, they were a bunch of 50-something ladies—a teacher, two nurses, an occupational therapist, a former opera singer—who didn't even know each other's names.

But after months of smiles and nods in the locker room, three of them decided to go out for coffee. Then another joined, and another, and the coffee became conversations, and the conversations became camaraderie.

One day somebody got sick, and the others all turned up to support her. Then someone's husband died, and everybody attended the funeral. Somebody got the idea they should visit a nearby garden together, and one recruited two of the others to volunteer with her at a thrift shop, and they started putting candles on muffins to celebrate their birthdays.

The years slipped by and what started as mere exercise evolved into a group of friends more loving and supportive than any of them could have imagined.

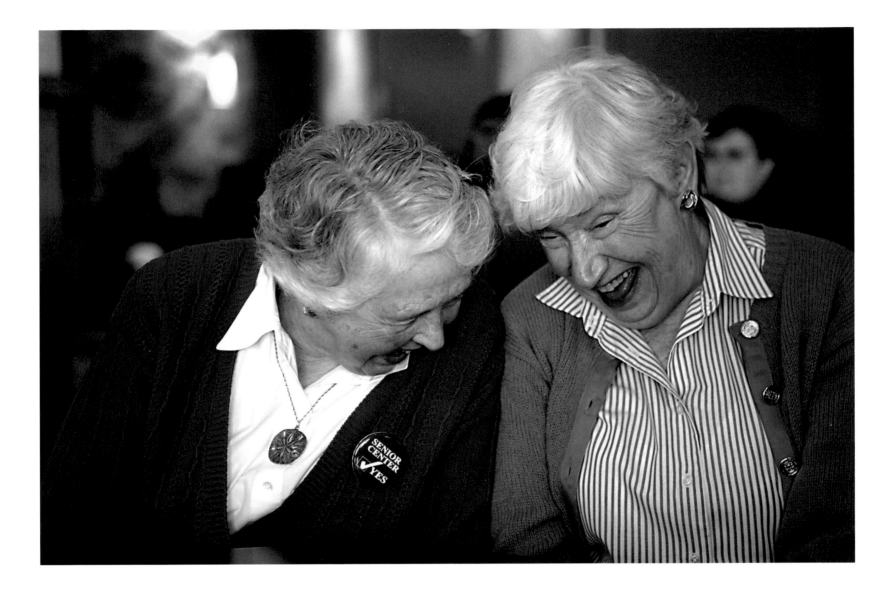

These six gray-haired grandmothers—a few others have come and gone—still meet three days a week to swim for an hour at eight in the morning, and then devotedly traipse to a café where they fill their cups and talk. People at nearby tables enviously lean in to eavesdrop on their lively chatter. They always seem to be having so much fun. No subject is off-limits: health, children, computer problems, social issues, books, politics. Jane, the lone Republican (*above* at left, with Nancy), has gotten used to their ribbing. When she had her knee replaced, the girls brought coffee and cake to her home until she could join them again in the water.

Age is an annoyance they tolerate but don't complain about. These "wonder women," as they jokingly call themselves, plan to keep swimming and caring for each other as long as they're alive and can make it to the pool.

—*Photos by Melody Ko*

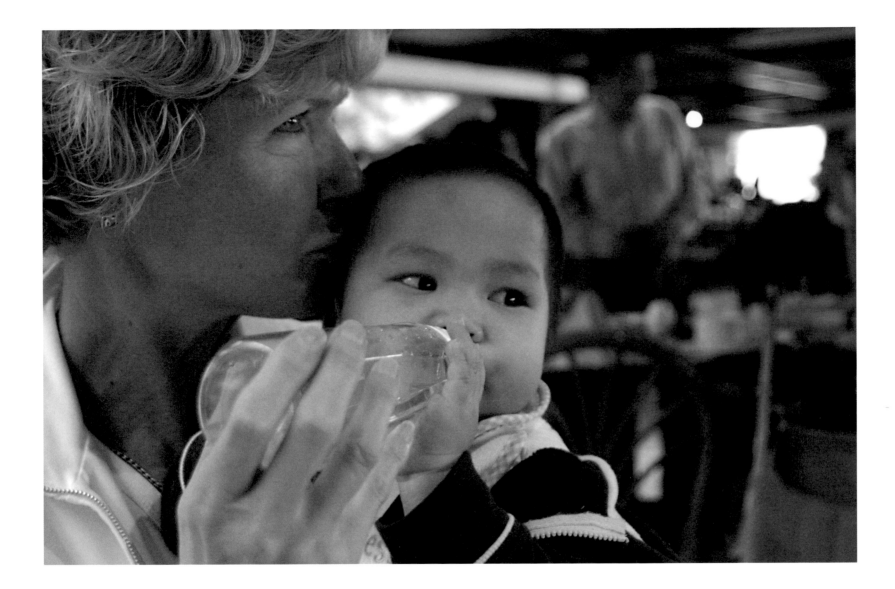

Homecoming. For many American women, the road to motherhood leads to China. Every year, thousands of U.S. families travel to adopt little girls (nearly all the babies available for adoption are female). All must pass through Guangzhou to secure permission from the U.S. Consulate to bring their new daughters home.

After adoptions are finalized, parents get their children's visa photos, then stop at a clinic where the girls undergo a medical exam. Finally, families visit the consulate to pick up the visas that allow the girls to immigrate. These daughters of China become U.S. citizens the moment they land on American soil.

Linda Carek (*above*), 48, flew to Guangzhou from Scottsdale, Arizona, with her husband Greg to meet the daughter they named Emma. The 14-month-old came to them from an orphanage, where she lived after being abandoned one week after birth. "She was so cute. She was grinning and giggling and she didn't stop," Linda says. "I was so ecstatic."

As her yearlong adoption process drew to a close, Linda felt tremendous relief. "I was anxious from day one," says the first-time mom. "It's so exciting to know that at the end, there's a little girl waiting for you."
—*Photos by Katharina Hesse*

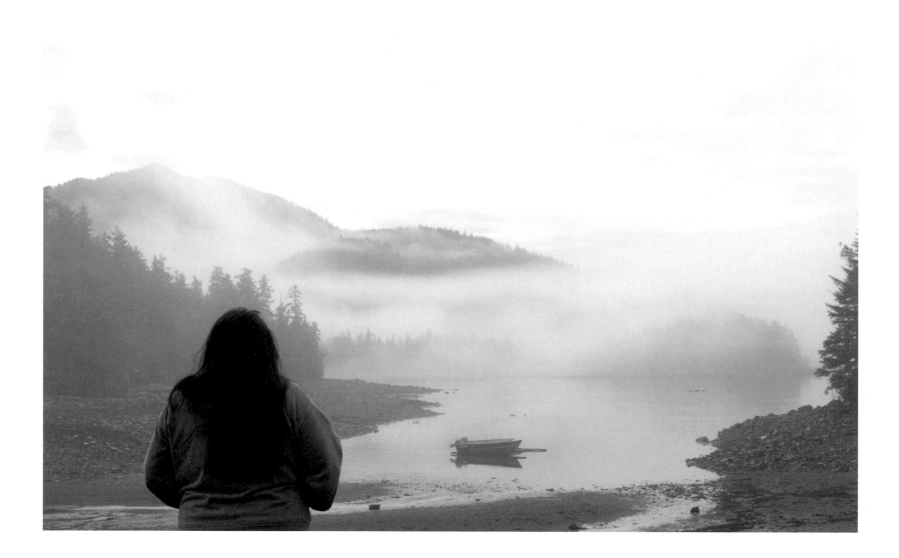

Native Voices. The Haida call it *s̲áal ḏlanaay*, first light. When Cherilyn Holter steps outside her home in Hydaburg, Alaska, in the morning, she watches the silver glow spreading over mountains, spruce forest, and the serene waters of Hydaburg Bay. She thinks of Fog Woman, who combed salmon out of her hair to bring bounty to the Haida people, a matrilineal tribe. And she wonders if her grandchildren will one day listen to the tale in the native language few now understand.

Only 65 people speak Haida today. Cherilyn herself was once a fluent speaker, before she was enrolled in a Head Start program as a toddler. "My grandparents told me that from now on it had to be English only," she recalls. "In their day, when the missionaries came to civilize us, it was brutal. If the children spoke Haida, they were beaten. So we're very close to losing our language."

Part of a group determined to resurrect the language and the treasure of memory and tradition it represents, Cherilyn spends her mornings speaking with

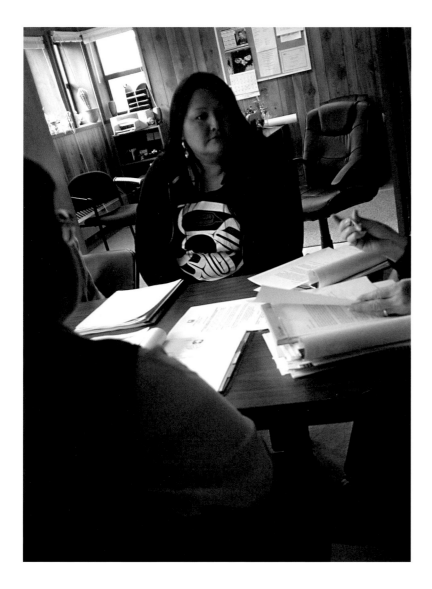

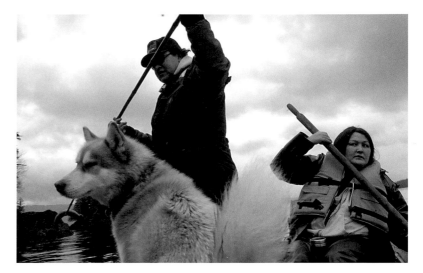

and recording six elders, ages 74 to 94, who've retained the dialect. They reminisce about the old life, explaining how to take a canoe on the water or how to sew a button on a dance robe. In the afternoon, Cherilyn teaches what she's learned in local elementary schools. "If we can create one fluent speaker, we can preserve the language for 50 years," she says.

Sometimes, she sorrows over the changes she's seen in her 40 years. "We didn't have TV until I was 13," she says. "With TV, we don't visit; we don't know how to create our own fun." But her own children, Damen, 15, Harley, 12, and Marilyn, 11, know how to fish, to harvest sea cucumber and abalone. "I get exhilarated thinking that although we've lost much, the lid is never on the box completely. I'm willing to do the work so my daughter will remember the stories to tell her children."

—*Photos by Farah Nosh*

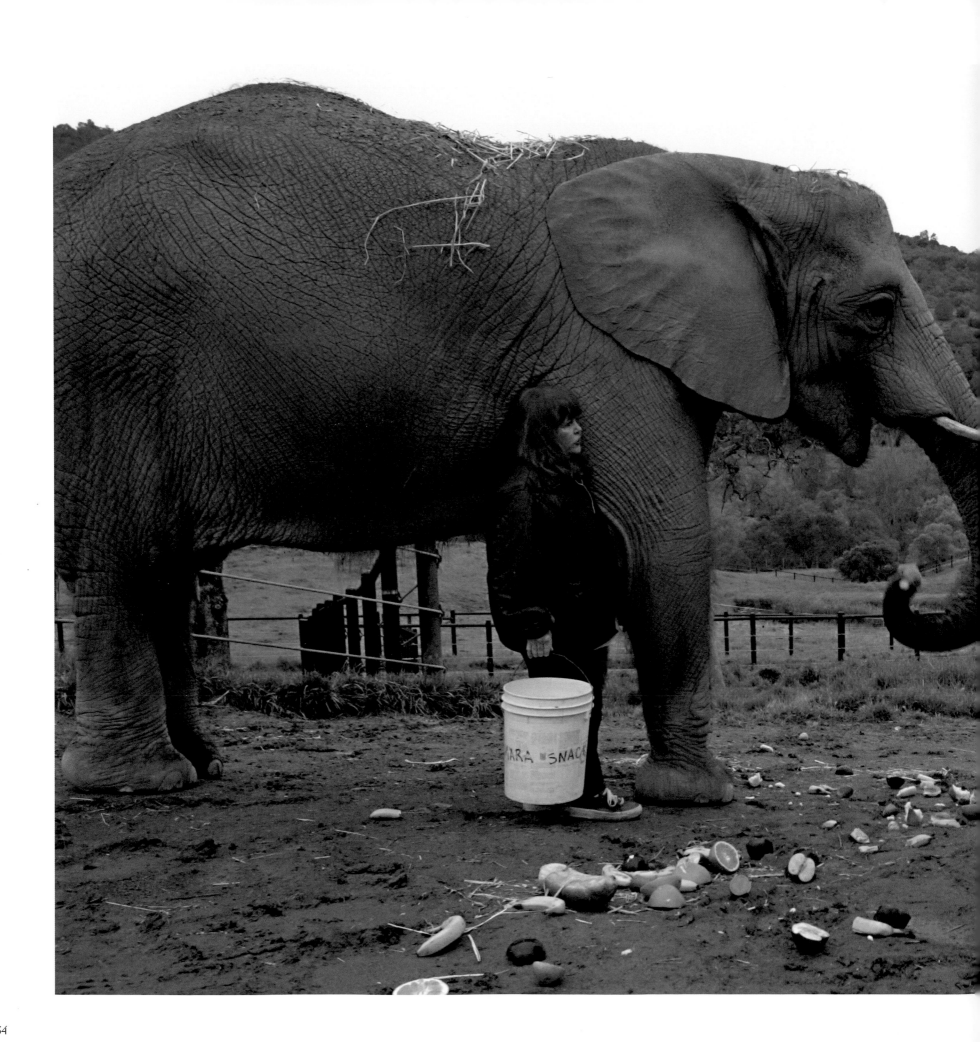

Call of the Wild. In the 1970s, Pat Derby was horrified by what she saw as an animal trainer in Hollywood with stars like Flipper and Lassie. "I believed you could humanely work animals in movies and TV," she says. "But the industry depends on making a profit, and you can't make a profit by treating animals well."

Pat practices what she preaches. In 1984, she launched PAWS—the Performing Animal Welfare Society—a nonprofit whose first move was to reform California laws for the care of captive wildlife. Now 62, she gives TLC to damaged circus animals and exotic pets at her three private wildlife sanctuaries in northern California. "I have never used any kind of weapon with animals," she says. "The idea of trying to force an animal to do anything is completely against my nature."

Her menagerie of lions, tigers, and bears includes a group of female elephants for whom Pat's life partner, Ed Stewart, designed and built the only elephant hot tub in the world. They are proud of raising an elephant named "71" (*left*), who now weighs 9,000 pounds. "She is like our daughter, our little princess," says Pat. "She is wonderful and smart. If she were a human child, she'd probably be at Stanford or Yale by now."
—*Photos by Carolyn Cole*

Leaving the Office Behind

❖

Photos by Carol Guzy

Pᴀᴛ Kʀᴜɢᴇʀ ᴡᴀꜱ ʟɪᴠɪɴɢ ʜᴇʀ ᴅʀᴇᴀᴍ. Sʜᴇ ʜᴀᴅ ᴀ high-powered job as head of litigation for American Standard, with a six-figure salary and lots of glamorous business and personal travel. She had a husband she loved, and a great West Side apartment in Manhattan, overlooking the Hudson River. Then motherhood rewrote her script. In 1991, after three years of trying to get pregnant, Pat, then 36, gave birth to baby John. Like the New York career woman she was, she hired a nanny and kept going. "The first time I lost it was at Halloween," she recalls. "I bought him this cute costume and was looking forward to trick-or-treating when I got home. But the nanny had already taken him out. I burst into tears, because that was supposed to be my job."

Her guilt stayed at a manageable simmer until her daughter, Paige, was born five-and-a-half years later. "I started to feel really nuts," Pat says frankly. "It was relatively easy with just one, but now John needed a different kind of attention than the baby. Plus he was in kindergarten at a public school and not getting the right kind of education. Our apartment felt cramped, and I was yearning to be with Paige to do all the things I hadn't been able to do with John. More and more, the stuff at work seemed trivial compared to watching your child take her first steps and being at the school play." Even the business travel she'd loved became a problem. "Like all the career women I know, when I was away I was always on the phone checking with the nanny, even though I'd left lists for everything. When men are away, they aren't thinking, 'Oh my God, I might miss something.'"

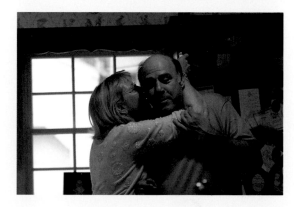

Reluctantly, Pat realized it was time for a change. She abandoned her job, not sure when she'd return, and she and her husband bought a house in Norman Rockwell-esque Ridgewood, New Jersey. She found the switch from lawyer to full-time mom wrenching. "I loved New York and was a fish out of water here—really kind of bitchy for a while," she says. "I felt so lonely and isolated. When I tried to bring the *Times* to my daughter's playgroup and talk about the news of the day, believe me, that did not go over. In the city, there's always something to look at or do. Here, it's the A&P. Everybody plays in their own backyards; nobody goes to the park."

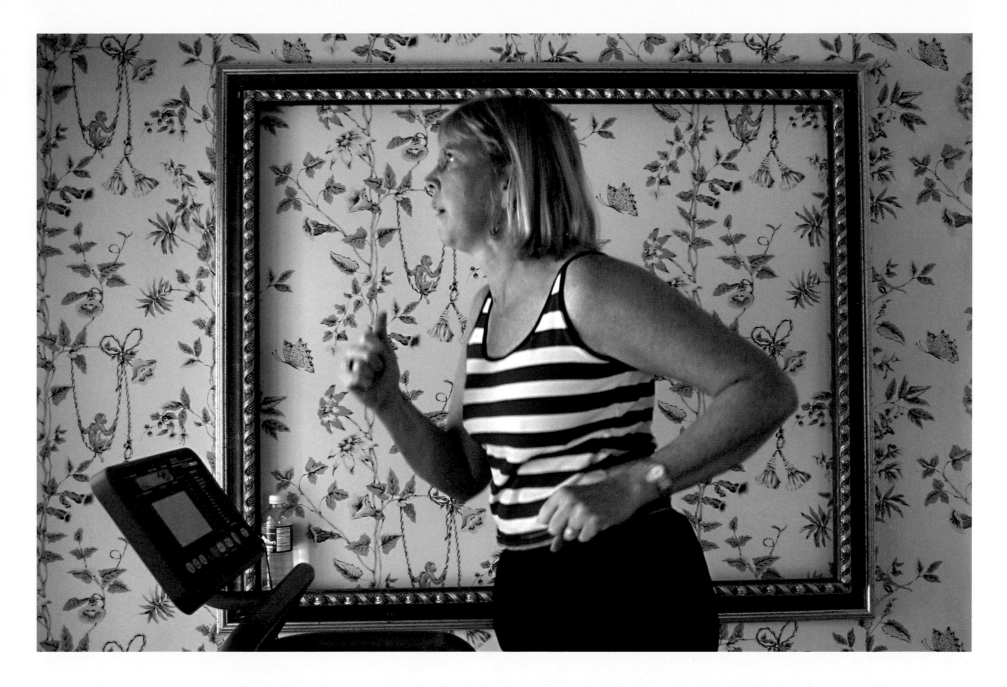

Although she has gone back to work part-time, Pat Kruger's life still centers on her family: her kids Paige (top left, in pink) and John; weekly visits with her mother, who has Alzheimer's; and her husband, John Bykowsky (bottom left), a former lawyer who now organizes adult sports groups for businesses.

To fill the void and make friends, Pat redirected the drive that had made her such a successful lawyer by volunteering at school, fundraising for the library, becoming a Cub Scout leader. It was…almost enough. "Do I feel I'm making a sacrifice? Absolutely," she says. "Every good mother makes sacrifices. Sure, it would be different if I didn't have kids. My husband and I would be traveling all over. But this was my choice, to do what is best for my family. That's what love is when you have kids, right? Maybe if you're Madonna you can have it all at the same time, but she doesn't look so happy to me."

Pat learned the upside of her new community the hard way. On the afternoon of Paige's third birthday, she got the news she had breast cancer: stage two invasive ductal carcinoma. Throughout her treatment—a lumpectomy, chemo, and radiation therapy—strangers as well as friends brought meals, drove her to appointments, ferried her kids

to activities when she was too tired to get out of bed. "That's when I knew I was in the right place," she says, wiping away the tears. "Oh what a mushball I am! But had I still been working and living in the city, I would never have had such a wonderful support system."

Nor would she be available now to support her mother, who has been diagnosed with Alzheimer's and lives in a good nursing home nearby. "Because I'm around, I can spend Tuesdays with her," Pat says, "and that's really nice. You should see her light up when I come to get her. She's a responsibility, but not a burden."

Surviving her cancer and witnessing her mother's decline have prompted Pat to set Thursdays aside as personal play days. "Women don't play enough," she says. "They'd be happier if they did, and I am trying to be happy." She's come to appreciate small blessings—time for a tennis game, lunch with girlfriends, sewing, giving dinner parties—and is letting go of the perfectionist bug. "Tidy I'm not," she says, waving an arm at her clean but cluttered house, where the stall shower in the powder room stores hockey gear.

Once, Pat thought she could plan out her life. Now she realizes that life makes its own plans for you. She doesn't regret her career hiatus, and now that her kids are a little older, she has gone back to work two days a week for her old company, which has moved to New Jersey. "I was amazed at how quiet the office is," she marvels. "It's this lovely island of calm. It feels beige."

Nor does she harbor second thoughts about her years as an at-home mom. "Being a mother is the most important job there is, and taking six or ten or twelve years out of your life doesn't leave you brain-dead. What could be more important than raising good people?" she says passionately. "Isn't that what the world needs?"—*C.S.*

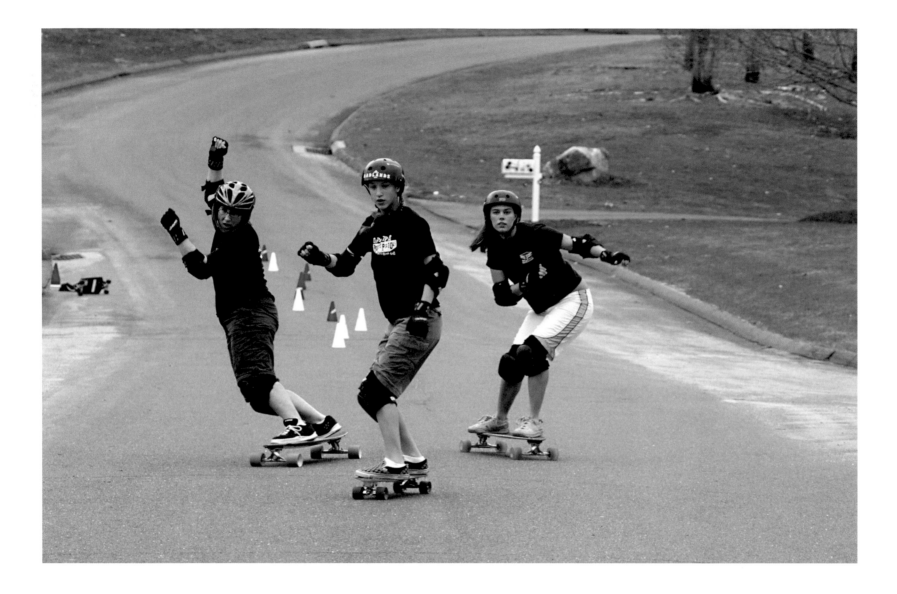

Skater Mom. "We pretend we're flying," says Lisa Woodward, 38, about the downhill skateboarding she does with her daughters Katii and Elisa Campbell, 15 and 18. Most mornings in warm weather, the trio heads out before 6 a.m. to skate the dips and valleys of their neighborhood streets in Avon, Connecticut.

Having ridden her first skateboard at age 6, Lisa encouraged her girls to try the sport. "As an adult I had nobody to skate with," she says, "so as soon as the kids got old enough, I taught them just so they could come with me." Both daughters have since become champions for their respective age groups in the American Cup Slalom Series (Mom placed third), and all three are ranked in the top 15 women slalom skaters worldwide. They continue to compete together in dozens of national meets each season. "A lot of father-son groups skate together," Lisa says of the close-knit competitive skateboard community, "but we're all about representing women."

And what do suburban onlookers say of the trio's early-morning spectacles? "The neighbors think we're crazy," Lisa says, "and my husband just shakes his head."—*Photos by Anne Day*

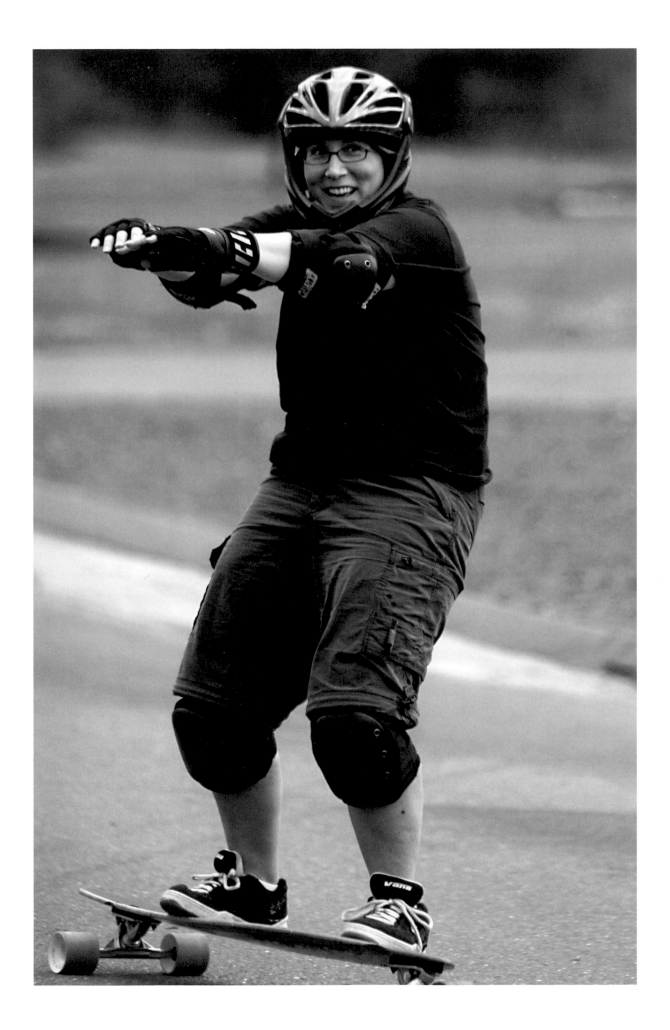

Fighting Chance. Nineteen-year-old Whitney Drayton has been hanging around gyms since she was too small to see over the top of the ring. That's how she connected with her dad, Papa Ray, and how he protected her from the drug world that destroyed his sons.

By the time she was 8, Whitney was serious about boxing. "I like punching a lot," she says, and saw the sport as something she could do with her life. Papa Ray, a former sparring partner for boxing legends like Sonny Liston, had one inviolate rule: No gym until homework's done.

At 5'6" and 141 pounds of sheer muscle, Whitney is lithe and quick and moves like a dancer. At 13, she took the Women's National Title, and has twice won Golden Glove honors. Still close to her dad, now her trainer, she works out five days a week for two hours a day at a gym in Quincy, Massachusetts. Papa Ray is very proud that Whitney graduated from high school last year. She plans to work part-time until she finds a sponsor so she can box as a full-time professional.

None of Whitney's girlfriends are boxers. "They think it's dangerous," she says, "'cause you get hit in the head and there's a lot of brain damage." That worries her, but she's counting on Papa Ray to protect her. "Any time I see you getting beat up," he assures her, "that's when I say, 'Enough for you.'"—*Photos by Melody Ko*

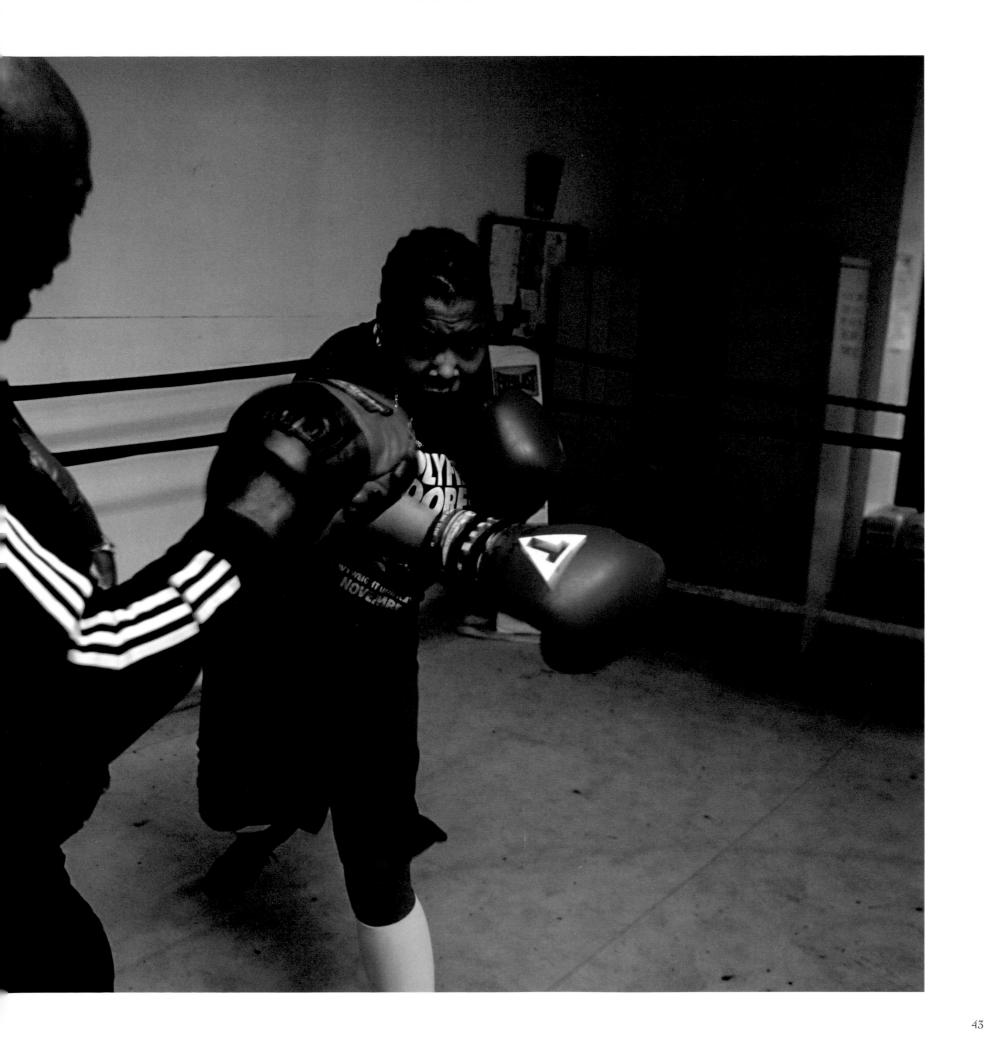

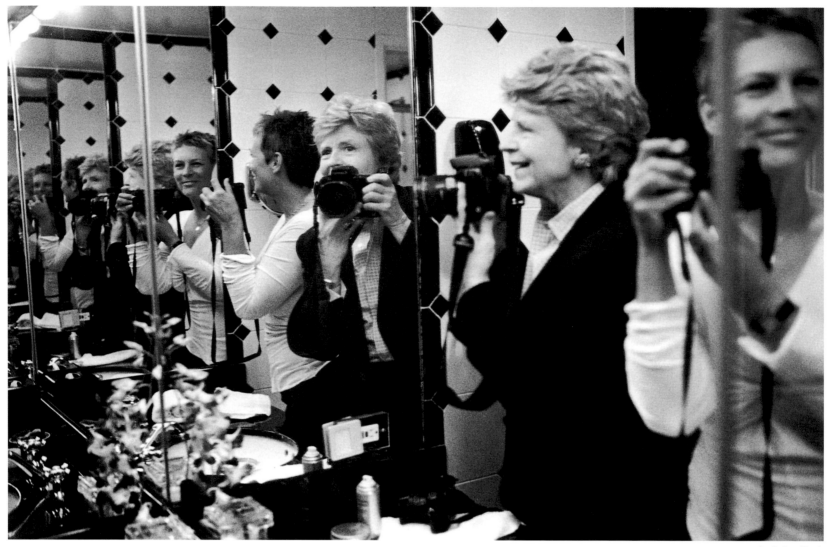

Jamie Lee Curtis

A Day with Jamie Lee.

April 8, Jamie Lee Curtis insists, was an anomaly: Her family was in New York only because the Museum of Modern Art was honoring her husband, actor and director Christopher Guest. "I don't get made up every day," she says. "I don't ride in limos or go shopping at Bergdorf's every day. I spend most of my days in jeans, dealing with stuff women everywhere deal with: my kids, my sick father, and dog poop."

Nevertheless, the day was fun for Jamie, who, in addition to being a world-renowned actress, is also an accomplished photographer: She was assigned to take pictures of some of the women in her life, including Diana Walker—a longtime White House photographer, who had in turn been assigned to photograph Jamie. Diana also happens to be one of Jamie's dear friends.

The shoot-a-thon started early: "I expected to get a breakfast tray at 6 a.m.," Diana says drily. "Instead I got a Leica M6 with Jamie attached." Jamie, in fact, had already been up for an hour and taken a series of self-portraits while getting dressed. (*continued on following page*)

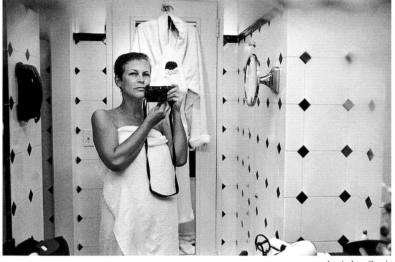

Jamie Lee Curtis

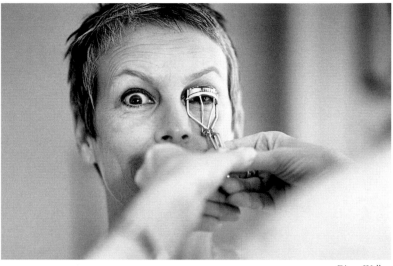

Diana Walker

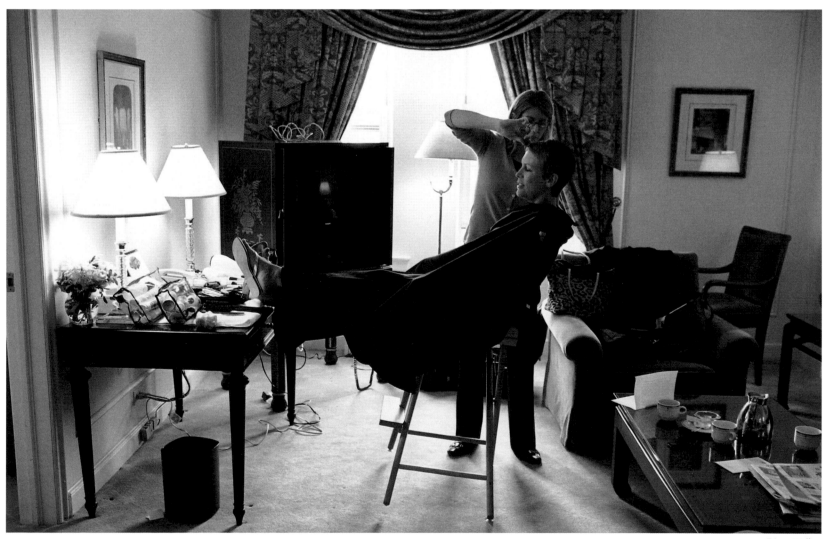

Diana Walker

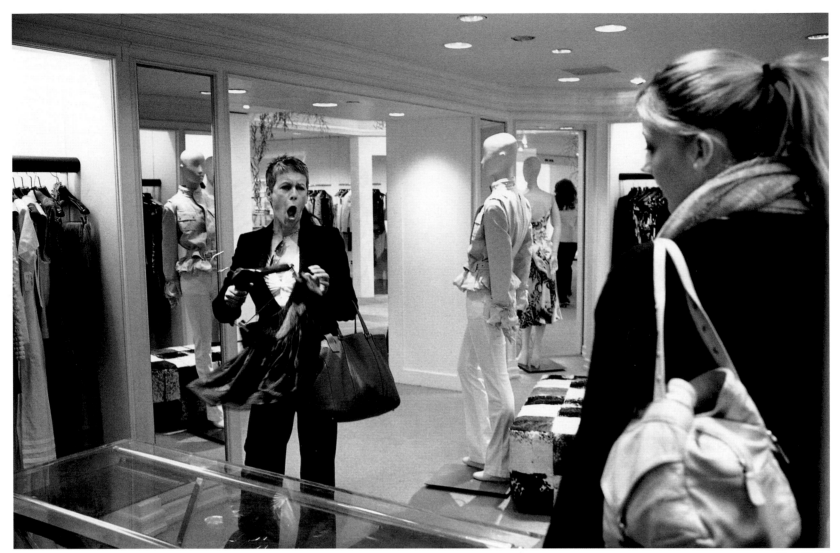

Diana Walker

Jamie Lee Curtis

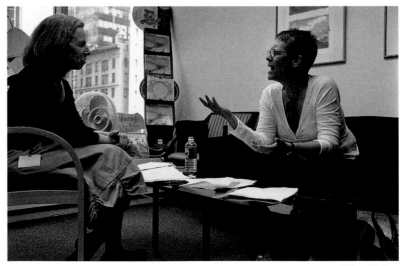

Diana Walker

Diana Walker

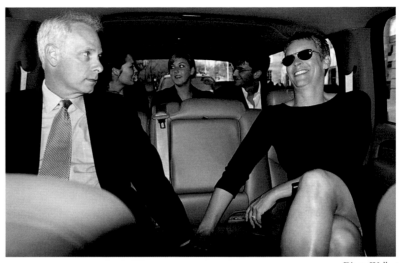

Diana Walker

Diana Walker

(*continued from previous page*) She had also photographed Kristina Hoffler (*far left bottom*), who at 6 a.m. was already working as a guest service agent at the Mark Hotel where both photographers were staying.

Diana shadowed Jamie as she had her makeup and hair done, then followed the actress as she shopped with her 18-year-old daughter, Annie, for a prom dress (*left top*); met with the editor of her children's books (*near left bottom*); was interviewed for a documentary on women's friendships; and went with her husband (*right top*) to the MOMA event. "It actually was a kind of stressful day," admits Jamie. "I did a lot."

The friends, who have known each other since

1992, come from different generations and backgrounds: Jamie, 46, grew up with movie-star parents (Janet Leigh and Tony Curtis), and has spent her career in front of the camera. Diana, 63, grew up in Washington, D.C., and has been photographing American presidents and politicos for *Time* magazine for more than 25 years.

"We say we are 'Leica friends' because we both use Leica cameras and so have a 'Leica' point of view," Jamie says. "We are kindred spirits."

Adds Walker, "We have a language of our own. Jamie is an incredibly loving, perceptive woman. She's an enormous addition to my life."

—*Photos by Jamie Lee Curtis and Diana Walker*

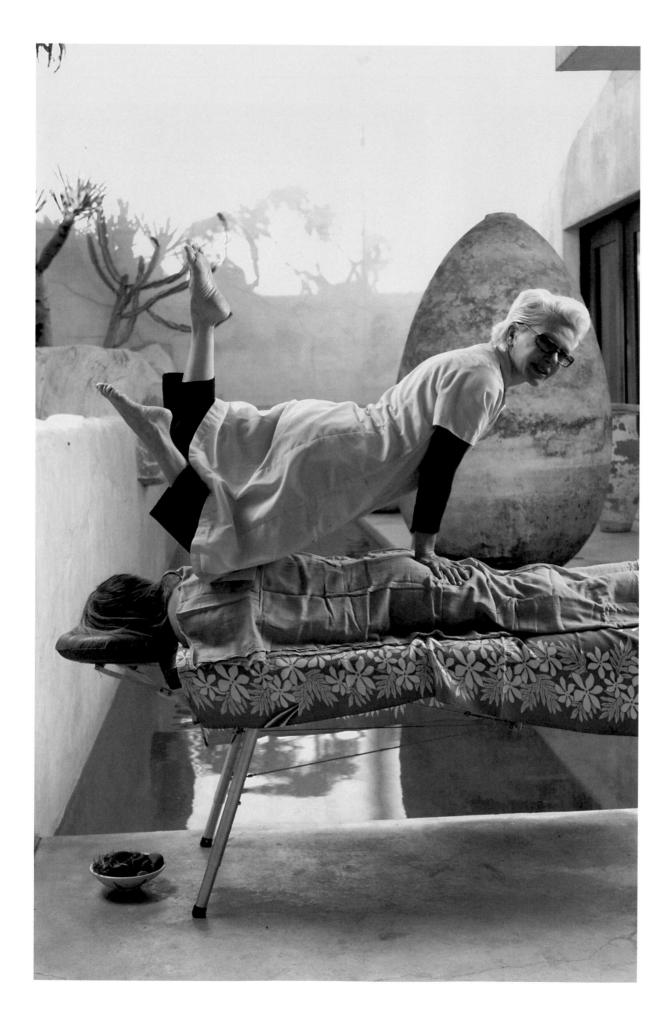

Healing Hands.

"My clients say I'm better than sex!" says Patricia Smets, massage therapist to Los Angeles's elite and muscle-weary. "They tell me: Make me feel good like you always do."

And so she does, using her signature combination of Swedish, Thai, shiatsu, and hot-stone massage techniques. "I love to touch people—it's wonderful to relieve tension, aches, and pains."

Making housecalls for up to ten clients a day, the 45-year-old Paris native is sometimes so busy that she barely has time to get massages herself. But she tries to at least twice a month, if not for relaxation, then for education. "I learn as much from getting a bad massage as a good one," she says.

Are her friends and family lucky enough to get freebies at home? "They know not to ask me anymore—too much work." Patricia says. "I only gave my husband massages back when we were first dating, just to reel him in."

—Photo by Véronique Vial

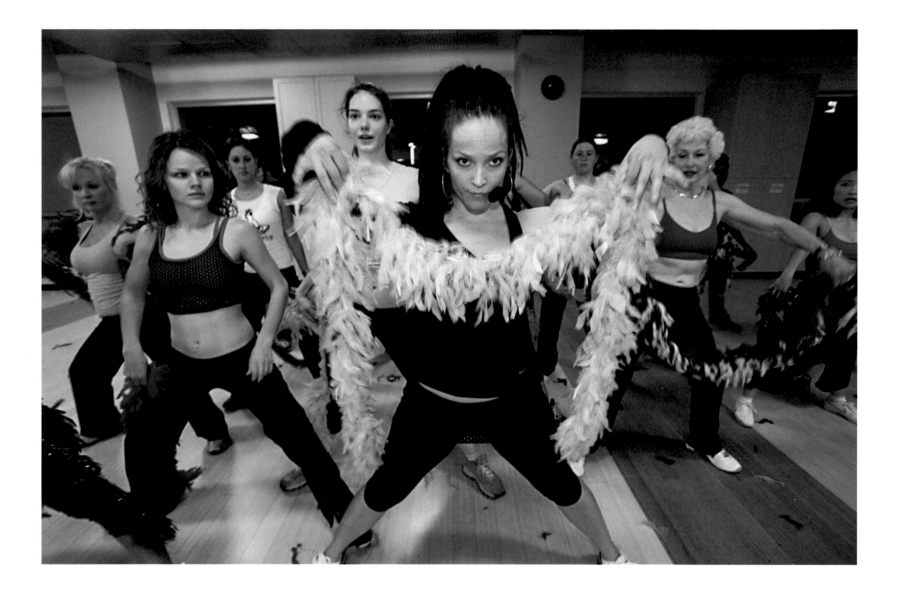

Boa Instructor. "Something comes over a woman the second she picks up a feather boa," says veteran fitness instructor Misty Tripoli. She's referring to her students' response to Boa Burn, the burlesque-inspired class she invented at Bodies in Motion, a West Hollywood gym.

Misty, 33, has been teaching group exercise for more than a decade. Two years ago, she added a fun prop to the mix to give her students a major confidence boost. "Using the boa helps take the attention off yourself," she says. "It helps you relax into the movement."

Now sharing her technique at fitness conferences across the country, Misty observes that many of her students return for reasons more meaningful than simply the novel workout. "It's funny how a class can change your life," she says. "I'll have women come up to me at the end with huge smiles on their faces—and it will turn into tears. They'll say: 'I never realized my body is sexy exactly the way it is.'"—*Photo by Lauren Greenfield*

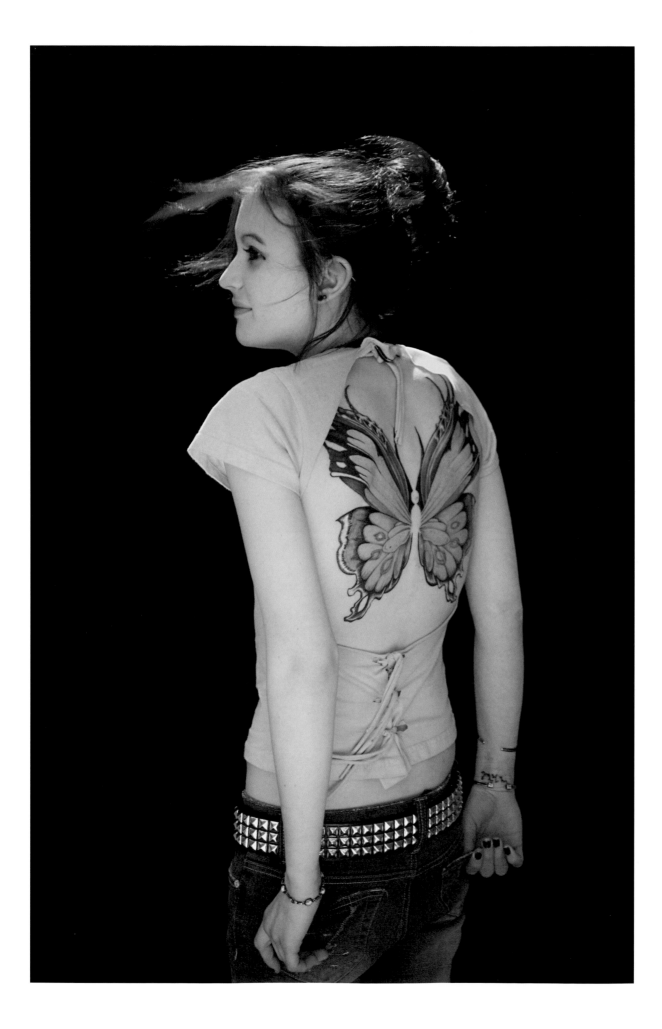

On My Street. "People think you need to go to an exotic place to take good pictures," says photographer Joyce Tenneson. "But everyone's block is interesting if you just look closely."

So for her shoot with some of New York City's most colorful young women, she set up shop literally in her own backyard. Joyce, best known for her books of portraits such as *Wise Women,* created an outdoor studio just steps from her home, on a stretch of sidewalk that fronts the Fashion Institute of Technology (FIT). The famous professional school counts designers Norma Kamali and Calvin Klein among its alumni.

"I hung a backdrop between a tree and a streetlight, and just stopped people as they walked by," Joyce explains. Passers-by included FIT student Lindsey Cook (*left*), who proudly displayed a large butterfly tattoo of her own design.

Eight hours and more than 30 subjects later, Joyce packed up, tired but inspired. "It was a very intense day," she recalls, "but also invigorating. I was so impressed with what individual spirits these women have. They are certainly not cookie-cutter types."
—*Photos by Joyce Tenneson*

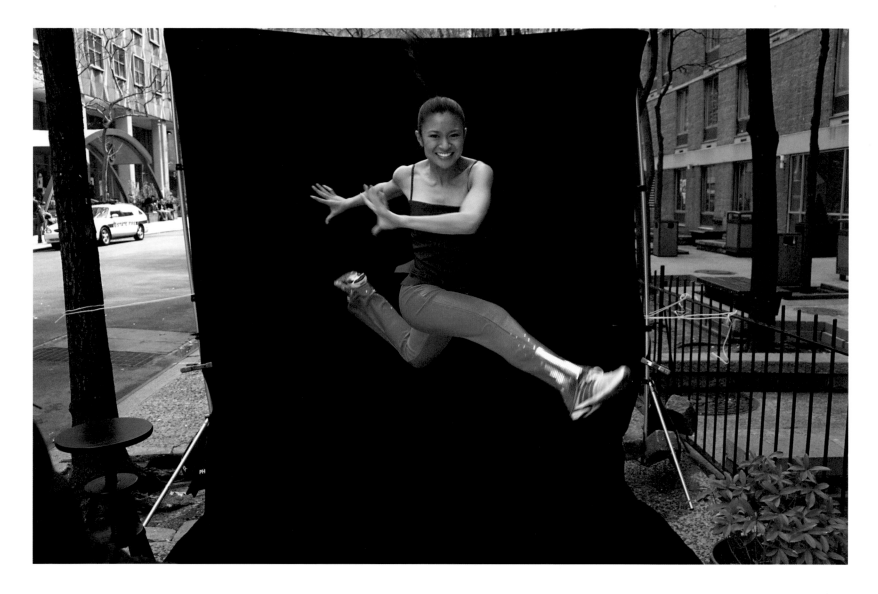

All About Mee

❖

Photos by Keri Pickett

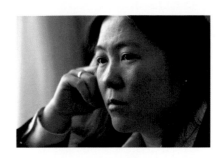

Sᴏᴍᴇᴛɪᴍᴇs ɪɴ ᴛʜᴇ ǫᴜɪᴇᴛ ʙᴇꜰᴏʀᴇ sʟᴇᴇᴩ, ᴀꜰᴛᴇʀ ᴀ ᴛᴇɴ-hour day in the legislature, having tucked in her young son and daughter, Mee Moua lies next to her husband, Yee, in their spotless three-bedroom home, and thinks about what her life might have been. The 36-year-old Minnesota state senator imagines that somewhere there is a parallel universe in which she grew up with no education, has lots of children, and lives in a dirt-floor hut. In this world she goes to the fields every day with a big basket on her back, like the relatives she left behind in her native Laos.

Mee thinks about how her Hmong parents fled the Laotian Communists in 1975 and walked for 19 days with their three young children, taking nothing but the clothes on their backs, until they reached the Thai border. How for three years they lived in a refugee camp with no electricity, sewers, or running water. How the luck of a family reunification program sent them to her grandparents in America. How a curious little girl who spoke no English slept with a pillow for the first time and learned to flush a toilet.

Newcomer Mee entered the fourth grade at a Catholic school in Appleton, Wisconsin, a white-bread town with maybe a half-dozen families of color. It was 1979, not long after the Vietnam War, and the Mouas became targets of anti-Asian diatribes. "Our house got egged," Mee recalls. "Kids wrote ugly words on our garage and peed on our lawn. We got spit at from cars when we walked to school." Even today, she gets hate mail. "Some people think I have no right to fly the flag or that my job as senator shouldn't be held by a foreigner. It should go to a 'real American'—even though an immigrant being elected to office is just about the most American thing that could happen."

Mee always felt like an outsider, even after the Hmong population swelled in Wisconsin. "I know what it feels like to be vulnerable, marginalized, and treated as irrelevant," she says, without rancor. "Growing up as an immigrant, I fought to earn respect from other kids." She joined the Girl Scouts, and for each badge her friends mastered, she got three. She excelled at soccer. Her sports skills and cheerful disposition helped overcome her fractured English. "In sixth grade," she recalls, with her easy laugh, "a girl-friend told me, 'It's okay that you're not popular with the popular kids, because you're the most popular with the ones who are unpopular.'" In high school, five-foot-tall Mee,

At work in the state capitol building in St. Paul, Minnesota State Senator Mee Moua is the first member of the Laotian Hmong tribe to be elected to a state legislature in the United States.

too short now for soccer, became editor of the school newspaper, acted in plays, and competed on the debate team, all while working as a hospital aide.

From early on, Mee navigated comfortably between two distinct worlds: the Hmong community—the St. Paul area, where her family settled in 1988, has one of the largest concentrations of Hmong in the United States—and the world outside. From dinners and sleepovers at the homes of her American friends, she observed such simple cultural norms as the proper way to make a bed: "In our house, Mom didn't understand sets. She put a fitted sheet on one bed and tied a knot in the corner of the flat sheet for another bed. I came home and showed her that in America there's a bottom sheet, a top sheet and a blanket." By high school, when her tribal girlfriends were mostly married and having babies, she increasingly identified with the college and grad-school goals of her friends from outside the Hmong community.

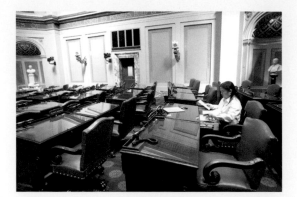

Although the Hmong in America are notoriously insular, Mee's parents wisely allowed her to explore beyond the borders of their community. "They realized the best way to maximize the opportunities America offered was to give me up to other adults who could educate me," she says. "My teachers, the librarians where I'd take the bus every weekend to devour books, would all tell you they adopted me. My mom and dad once told me, 'We don't have much education, and when we die we won't leave you anything, but we can invest in a future for you. You are our pot of money. If you teach yourself and take care of yourself, that's our savings for you.' I owed it to them to be successful."

In type-A fashion, Mee repaid her debt, earning a BA on scholarship from Brown University in 1992, a master's in public affairs from the University of Texas in 1994 (her mentor was a professor, former congresswoman Barbara Jordan), and a law degree from the University of Minnesota in 1997. With her initial paycheck from the law firm she joined—she specialized in immigration law—she sent her parents on the first vacation they'd ever had, to visit relatives in California. In 1999, she married the only man she'd ever really dated, a newspaper reporter who is now in real estate. Husband Yee was attracted, he says, by Mee's intelligence, passion, and idealism: "She has a vision of what she wants the world to be. Her worst quality is that she can't say no."

When her state senator stepped down to become mayor of St. Paul in 2002, Mee, a progressive Democrat, narrowly won a tough uphill battle for the special election to fill his seat, and was reelected ten months later to her first full term. As a legislator, she is a tireless champion of the disadvantaged—the old, the poor, the sick, the young. She's a natural politician, her gaze intense, her style touchy, warm, and animated. Her old debating days made her a compelling speaker with a gift for translating complex ideas into simple terms, and she forges connections by lacing her

Senator Moua studies upcoming legislation (left top), and later says hello to some of her constituents during a lunch date at a local Hmong-run restaurant (left center). Mee and her husband both work full-time, thanks in part to her mother-in-law, Sai Yang (left bottom), who lives with the family and takes care of their two children.

Before bedtime, Mee entertains her 18-month-old daughter, Sheng (above).

speeches with personal anecdotes. Of course she understands a mother's concern for educational budget cuts; she has young children. The spiraling health costs of senior citizens? Her aging mother has medical woes.

Mee's frenetic life leaves little time for exercise. "So I've given myself permission to be fat," she says, laughing. "It's liberating not to have a hang-up about whether I can fit into a size ten or a size 12." To Mee's surprise, motherhood has softened her intensity. "Having children took the focus off me and my wants," she says "and made me a nicer, kinder, more thoughtful person." She feels good about the healthcare and education bills she's introduced to help her constituents, but just as gratifying is coming home to a 5-year-old son who sings in his sleep. "I wish that for all children—to be able to go to sleep and dream happy, wonderful things that provoke them to sing in their sleep."—*C.S.*

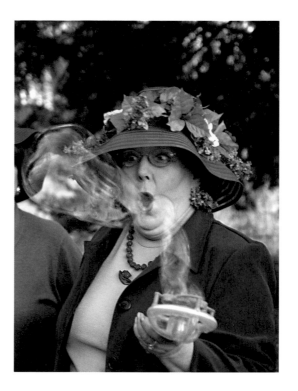

Red Hattitude. "Nobody has to bake brownies, nobody has to write a report—it's just a bunch of women having fun," says Queen Mum Nina Mathus (*left*, seated with hand raised) about her Salisbury, Connecticut, chapter of the Red Hat Society.

The spirited international "disorganization," founded in 1998 by California native Sue Ellen Cooper, now boasts more than 1 million members—age 50 and up and proud of it. As for their signature accessory, Nina explains, "Red stands for sexy, hot, full of life! It's a defiance of a society that respects youth more than wisdom and maturity."

Meeting once a month for outings to Broadway shows, films, or cocktails, the chapter calls itself "Just for Fun!" and prides itself on sticking to the hedonistic ideals suggested by its name. "We're not interested in saving the world," Nina adds, "just having a good time"—as demonstrated by a bubble-blowing Lynne Martin (*above*).

The group did, however, have a light-hearted discussion of creating a Red Hatters charity pin-up calendar. Nina jokes, "It would have to be quite artfully edited."—*Photos by Anne Day*

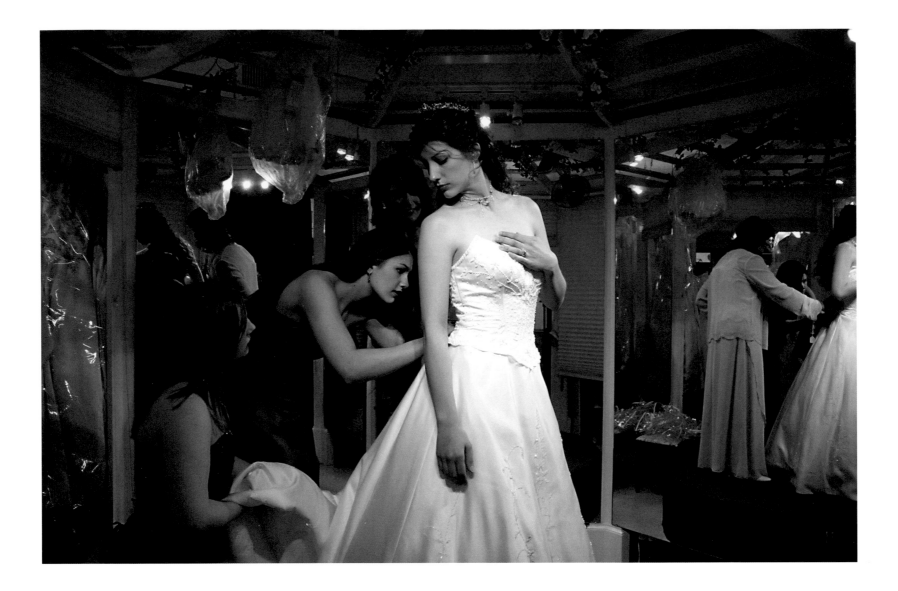

Wedding Belles. "She looked so beautiful in everything," Diane Shugrue recalls, speaking of her visit to Ida's Bridal Shop in Torrington, Connecticut, with her 21-year-old daughter—and bride-to-be—Carly.

Nearly every bride seems to have a cautionary tale about clashes with her mother over wedding plans, but Diane says it has been mostly "smooth sailing" with Carly. "We definitely have the same taste; I've picked out her clothes since she was little," says the 48-year-old mother of three.

Throughout the afternoon, the store's veteran proprietor, Ida, was quick to offer her practiced opinion. "Every time Carly put on a new dress, she looked so pretty. Ida would ask, 'Can she just stand in my window for a minute?'" The bride ultimately chose a simple, fitted silk gown.

Even amid the bustle and train, Diane still had time to reflect on the poignant moment. "It's scary to see your first one go off," she says. "You remember how little they were. Time flies." —*Photo by Anne Day*

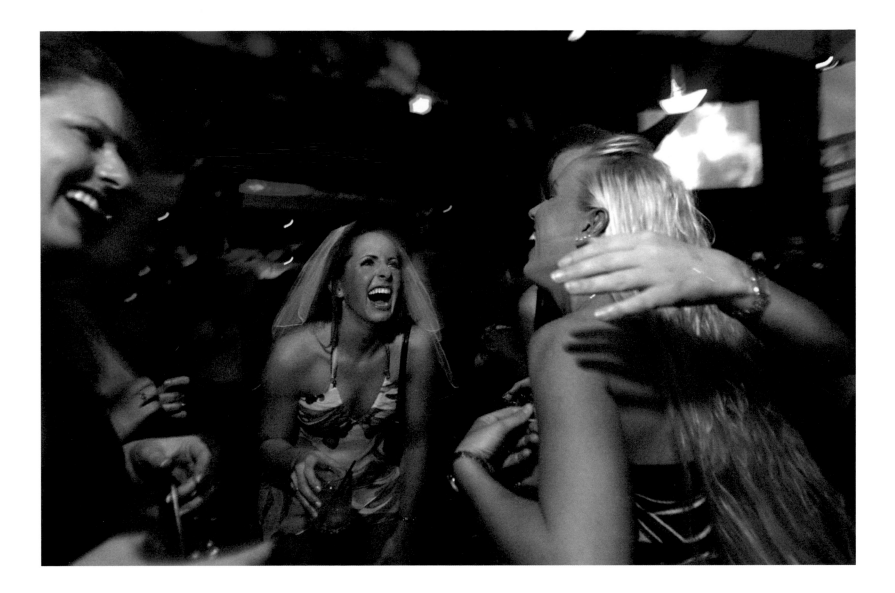

The Last Dance. Their mothers' generation had to settle for old-fashioned bridal showers, usually staid affairs with tea and cake and older family matrons delivering mawkish advice and gifts of a decidedly practical nature. But brides-to-be of Sarah Godfrey's age don't settle for such a placid send-off from the world of single-gal-hood—they've taken the age-old custom of the bachelor party and made it their own.

"We wanted to go all out—we didn't care how bad we looked on Monday," says maid-of-honor Karen Belanger (*above*, at left), 29, describing the outsized plans for her friend Sarah's final fling. For the group of

San Francisco Bay Area nurses, that meant just one thing: Las Vegas, only an hour's flight away and one of the bride's favorite party spots. They managed to keep their destination a secret for three months, until the night before they caught a plane. Sarah, 26, was thrilled with the choice.

"It was a great bonding time for all of us," says Karen. "Some of the bridesmaids didn't know each other well, and now we all have something to talk about and remember." —***Photo by Deanne Fitzmaurice***

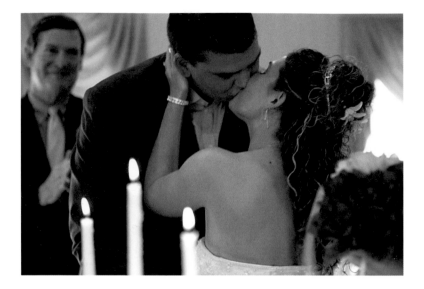

Going to the Chapel. Tracee Warren's wedding at Little Chapel of the Flowers in Las Vegas differed from her girlhood fantasies. Still, she says, "It was perfect. It was just smaller than I envisioned." She adds, "I also never thought my son would be there."

Tracee, 23, always wanted a wedding and a child. She got both. Just not in the typical order. "I've never thought there's only one way to do things," she says. She did marry the man of her dreams, 22-year-old Tim Warren, her high school sweetheart and her child's father. "I always pictured *him* there," she says.

In addition to 7-month-old Alec (*right*), Tracee's 14 guests were close family members. "Everyone I care about was there. There's nothing I would change about the day." That includes getting hitched in Vegas. When her fiancé proposed the idea, Tracee worried that a Vegas wedding might have a "drive-through feel." "But I never felt rushed," she says of her eight-minute ceremony.

Tracee also never imagined she'd plan her wedding online. "I logged on and picked the flowers, day, and chapel," she says. Her wedding package allowed "virtual guests" to view the wedding online in real time. "People from Mom's work watched on the computer screen and toasted us," Tracee says. "They threw rice at the computer." —*Photos by Deanne Fitzmaurice*

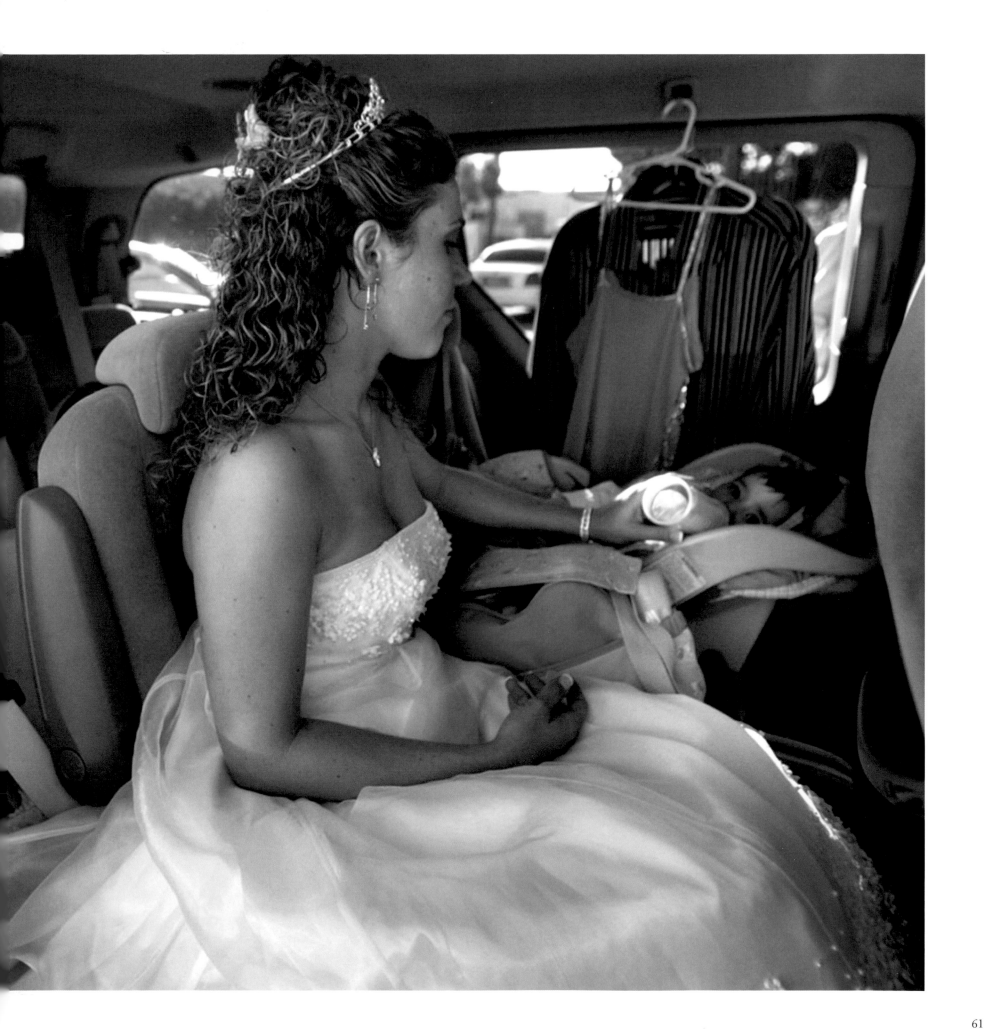

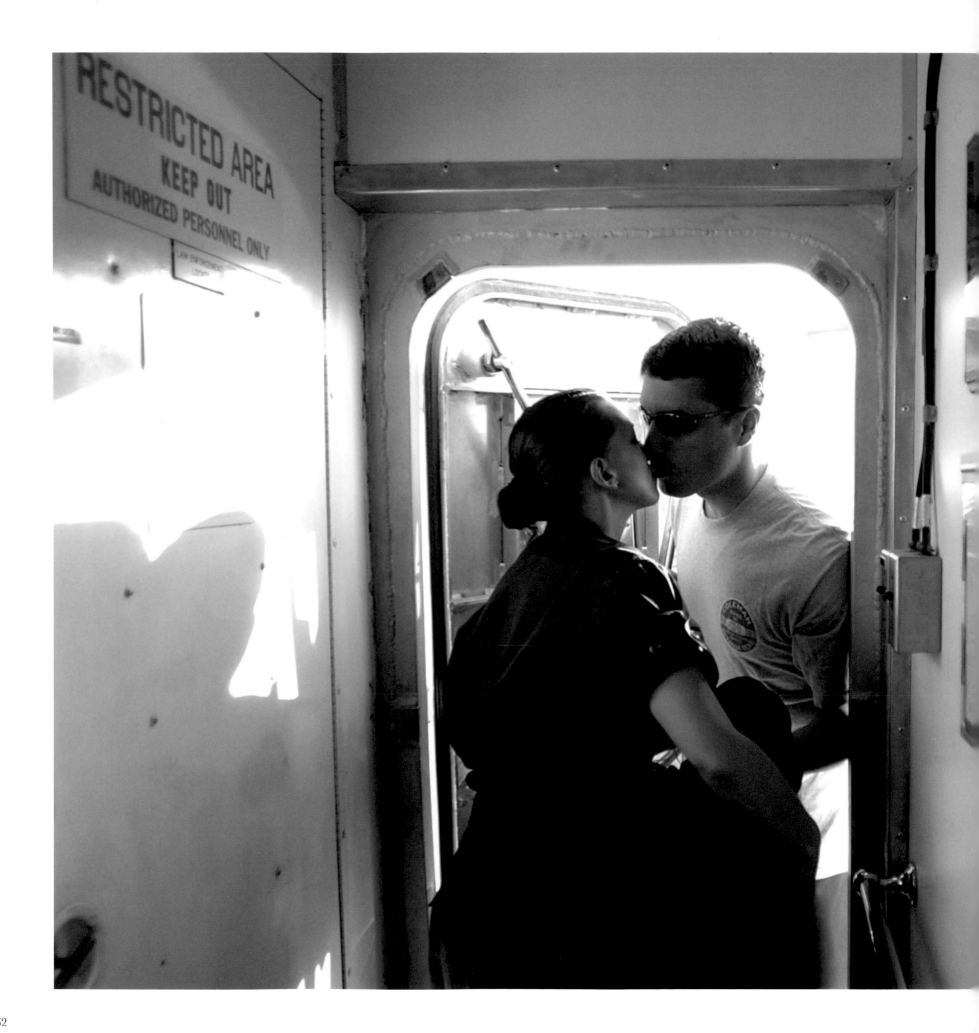

Military Engagement. So much for the blissful life of newlyweds. For Lieutenant Jo-Ann Feigofsky, it will be fleeting at best. In eight days, she will marry her fiancé, Stephen Burdian, at a Florida lighthouse, take a week-long Hawaii honeymoon, then not see her husband again for two weeks. This is what married life will be like for the new Mrs. Burdian, an officer in the U.S. Coast Guard who is serving a two-year stint as the captain of the *Key Biscayne*, a patrol boat based in St. Petersburg, Florida.

But she wouldn't want it any other way. "Being in command was what I wanted to do ever since I joined the Coast Guard eight years ago," explains Jo-Ann, 31, the daughter of a retired New York City police officer. "Stephen understood that, and we decided I should do it, even though it means we'll be apart." *(continued on following page)*

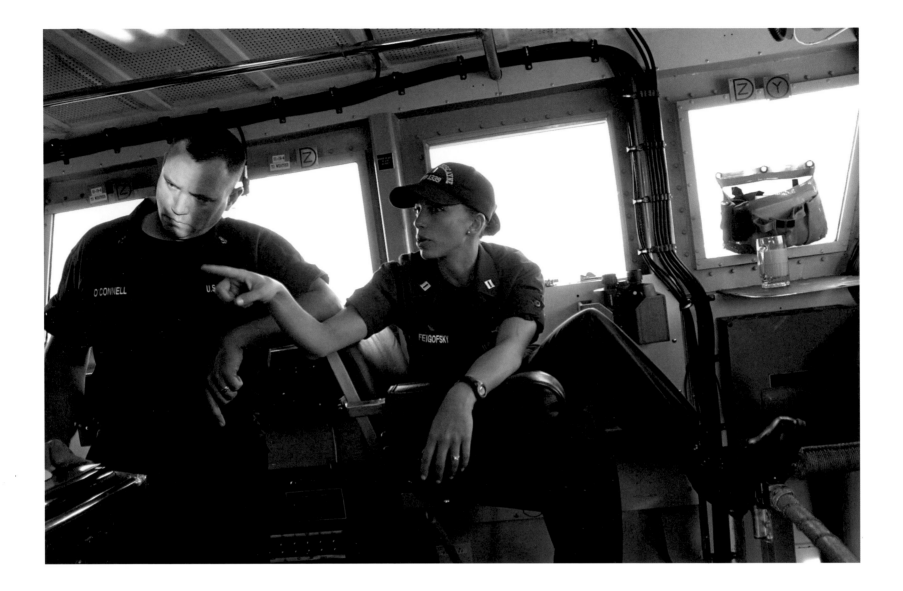

(*continued from previous page*) At sea, Jo-Ann oversees a
17-man crew—she's the only woman, which she says
"isn't an issue"—that chases down drug runners, tows
disabled boats, and tracks Cuban migrants trying to
reach Florida on makeshift rafts. As the captain, Jo-Ann
is in charge of every detail, from how to approach a
suspect boat to deciding on which type and how much

force to use, while keeping her crew safe in sometimes
precarious situations. She says she can't worry about
what she might be getting them into. "I don't have time
to take the long view, which might make me scared," she
says. "I'm too busy dealing with what's before us."

When her two-year tour is over in 2006, Jo-Ann
plans to move to Washington, D.C., where Stephen is a

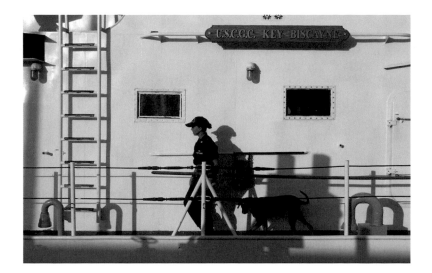

Coast Guard assignment officer, and start a family. Eventually, though, she wants to get back to sea. "People tell me that'll be really hard with kids," Jo-Ann says. "But it's always hard. You never see a woman with her three kids saying, 'Oh, this is a piece of cake.' Stephen and I will work it out."—*Photos by Melissa Lyttle*

Support System. Most people would call it a steep mountain. Aly Shanks calls it a hiccup. "That's really my husband Buddy's word," she says. "We're just dealing with a hiccup in our lives, and then we'll move on."

Aly's "hiccup," however, is a case of aggressive invasive ductal carcinoma in her left breast that has metastasized to one lymph node. She found the lumps herself while working for the Peace Corps in Chad. Aly, 43, met her husband of two years in Africa, where she has lived and worked since 1992. For now, the couple has relocated to Denver to be near Aly's family during her treatment.

"What's happened to me is scary," Aly admits, "but I'm more thankful for the care I'm getting, and the love and support of friends and family. I think we'll all get something out of dealing with this."

She is remarkably open about her ordeal, penning long emails for her vast circle of acquaintances, each one ending with a reminder: "Women—do your monthly breast self-exams!" Far-flung friends from California to Burundi have sent her scarves to cover her newly shaved head (she didn't want to watch her hair fall out slowly).

She and Buddy are planning to return to Africa for a new post this fall. "This illness has given us time to figure out, 'What's next? What do we really want to do for the next ten years?' We'll start by going back to Africa, and then see." —*Photos by Judy Walgren*

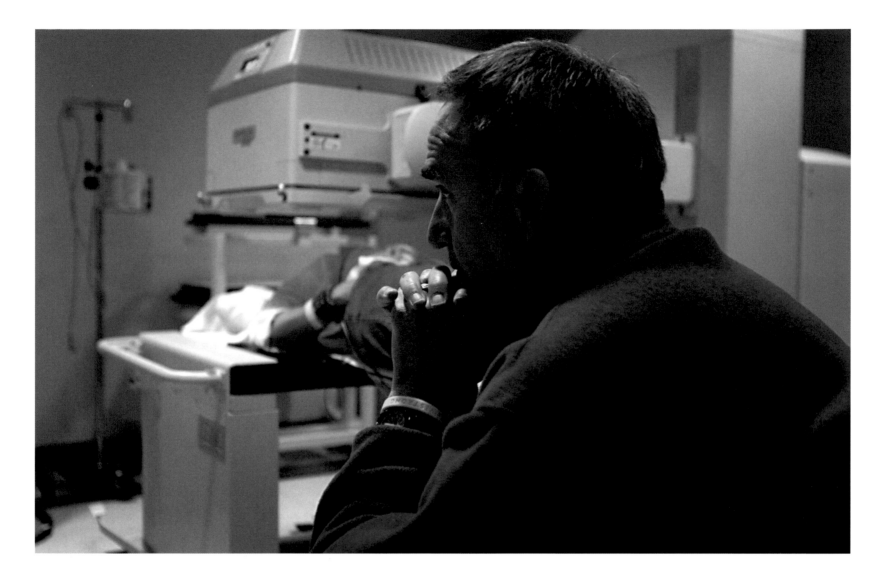

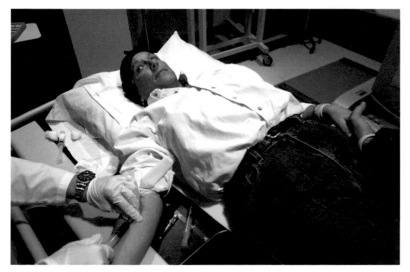

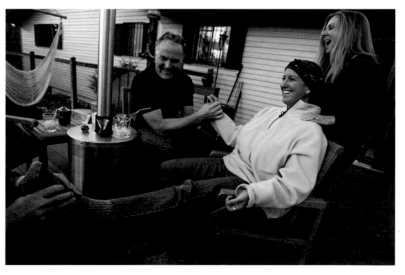

Moved by the Spirit

❖

Photos by Nancy Andrews

UNANNOUNCED, SHE STRIDES PURPOSEFULLY DOWN the hall of the nursing home, a large woman with a surprisingly soft voice, poking her head into open doors: "Hello, I'm Sister Kaye from Power House Ministries. Would you like me to pray with you?" A nod suffices to unleash a torrent of words, tumbling from Sister Kaye's wide mouth like a mighty river flowing directly from heaven.

A frail, faded beauty with a long white braid trailing down her back grabs Sister Kaye's bold black-and-gold designer coat. "When I could see, I wrote poems to God. Thousands of them," the woman says, and recites a verse. "The poems just don't come to me anymore. And I don't know where the old ones are. My daughter took away my things."

Sister Kaye bends over the woman's chair, always at the ready to deliver God's healing power. "You know what? I'm going to pray you get your poem-writing back. Can I lay my hands on your head? Okay? Jesus, I command her body to be loosed in your name. I bind the spirit of confusion. I bind the spirit of depression, oppression… whatever you have to do, Father, whatever miracle you have to pull off for this relationship to be restored between her and her daughter, I ask that you do it." Suddenly Sister Kaye begins praying in tongues, and then just as smoothly slips back to normal speech, where quotes from Scripture pour forth as naturally as she'd recite the names of her six siblings. "As it says in Matthew, chapter 6, 'Thy will be done.' And Daddy, if there is not enough faith for it, I ask you to do it anyway, and charge it to my faith account, in Jesus' name."

Twenty-three years ago, Kathryn Stramler, now age 57, was a single mother struggling to support her two kids, working at a car-leasing company during the week and running a beauty salon on weekends. (Compliment her neat ponytail, and she'll whip it off to show you how easy it is to pin on a hairpiece.) Her marriage ended when she found her husband sleeping with her best friend, triggering a depression that included two suicide attempts. One day, a brochure advertising a laymen's Bible-training course showed up in her mailbox. She enrolled, and graduated two years later at the top of her class, an altogether transformed woman: "I was flabbergasted by what I

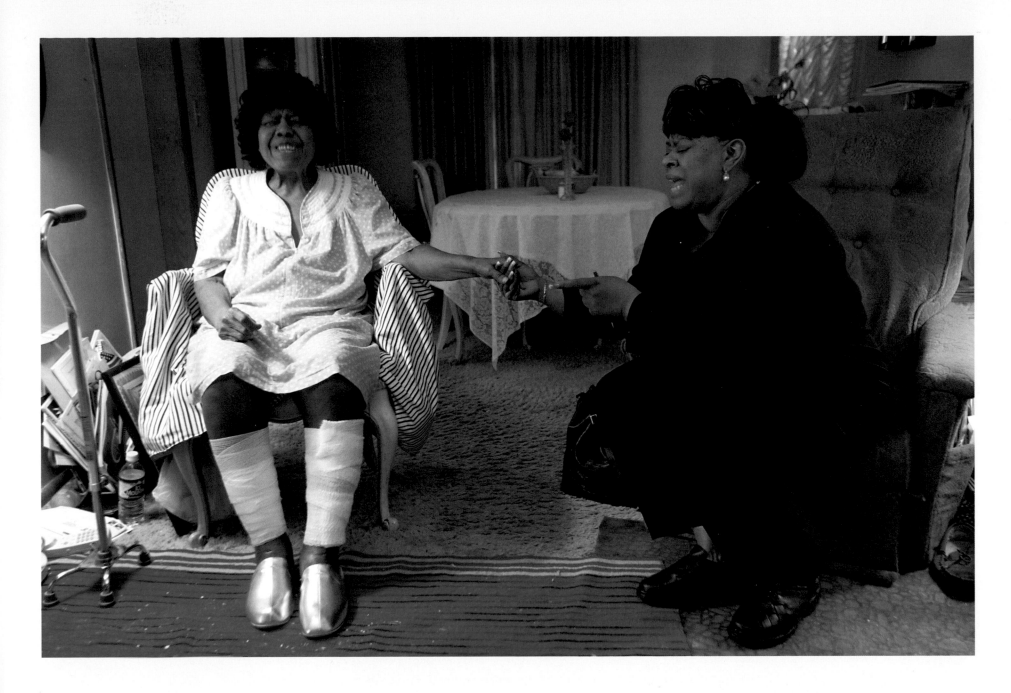

Twenty-three years ago, Sister Kaye Stramler put her personal demons behind her and became a traveling minister. At the home of Luella Davis in Detroit (above), she offers a healing prayer.

learned. I always knew there was something higher and better than me. But I never really knew how I could get God to work for me." She left the little Pentecostal church where she'd been raised by her factory-worker parents and slowly progressed from volunteer to full-time worker at the 23,000-member, nondenominational Word of Faith International Christian Center in suburban Detroit.

She eventually came to head the church's outreach effort, creating the first manual to train SWAT troops—"Our Soul-Winning Action Team," she explains. "We'd go into neighborhoods, knock on doors, pray with people, and ask if they'd like to receive the Lord. 'It's that simple?' they'd ask. Yes, always has been. Believe and be saved. God set up the system so nobody has to work for it. You don't sell barbecue tickets. You don't sing. You don't usher. You just say okay." When Sister Kaye gets going, the volume is low, but the speed's set on high. You join her on a roller-coaster ride that swoops from

jive to Jesus, from intimate, in-your-face, practical wisdom to a rant on the word of the Lord, all connected by her unshakable belief in the Bible as the roadmap for living.

It's perfectly normal for this hugely entertaining and deeply spiritual woman to converse with God. Each day before dawn, they chat in bed during her morning prayers. "God talks to *you*; you just don't know it," she says. "Prayer is you and God having a conversation. Not in Bible language. Not in Elizabethan English. In your own style."

Seven years ago, Sister Kaye says, God brought her a vision of a bird feeding babies in a nest and then batting them out into the world. Shortly afterward, her bishop confirmed the message: "Kaye, it's time for you to get flying." That was the beginning of her aptly named Power House Ministries. With a stipend from Word of Faith, she founded a nonprofit corporation, which she keeps alive with fees from her leadership seminars for church groups and women's organizations, sales of her hilarious audio- and videotapes (with titles like *Me Tarzan, You Jane* and *Will the Real Liberated Woman Please Stand Up?*), and guest-preaching appearances all over the country to audiences as large as 5,000. Her preaching brings in donations ranging from $100 to $3,000. "The workman is worthy of his hire," Sister Kaye says, "but I leave how much they decide to pay me up to them and God. See, I'm just a messenger of God, who loaned me his power of attorney."

Despite her gregarious public persona, Sister Kaye is a loner by nature, still overcoming issues of self-worth stemming from a childhood stammer and teachers who told her she didn't have the brains to go to college. Her best friend is her daughter, Michelle, who after a painful-to-the-bone estrangement now shares her mother's condo and mission. "My daughter tells me, 'Mama, you rescue people all the time but don't let anybody rescue you,'" Sister Kaye says. "So I'm working on taking better care of myself. Of course I would welcome a relationship, but men only admire women of power from a distance. A lot of people never bother to find out about Sister Kaye as a lady."

Sister Kaye starts each day by rising early to pray (above left), *then exercising to a Richard Simmons tape* (above).

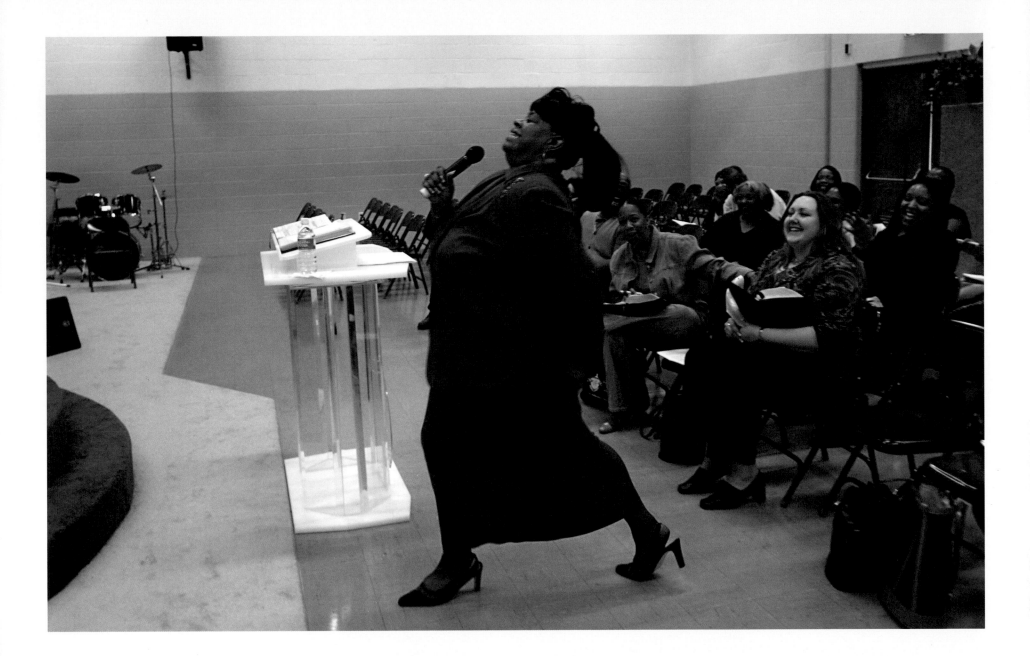

Sister Kaye's exuberant evangelical style has attracted audiences of up to 5,000 nationwide. But she also preaches to more intimate groups, like this gathering at Love Life Family Christian Center in Roseville, Michigan (above).

What she'd like to change in her life is her weight. She's determined to lose 100 pounds before next Easter, and exercises every morning to a Richard Simmons tape. "I'm not on a die-it, where your body's always saying 'I'm dying for food.' I'm on a live-it. If I lose two pounds in a week, that's a good thing. I go and pull some dress that's too big out of my closet—it can be a size 28—and sashay around the house tooting my horn: 'Girl, you look good! You are on it today! I am proud of you!'"

Sister Kaye writes poetry, dresses meticulously, and has a weakness for accessories that she often buys on QVC. As earthy as she is spiritual, Kaye never forgets for a single minute what God has brought to her life, and how honored she is, despite the sacrifices, to dedicate herself to his service. "Honey, nobody in their right mind who wasn't born to serve wants to preach the gospel," she says. "I do consider myself blessed that I can have an impact. Still my life is a fishbowl. God has given it meaning, but he owns me. Ministry is not a job I do. It's what I *am*."—*C.S.*

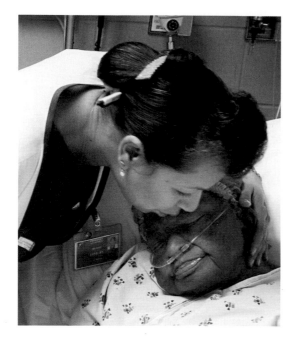

Late Shift. Night after night, from 7 p.m. to 7 a.m., nurse Renée Love bends over her patients with the focused, tender care that is second nature to her. Renée, 49, works in the ER at Washington, D.C.'s Providence Hospital. By choice, she works the night shift. "I'm not a morning person," she says. "When I get off work, I like having everything to myself." Such times are a welcome counterpoint to the constant momentum that keeps her on her feet at least ten hours out of her 12-hour shift.

Separated, with no children, Renée lives a quiet life in Maryland. Despite what she now describes as "her calling," she says she never planned to be a nurse. "I wanted to be a speech therapist, or teach blind children Braille." Instead, a search for a night job while in college led her to a nursing assistant position at a geriatric hospital. "That was the beginning of my passion," she says. Shortly afterward, she enrolled at Johns Hopkins University for her nursing degree.

What keeps Renée going is a deep compassion for her patients, especially for older people. "I like taking care of the elderly," she explains. "People will always love babies. But older people have lots of needs. They are an elder kind of baby." —*Photos by Alexandra Avakian*

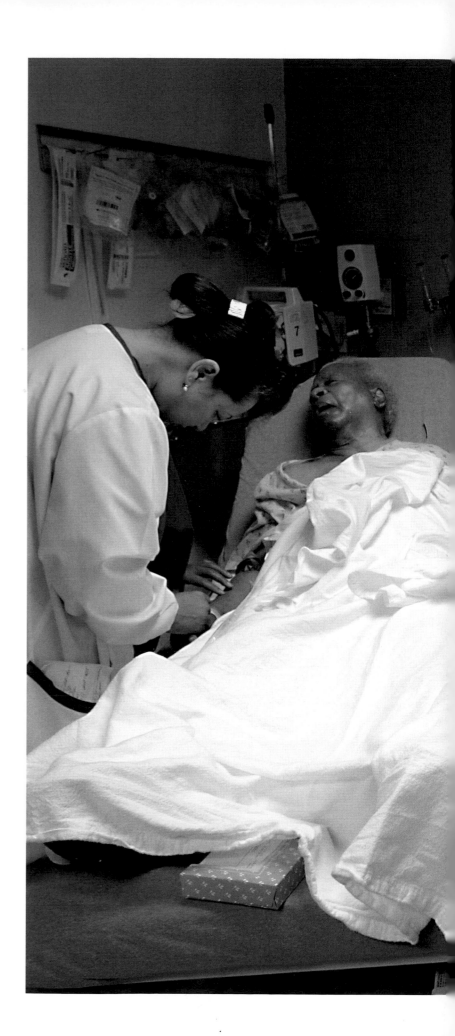

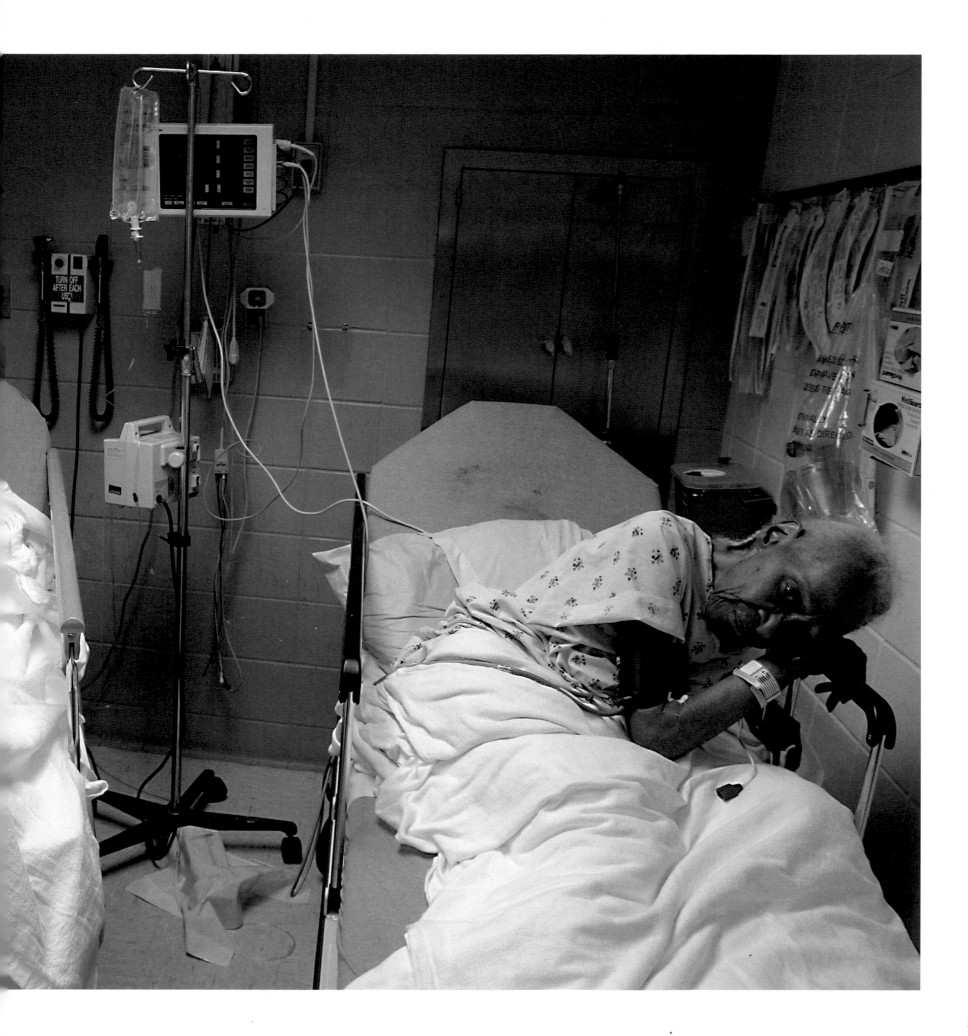

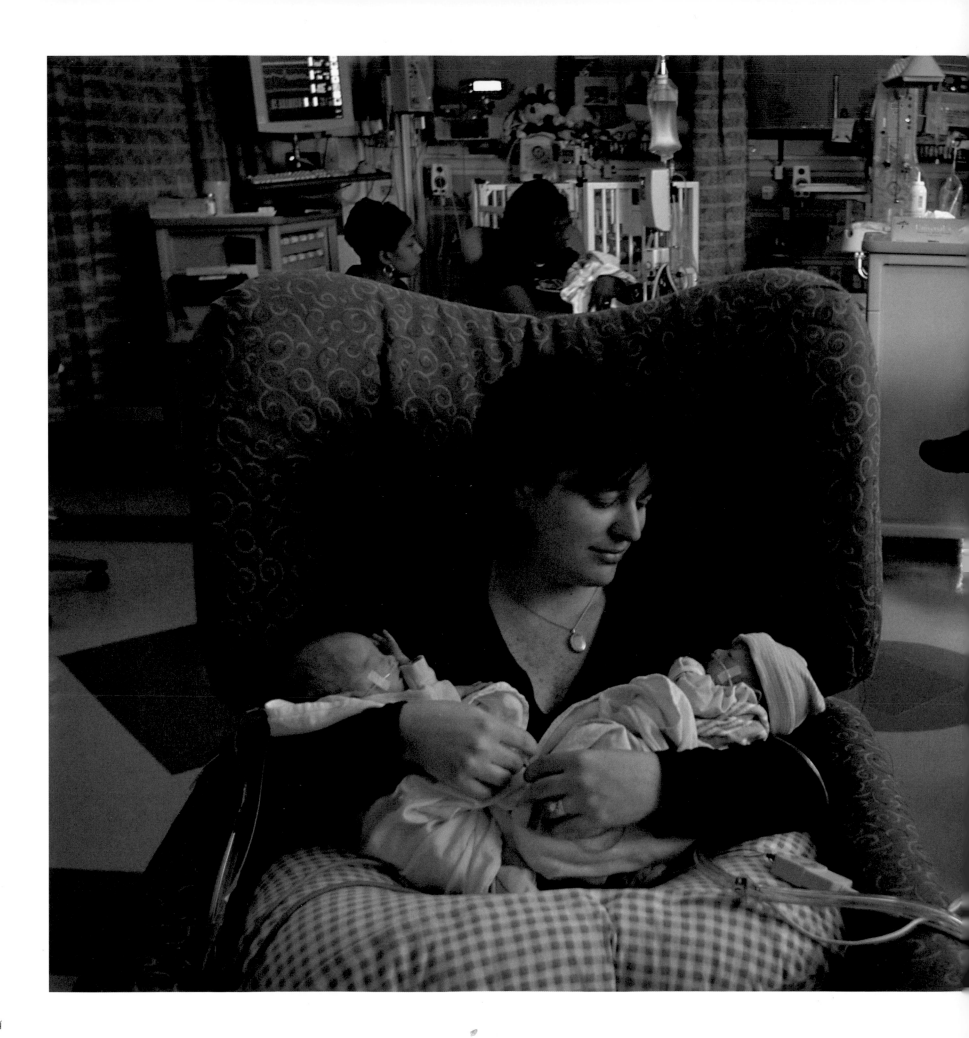

Small Miracles. When Deborah Vacca went into premature labor in her 21st week of pregnancy, she didn't think her twin girls were going to make it. "My doctors said if they were born that early, nothing could be done," she remembers. But by going on bed rest, Deb, 31, was able to buy her babies precious time. The girls were born at 25 weeks. Emma (*far left*) weighed one pound, ten ounces, and Hannah was just an ounce more.

On April 8, Deb had already spent eight weeks watching her babies struggle for life at the University of North Carolina's Newborn Critical Care Center in Chapel Hill. They battled pneumonia and sepsis, and underwent eye surgery. Their fragile bodies remained threaded with tubes. "The first time I held them, I thought they were going to crush in my hands," Deb says. She spent each day cuddling her girls, trying not to think about how, at day's end, she would go home empty-armed.

Photographer Susie Post Rust's own daughter occupied an isolette in this same room, just a few weeks before these pictures were taken. Susie's baby eventually went home—and so did Deb's girls, eight weeks after the day Susie photographed them. The waiting and watching paid off: They are healthy and strong at more than six pounds apiece. —*Photos by Susie Post Rust*

New Sheriff in Town

❖

Photos by Cheryl Diaz-Meyer

IT'S A RAW NIGHT, EVEN FOR EARLY SPRING. STANDING SHIVERING IN A PARKING LOT are a couple dozen men and a handful of women, guns strapped to their legs, handcuffs dangling from belts, bulletproof vests bulging beneath regulation blue shirts covered by jackets reading "Dallas County Sheriff." These are tough guys, pumped to get moving on a roundup of fugitives with outstanding arrest warrants. Here to rally her troops, walking among the uniforms, shaking every hand, is Lupe Valdez, a small, sturdy woman in a belted black coat and low-heeled pumps. She rattles off a short interview in perfect Spanish for a reporter covering the event for Hispanic TV, then turns to the officers and like a worried mother says, "You know your jobs. You know what to do. I'm just telling you to be careful and come home safely."

Just months before, on November 2, 2004, Lupe stunned Texas by becoming the first woman ever elected sheriff of Dallas County. Local Democrats, seeking a viable candidate to clean up the scandal-ridden office, approached her because of her 20 years of experience as a federal agent. She went off alone for four days to mull over her decision. "I asked myself three questions: If I win, can I mentor? Can I be an influence? Can I make a difference? The answer to all three was yes, so that tipped the scale." The campaign was grueling. The press described her as an under-financed, under-organized underdog with four strikes against her: She is female, a Democrat in a heavily Republican district, Hispanic, and a lesbian. When her opponent accused her of having a "gay agenda," she refused to go negative, against all advice, and replied, "I am who I am. I can't change that. What you want is a person who will be honest and up-front with you."

Raising a scant $175,000 ($25,000 of it from her own pocket), she relied on zeal and ingenuity—targeting female swing voters and anybody with a Hispanic last name—to garner an 18,000-vote victory. This daughter of migrant workers now controls 1,700 employees in the ninth largest county in the United States, a sprawling 902 square miles with 30 different municipalities.

Lupe, 57, is a veteran at beating the odds. She would likely have spent her childhood like her six older brothers, picking green beans and beets in farms from Texas

Lupe Valdez is the first woman ever elected sheriff of Dallas County, Texas. Sheriff Valdez shares her home near downtown Dallas with her dogs Vinny (above) and Loco.

to Michigan, except that her mother said "Enough!" and insisted the family put down roots so her two youngest could attend school. Her father proudly refused public assistance. They lived in a house built from salvaged scraps. Meals were cooked from farmers' discards; clothes came from cousins' closets. Lupe was 20 before she owned a new pair of shoes. Defying her father—Hispanic women, he said, didn't need educations to have babies—she bussed herself across San Antonio to an upper-class high school and struggled through. Her classmates did not invite her to parties.

It took Lupe six years to finish college, financed by menial jobs. Her father refused to help her out. "What makes you so stubborn?" he'd holler. "Why do you have to go against what we want?" "Because I don't want what you want," she'd say. She worked her way up from a job in the county jail, through several government agencies, and became a U.S. Customs agent in 1987. The only constant was how her male cohorts belittled her. "I put up with it," she says, "because there just weren't that many good-paying jobs for women. I wanted to say to those guys, 'I'm just as human and decent as you are,' but I couldn't."

Still shy but no longer timid, Lupe is adjusting to being recognized in restaurants and making headlines with everyday actions, like adopting a dog from the SPCA. "I love it when parents introduce me to their little girls and say, 'She did it and so can you.'" Not much fazes the Dallas County sheriff anymore, not even the gradual loss of all her hair due to a condition called alopecia. She wears a wig now, and has tattooed eyebrows.

Her most profound struggle was accepting her sexual orientation. Growing up, Lupe says, dates never interested her as much as her schoolwork. But it wasn't until she was in her late thirties, when she found a gay and lesbian church in Dallas, that she came to grips with what her religious beliefs had kept her from facing. "It was Easter Sunday," she says, "and I remember sitting in that church and crying. Was it possible I

Outside the county jail, Sheriff Valdez banters with some of the detention officers in her jurisdiction (above left), *and later greets constituents after speaking to a Hispanic women's group at Texas Woman's University* (above). *"The quality of mine I like best," she says, "is my ability to identify and connect with all kinds of people, whether it's a cop, somebody serving me at a banquet, a young minority girl I might inspire, or the women who want to shake my hand after a speech."*

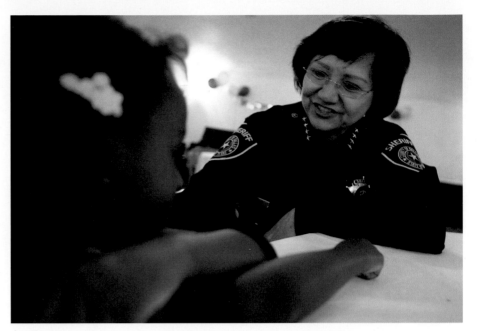

In the evening, Lupe chats with the Reverend H. J. Johnson (above), on the way to a birthday celebration at Cathedral of Faith church (above right). The Cathedral of Faith congregation in South Dallas helped deliver Lupe's 18,000-vote victory in November 2004. Valdez won over voters with her straightforward talk and warm personal style.

could have a relationship with God and still be a lesbian?" She decided the answer was yes, and cautiously came out over the next decade and a half, always afraid she'd lose her job if the government discovered she was gay.

It's been a tough road, and Sheriff Valdez is tough. But when she flashes her radiant smile, the sternness in her face melts away to reveal a kind, thoughtful woman who keeps stationery in her car to write thank-you notes in her spare moments, who calls employees to offer sympathy for illnesses and losses, who for years has given 20 percent of her income to charity, who volunteers for Big Brothers Big Sisters and builds low-income houses with her church group. "I come from nothing," she says, "and I don't forget that." Though she is always running late, she doesn't wear a watch: "When I'm with someone who's finally gotten to see me, I want them to feel they have all the time they need."

There are a few things Lupe misses in her life—more time to socialize, work in her garden, have friends over for dinner. But most of all, she'd like a companion. "Having someone interested in me for who I am would be very precious," she says. Otherwise, her disadvantages have mostly morphed into assets, perhaps because the one constant on her path has been her faith. "I remember one night I was arguing with God, and I yelled, 'Why does it have to be so difficult?' And I heard God say, 'You haven't failed. It's been hard all along and you didn't stop. So why do you want to stop now?' And I began laughing. But after that, my whole attitude changed. I understood that life gives you two choices: You either sit down and quit, or you do what you've gotta do."—*C.S.*

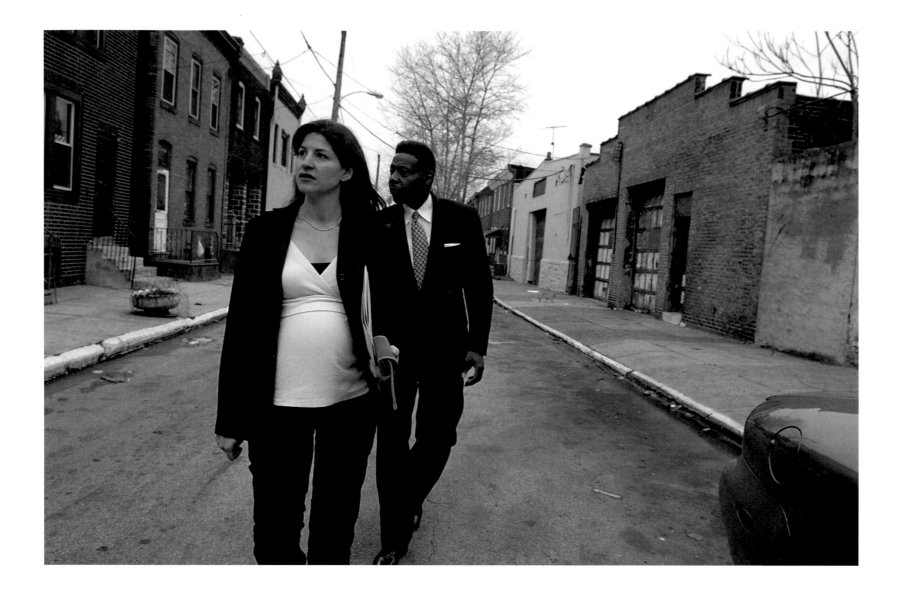

Law and Order. "Even though it's often really ugly, my job offers a very real, rich, human-filled environment," says Jennifer Selber about her new position as one of Philadelphia's district prosecutors in the Homicide Unit. Formerly in the Major Trials division, she was promoted just two months ago, and now handles only murder cases.

Interacting with detectives, witnesses, and victim's families, as well as appearing in court nearly every day, Jennifer, 35, remains undaunted by situations others might find forbidding—like visiting a murder scene with detective Aaron Booker (*above*). "It's our job to work with the police department to piece things together," she explains. "When we're not in court, we're struggling to make our cases stronger so we can win them."

Already the mother of a 3-year-old boy with her medical-resident husband, Joshua DiSipio—and shown here just a week before the birth of her second child— Jennifer maintains that the hectic district attorney's life is quite accommodating to a parent. "My job rewards my performance, not how many minutes I'm at the office," she explains. "If I do my work at home after the kids go to bed, it doesn't matter. It's whether I get the job done for the citizens of Philadelphia."—*Photo by Vicki Valerio*

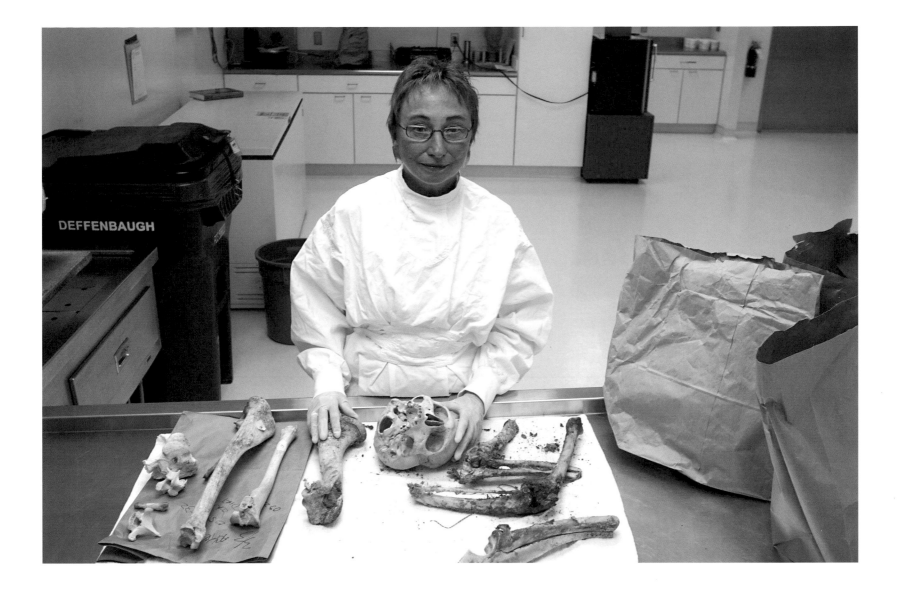

Piece by Piece. "I had never even seen a dead body before," recalls Jefferson County Chief Deputy Coroner Triena Harper, reflecting on her life 23 years ago, a time when autopsy reports, fingerprints, and dental IDs seemed the stuff of crime dramas and pulp fiction. Now they're part of Triena's daily vocabulary.

After years as a psychiatric social worker, an EMT for the fire department, and an arson investigator, Triena applied to the coroner's office in Boulder, Colorado, on a whim, thinking it might be a good place to merge her medical, forensic, and psychiatric backgrounds. It was.

"It's the most challenging, interesting job I've ever had," she says. Her favorite aspect, she says, is "identifying the unidentifiable."

The role also has its painful moments. Triena, 59, informs the families of the deceased when a body has been found. "It's never easy to knock on the door in the middle of the night and say your teenager isn't coming home," she says. "But I think you can make a difference. You can offer a family support and guidance; you can give them answers."—**_Photo by Joanna Pinneo_**

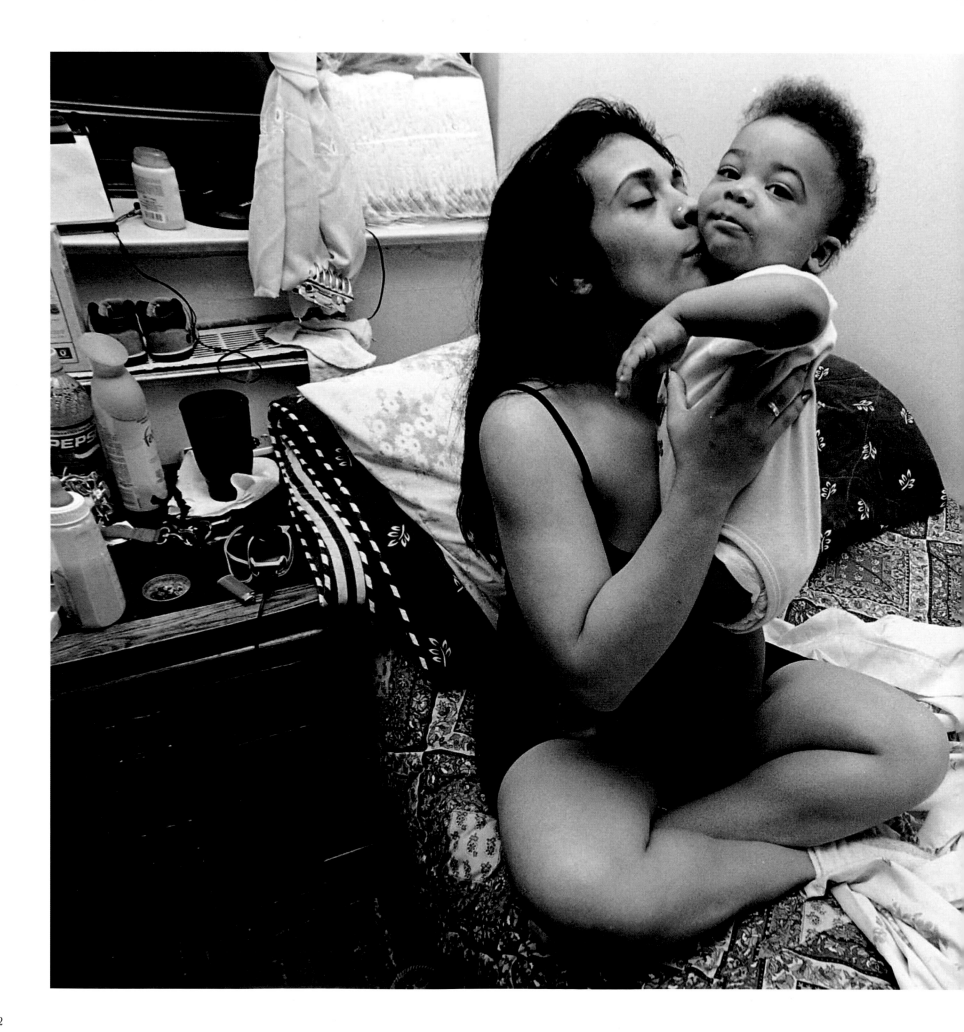

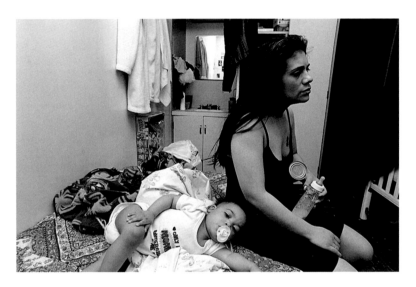

Starting Over. When Elizabeth Alequin prepared to leave prison on a work-release program in January, she knew one thing for sure: She never wanted to go back. During her 18 months in two New York prisons for a drug conviction, Elizabeth gave birth to a baby boy, Anthony (*left* and *above*). She was lucky to have him with her in prison. But she knew she could lose him forever if she returned, or couldn't afford to support him. So Elizabeth, 31, found herself in the same predicament shared by thousands of female ex-inmates across the country: Where do you go to get back on your feet?

One option is Hour Children, a program that offers transitional housing, *(continued on following page)*

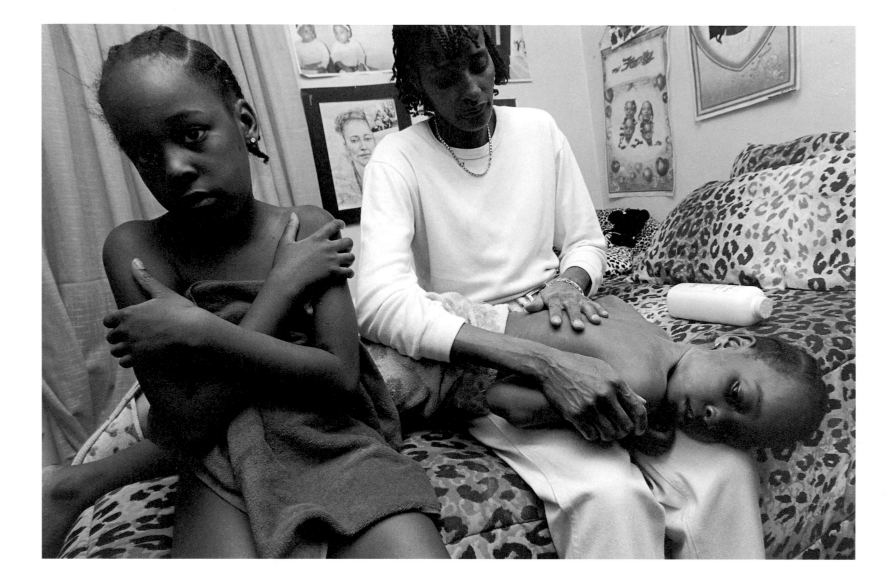

(*continued from previous page*) daycare, and life skills support for ex-inmates in Queens, New York. Founded in 1995 by Sister Teresa "Tesa" Fitzgerald, a Catholic nun who's worked in New York prisons for 20 years, Hour Children started out as a home for the children of inmates. Today, the program has four transitional houses where women on work-release from prison can stay with their children, and two low-income apartment buildings with room for up to 50 families at any one time.

For Elizabeth, who's about to go on parole after four months of work-release, the next step is getting a job, then an apartment in an Hour Children building, so she can stay close to her new family of women. Says Sister Tesa, "The women form a community and are able to learn from each other and build a support system. That's why this works. They help each other get through."

The residents agree. Rosemary White (*above*) has been in the program since her release five years ago. Stormy McNair (*right*) came to Hour Children after a year and a half in prison. A first-time offender convicted of grand larceny, Stormy gave birth to one son in prison, and reconnected with another at Hour Children. She never plans to leave them again.

Because of their shared experience, Stormy and Elizabeth were able to offer support to Debra Dicent

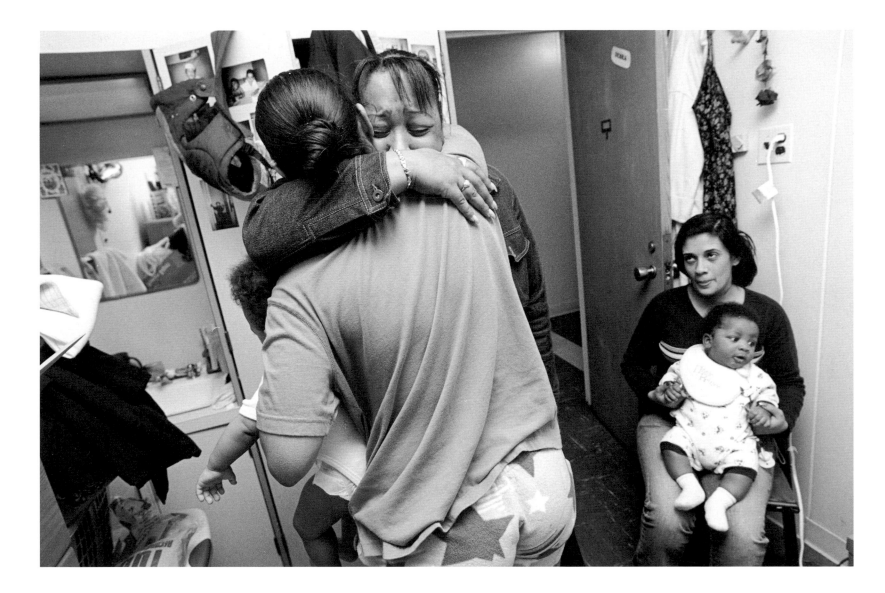

(*above*, hugging Stormy) on the day she located her long-lost 20-year-old son—only to learn that he himself is in prison. After being out of touch for many years, Debra now hopes to be reunited with him.

Elizabeth speaks for many of her new friends when she says Hour Children has provided exactly what she needed. "I didn't want to be a burden to my family," she says. "But I knew I couldn't do this all on my own. Here, it's a stepping stone to getting my own place and doing my own thing. I love it."

—***Photos by Brenda Ann Kenneally***

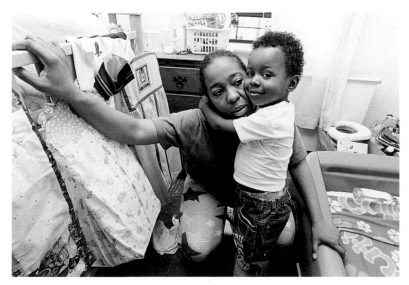

A Healing Heart

❖

Photos by Sharon J. Wohlmuth

It's 5:30 a.m., and Anne Rosenberg is already wide awake, checking her email, catching up on her patients' charts, fixing breakfast for her two teenage sons, Evan and Ryan. Accompanied by her ever-present Jack Russell terrier, Melanie, she's out the door by 6, throwing hay to the horses and grain to the potbellied pigs that share her farm in southern New Jersey. By 6:30, she's showered, her wild brown hair blown straight. She hugs the boys as they get ready to drive themselves to school and is on her way into Philadelphia to one of her two medical offices.

Anne was named after her great aunt, who was known for her patience and kindness; and she inherited her father's hands and skill as a surgeon. But beyond these traits, "Dr. Anne"—a woman who is equally at home in black stilettos or paddock boots—is a woman of her own invention.

Anne, 48, grew up with a younger brother and sister in the small town of Cinnaminson, New Jersey, and attended a private Quaker school. "If you had asked me when I was in second grade, 'What do you want to do when you grow up?' I would have said, 'I want to be a surgeon,'" she says. "When I was 10, I spent my afternoons watching my dad operate."

Today she is a successful surgeon herself, specializing in breast cancer treatment at Thomas Jefferson University Hospital-Kimmel Cancer Center in Philadelphia. In a typical moment during a busy day at the hospital, Anne slowly walks a patient to the operating room, her strong arm wrapped around the woman's waist.

"God gave me a certain talent to be able to operate," Anne explains, "so being a surgeon happens to be something I'm able to do." But what she does isn't just about her technical skills as a physician. It's as much or more about the emotional support she provides her patients.

Her gift of healing is evident as she talks with them and their families. "I look

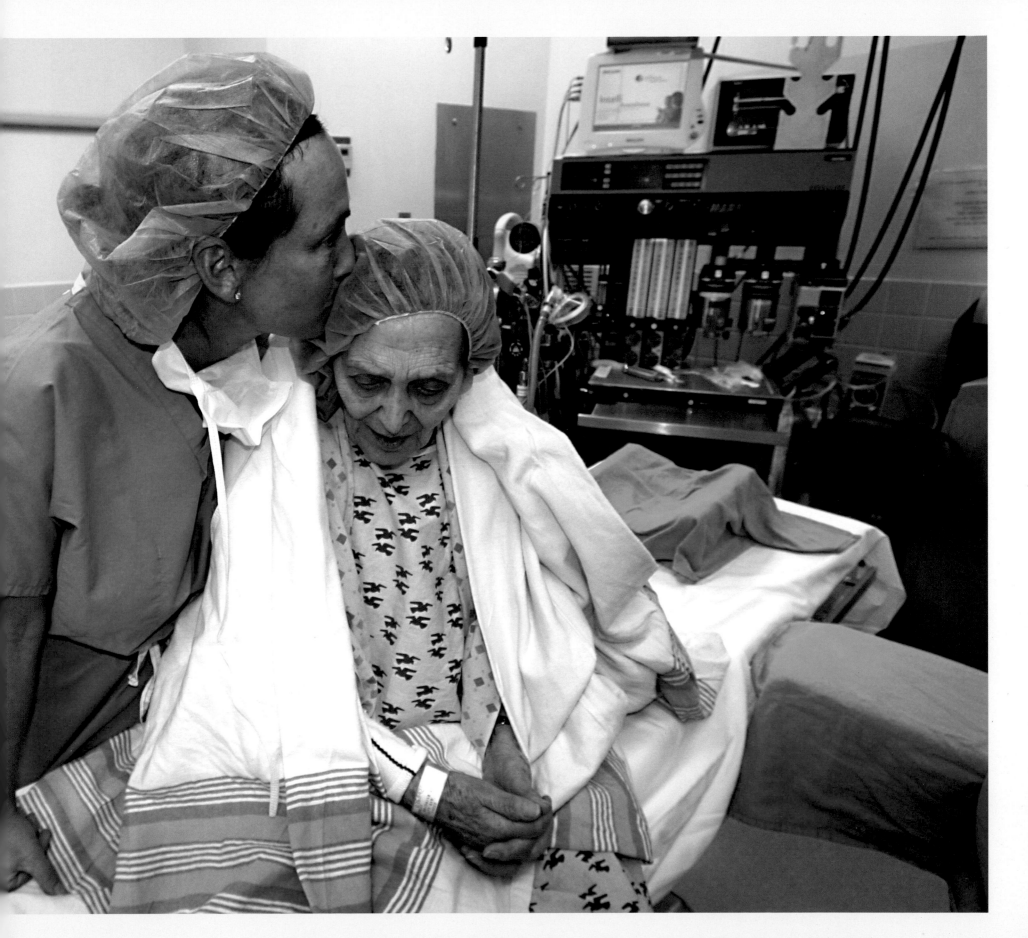

After performing a breast biopsy, Dr. Anne Rosenberg provides support to patient Shirley Horowitz. "Anne is not just my doctor, she has become my friend," says Shirley. "She makes me feel whole."

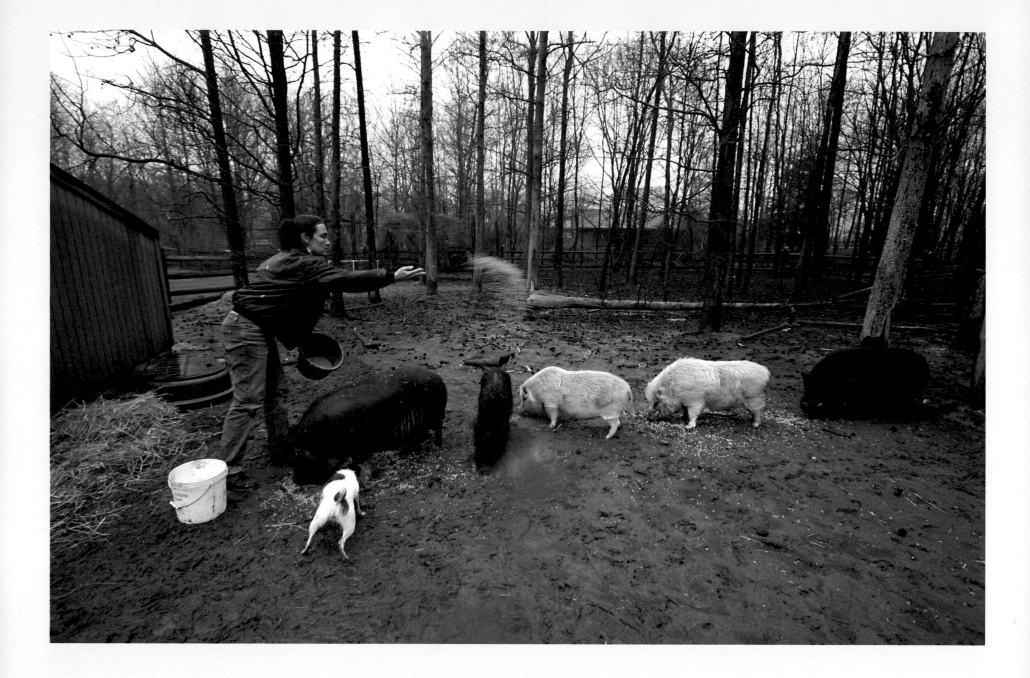

into them and try to figure out what issues are really important: Is it the thought of losing the breast? Is it their kids not knowing about the cancer that's bothering them? Is it that the marriage hasn't been good, and this is going to bring it to a head? There's a part of me allows me to look into others and ask these questions."

In addition to her hospital duties, Anne manages her medical practice in two locations—Cherry Hill, New Jersey, and downtown Philadelphia—and often ends the day sharing cartons of Chinese food with her two boys at their 50-acre farm an hour outside of Philadelphia.

Her elder son, Ryan, 16, is reserved and contemplative, intensely attracted to science. Evan, 15, is outgoing and interested in horses. The boys, apparent opposites, are each a reflection of their mother. "Most people would introduce me as a physician or surgeon," she says. "I define myself as Ryan's and Evan's mother. My kids and I have a

Anne believes that caring for her animals makes her a better doctor, teaching her how to create trust through touch alone. She finds time each day to bond with her favorite horse, named after her beloved Uncle Max (above right).

close relationship. It's been just me and them, and we work every day to communicate and respect each other—usually successfully."

Anne has been raising her boys as a single mother since her marriage to her husband, Tom, dissolved during the 1990s. They met as graduate students at a mutual friend's graduation party for Anne, who earned her medical degree from Thomas Jefferson University in Philadelphia. A year later, when Tom finished law school, he asked the same friend to invite Anne to his party. After dating for a few years, they married in 1984. She was 28, and in her fourth year as a resident.

The two boys were born after a year and a half of infertility treatments—a time when Anne kept herself busy with her work, and designing the family house and horse farm. But by the time Ryan and Evan were toddlers, Anne recalls, "the marriage was in trouble. I think the combination of having endured the stress of infertility treatments

and the pressure of two full-time careers put significant stress on the relationship." They were separated for two years.

When the divorce finally came, just before her 40th birthday, "I felt so sad," Anne says. "I felt I had let my children and my parents down. My morals and my religious background taught me that I should be committed to marriage, but at a certain point I knew that apart would be best, and so we have created a new life."

At home, Anne tends the garden and feeds and cares for the animals on her farm—13 horses and a menagerie of sheep, goats, and potbellied pigs. Committed to her Jewish faith, she has instilled in her boys the tradition of "Mitzvah," trying to do a good deed each day, and Anne has adapted an old custom by naming her animals after beloved, deceased relatives—her favorite horse is named for her Uncle Max.

"My animals show me every day why you must be honest, consistent, safe, and even occasionally vulnerable," she says. "Animals know if you're not honest. They have taught my children how to approach another being, how to make eye contact, establish trust, and build a lifelong relationship."

Her open hands stroke the muzzle of a foal or plant a seed in her garden as easily as they offer a patient a light touch of reassurance.

"Having gone through bad times and come out at the end, it's made me see things in people that sometimes even they don't see," she says. "I can tell you story after story of women who came into my office immobilized by having cancer—and then, five and ten years later, they're artists. They're exhibiting their work. They've gone back to school. They're raising their grandchildren. They're growing a garden."

Like her patients, Anne strives on a daily basis to reshape and enhance the life she has created for herself and her sons. She sums it up this way: "The three of us work every day to make something good."

Anne is always occupied, even when relaxing. Formerly a competitive rower, she has taught the sport to her sons Ryan (above left) and Evan. Catching a few minutes' peace, Anne knits an afghan for a friend, watched over by her Jack Russell terrier, Melanie (above).

Most days end with the family gathering in Anne's room for a take-out dinner (right), catching up on homework for the boys and patients' charts for Anne, and perhaps a late movie on television.

Live Wire. Dee von Entress came upon electricity by happy coincidence: An electrical training program caught her eye when she was researching graduate schools for a master's degree in education.

"I had always been fascinated by projects at home," says Dee, 36, a Portland, Oregon, native, "and it suddenly made perfect sense." After a five-year apprenticeship, she signed on with one of the city's top electrical construction firms, and now spends her days working on high-tech upgrades and rewiring large commercial spaces. "You can't be absent-minded in the electrical trade," she says, "because there's an invisible danger that will take you out."

Already the mother of a 17-month-old daughter with partner Judy Fortune, and now six months pregnant with the couple's second child, Dee plans to take time off from construction sites and get reacquainted with her first love: education. She's back in the classroom, teaching "Electricity for the Non-Electrician" at Portland Community College. "It's all come full circle," she says.
—*Photo by Jan Sonnenmair*

A Home of Her Own. "In the back of my mind was always this idea," says Karen Owens, "that I needed to wait until I find the right man and the right relationship and then we'd buy the house." After twice moving into (and out of) boyfriends' houses, Karen, a school psychologist in Austin, Texas, decided to take the leap—alone.

Faced with the choice of moving to the suburbs or buying a fixer-upper in the city, Karen, now 36, chose the latter, buying her own stamp of land just ten minutes from downtown.

"I always thought there was a secret club of men who had skills with power tools," she says, "but then I realized, I've got an advanced degree. I know how to figure things out." Among other chores, the self-taught carpenter has replaced the toilet, rehung the back door, and put down hardwood floors in the bedroom. "I get nervous when I'm tackling new things," she says, "but afterward it feels great—I feel strong and competent. Having my own nest gives me a sense of security."

With Karen as a role model, a networking circle of home-buying single women has sprung up in Austin, referring each other to brokers, inspectors, and electricians. Says photographer Amber Novak, who recently bought her first home, "Seeing Karen, I thought, 'I could do that, too.'"—*Photos by Amber Novak*

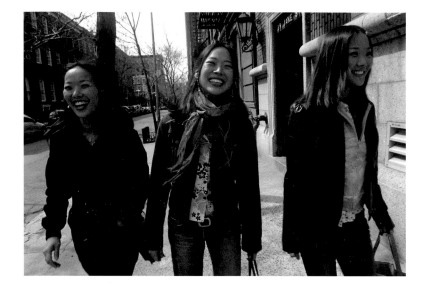

Classical Beauties. If musical talent springs from the genes, the Ahn sisters are a perfect case study. Pianist Lucia, cellist Maria, and violinist Angella form the Ahn Trio, a classical ensemble that travels the world, performing close to a hundred concerts a year. These Juilliard-trained "Seoul" sisters, who immigrated from South Korea right before their teen years, also find time to appear in Gap ads, on MTV, and on *People* magazine's "50 Most Beautiful People" list.

To prepare for upcoming concerts, they gather to practice in Maria's apartment (*right*). Each sister has her own place in New York City. Twins Maria and Lucia, now 35, roomed with Angella, 33, right after college. But as much as they cherished their intimacy, they needed time to be apart. "At first, it was the honeymoon phase and we were hanging out every minute together. Then it went to, 'Well, I'm kind of sick of you, too. If I have to live with you one more day, I'm going to kill you,'" Angella says with a laugh. (*continued on next page*)

(continued from previous page) They all scoff at the notion that sisterhood gives them a special musical chemistry. After all, who wouldn't have chemistry after more than 20 years of performing together? And they still surprise each other. "When we're playing and all of a sudden something really brilliant comes through, we'll say, 'Whoa, where did that come from?'" Angella says.

Being colleagues, they sometimes disagree. But being sisters, they can afford to be frank, even ruthless.

How do they settle differences? If two agree, the third must go along. "It's a good thing we're not a quartet," Angella says.

Besides music, the Ahns love food, a passion that stretches back to their mom's fabulous home cooking. They're wild about soup dumplings from Joe's Shanghai Restaurant in Chinatown, where they often relish a meal with Angella's husband, Michael (far right bottom).

Yet they remain svelte enough to slip into the

slinky outfits that they wear onstage. Whenever Maria shops for a dress, she sits down in a cello-playing position to see how the garment falls (*above*). What if she ends up buying the wrong thing? No problem. After all, sisterhood has major advantages. "I wait and wait for my sisters to buy things that are a little too big on them," Angella says. "We recycle clothes all the time. We wear each other's shoes. We get sick of something, give it to each other, and five years later, it comes back." —*Photos by April Saul*

Faith in the Heartland.
Back in her twenties, Devorah Leah Lederman was a secular, Oberlin College–educated New Yorker working on her Ph.D. in English. "A typical liberal, intellectual baby boomer," she says. Today, at 46, she's a Hasidic Jew and a stay-at-home mother of six living in Postville, Iowa.

"It was an intuitive, gut thing," Devorah says of her transformation. As young marrieds, she and her husband, Mordechai, were non-observant Jews, but eventually they were drawn to raising their family in the Hasidic neighborhood of Crown Heights, Brooklyn.

But while Devorah was happy with their spiritual life, she recalls, "I was tired of the grime and the traffic of New York. I wanted a real house, with a real yard, and a real swing set." She also wanted a strong Hasidic community, which left the Ledermans considering just two options: Israel, or the unlikely city of Postville, where since 1987 a religious population has sprung up around a kosher meat processing plant.

And so, five years ago, the Ledermans settled in Iowa. "The pace is better here," she says. "My kids can ride their bikes to school." And while her wig and ankle-length skirts sometimes attract curious looks at the local Wal-Mart, Devorah feels at ease. "Everything in my life is shaped by faith," she says. "Divine providence brought us here." —*Photos by Robin Bowman*

Home on the Range.

Since 1994, Karin Carswell Guest's family has run a cattle ranch on the north shore of Kauai—2,500 gorgeous acres she rides every day as herd manager. "It's hard work," says the mother of three, "but it's rewarding. It keeps me strong, outdoors, in the sun."

Everyone works the ranch. Her mother and sister take turns running the horse stable; her father tends cattle and markets the beef; and her brothers rope in tourists to hike, swim, and kayak.

Karin, 35, often takes her 2-year-old when she is moving cows or vaccinating horses. Recently, she brought all three children along because "a heifer was having a difficult birth and we had to pull a calf at nine at night."

"Our family's very tight," says Karin (*above*, with sister Kelley and sister-in-law Denise). "We all live within five or ten minutes of the ranch. We all work together and we all have kids and we support each other. The ranch holds us together." It also gives her family a mission: to keep the land—at one time owned by a nineteenth-century ancestor—out of developers' hands. "Our goal is to keep it an open space," Karin says. —***Photos by Barbara Ries***

Built for Speed

❖

Photos by Ami Vitale

LEILANI MÜNTER BARRELS DOWN THE HIGHWAY, LATE FOR HER PART-TIME JOB WITH Nascar.com, interviewing race-car drivers she'd much rather compete against. Her left hand darts riskily from the steering wheel to the gear shift of her '97 Volkswagen GTI, while her right hand cradles a cell phone to her ear. She talks almost as fast as she drives as she tries to close a deal with a sponsor for the $15,000 she needs to enter a race that's a month away. Pulling into the speedway parking lot, she digs a worn pouch from her purse, applies foundation, mascara, and blush using the sun-visor mirror, runs her fingers through her auburn mane, and heads for the pits to find her cameraman. Above the deafening roar of engines vrooming past, she shouts: "Welcome to my life! It's total chaos!"

Ask Leilani, 29, why a former model with a college degree in biology would risk her life racing cars, and she'll shrug: "The first time I got out of a stock car, I knew it was what I wanted to do for the rest of my life. Something happens inside, an adrenaline rush when you take a car full out, that you can't explain. I was on the track once and a crew member said to me, 'Didn't anybody warn you before you got in the car that you might as well have wrapped a cord around your arm and shot yourself up with heroin?' He was right. It's such a great feeling that you want to get it again and again."

As a kid in Rochester, Minnesota, Leilani preferred football and soccer—and later snowboarding and scuba diving—to girly games like hopscotch. Her three older sisters had dolls; she had an Atari with a gun that blew up asteroids. Her website trumpets, "Well-behaved women seldom make history," quoting Harvard prof Laurel Thatcher Ulrich. "I always liked speed," Leilani says. "The year after I got my driver's license, the state wrote me a letter saying I had so many speeding tickets I was a danger to society, and they made me attend driving classes." Still, there were no signs in her early years that she would someday be doing laps at 170 mph. The most rebellious thing she can remember from high school, where she had a 4.0 average, was throwing a party when her parents were out of town. Her Hawaiian-born mother was a nurse, and her German-born father a neurologist. They divorced amicably when she was four. She shared her week between them, and remains close to both parents as well as her sisters.

While Leilani was at the University of California, San Diego, friends introduced her to amateur racing. She soon scraped together some cash from modeling jobs,

Aspiring Nascar driver Leilani Münter left Hollywood behind and moved to Mooresville, North Carolina, to pursue racing at full throttle.

enrolled in driving school, and raced whenever she could. She financed her addiction by working in movies. Hired as a stand-in for Catherine Zeta-Jones in *Traffic*, she continued that work on such films as *America's Sweethearts* and *Ocean's Eleven*. Meeting Brad Pitt and George Clooney got her heart pounding, but movie-making bored her— too much standing around and too little action. "I wasn't passionate about it like I was passionate about racing," she says. "And I knew if I wanted to be taken seriously, I had to move to North Carolina. So I left the Hollywood money and came here."

A nontraditional career presents those kinds of hard choices. "One of my sisters is married with two kids, and that's her whole life," Leilani says. "It's really cool for her, but I don't think that cooking and cleaning and being a housewife would ever satisfy me. I plan to get married, but I'm not sure about children. I want to accomplish stuff, make history on the track. And that's hard to do when you have kids."

Even without kids, Nascar racing is an uphill battle if you're not a man. Just ask Leilani's friend and mentor Shawna Robinson, who's been clawing her way up for 20

Practicing on a real racetrack is extremely expensive—up to $50,000 a day—but Leilani keeps up her driving skills at a local go-kart track with Nascar buddy Shawna Robinson (above, at left).

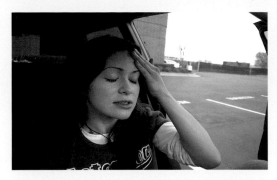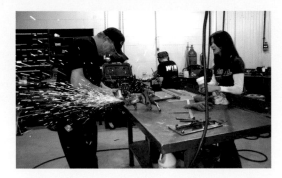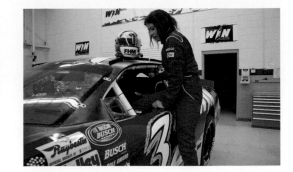

years. Although more than a third of the sport's 80 million fans are female, very few women race at the top of the pack. Leilani's face and figure get her attention, but she has to earn respect. In magazine spreads in *Esquire* and *Men's Journal,* among others, she oozes sex appeal. *Playboy* has offered her enough money to pose nude that she could race full-time. She turned it down. "I want to make it in racing based on my talent," she explains. "And when I walk into the garage, I want to hold my head up high. I'm not stupid. I know it helps in the sponsor world that I'm marketable. I may use my looks to get into a car, but they don't make me drive any faster."

A year ago she showed up to race at the Texas Motor Speedway and got a lot of who-the-hell-is-this-babe looks from the regular drivers. But all that disappeared when she qualified fourth, and finished sixth out of 26 cars. "The highlight," she says proudly, "was when the competition director came to shake my hand and said, 'If anybody ever doubts your driving ability, here's my cell phone number. Have them call me.'"

Leilani has the concentration, stamina, and fearlessness (except when it comes to spiders and heights) that are more important than size or strength to succeed on the track. What she needs is cash to keep her there. The cars, the crew, and the fees for practice time eat up millions. Recently she had to borrow money from her boyfriend to buy a pair of decent slacks for an interview with a potential sponsor; she had only $14 in her bank account. The bulk of her time and energy goes into phone calls, mailings, meetings, and solicitations, in pursuit of a company—hopefully a women's brand—that will plaster its name all over her race car and finance her career. Her dream is to spend her days completely focused on racing, instead of cobbling together the odd TV job and helping out at body shops. She lives in a rented bedroom in a suburban tract house, where all she owns fits inside four walls.

"Sure I get frustrated and disappointed scrounging for support," she admits. "I just try to remember what I've accomplished. A guy like Nascar champ Mike Waltrip ran 463 races before he won. I've only been out eight times and already placed in the top ten. Ultimately would I love to be a big Nascar cup driver? You bet. But right now, I'd just like to be out there every weekend, and not worrying about a sponsor. I don't need to make a bunch of money. I just need to race." —*C.S.*

Love Goes On. Maureen Fanning, 49, saw a photo recently from the early years of her marriage to her husband, Jack. The two were at a party at the elegant Windows on the World, atop One World Trade Center. Manhattan's East River lay behind them. Maureen was two weeks pregnant with her first son. Nine months later, Sean was born, a hefty, healthy 9 pounds, 11 ounces.

But doctors diagnosed Sean with autism when he was still a toddler. Jack and Maureen put off having a second child until 1995, when Jack, chief of the Hazardous Materials unit for the Fire Department of New York and a member of a federal search and rescue unit, responded to the Oklahoma City bombing. "Jack came back and said he wanted another child," Maureen recalls. Within ten months of baby Patrick's birth, the Fannings knew that he, too, was autistic.

The couple held their family together for five years: Maureen, a registered nurse, *(continued on following page)*

(continued from previous page) worked three jobs; Jack became an internationally renowned expert on responding to terrorist attacks. Their life wasn't easy, but "We had more than a marriage," Maureen says. "It was a partnership. We were like two pieces of a puzzle. He was a very special person. When I think of him now, I think only of goodness." Her voice breaks.

Jack died in the rescue efforts at the World Trade Center on September 11, 2001. With her compensation money, Maureen has set up the Jack Fanning Memorial Foundation for autistic children, which includes two group homes in Long Island.

Her daily schedule is relentless. Sean, 16, and Patrick, 9, are active, healthy boys, and Maureen is

juggling mothering duties with fundraising activities for the foundation (*above right top*) —and still very palpable grief. "But I can't give up," she says. "That would be to betray what Jack and I had. Just weeks before he died, he told me that if he won the lottery, we'd set up a group home for autistic kids. So now I'm doing that. It will be something wonderful." —***Photos by Lori Grinker***

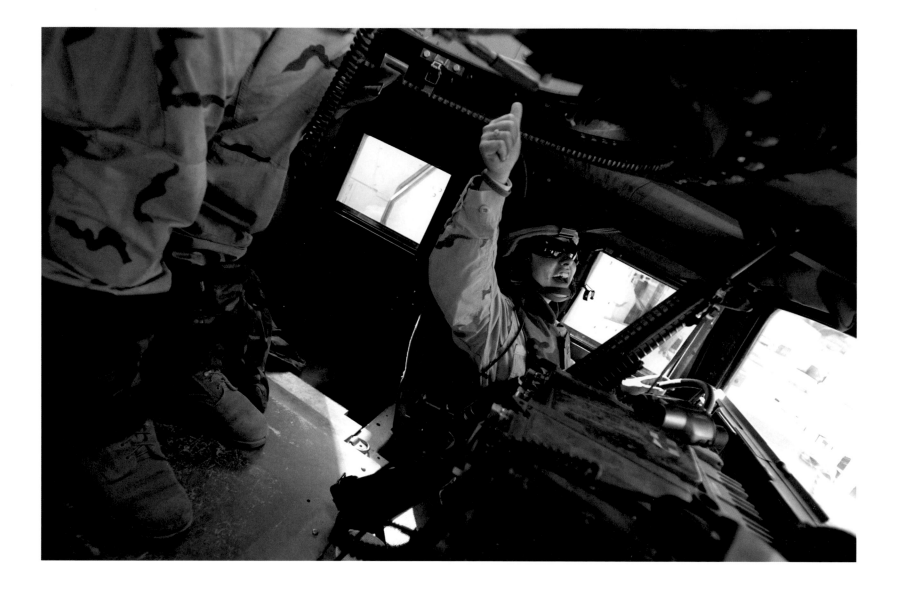

In the Green Zone. Private First Class

Jennifer Lipzer, an Army medic stationed in Baghdad, is proud to be the only woman on her team, which provides security for a colonel. "When we started training, I had to prove myself. Now they treat me like a sister," she says, recalling the day she aced the marksmanship test and four men failed. "It's like having a big band of brothers. I trust them and they trust me."

Even so, Jennifer, 20, says she is "very much a girly-girl. People in the States send packages marked for 'Any Soldier,' and I always get the ones with nail polish and gel. I love painting my toenails."

The dangers of her job are sobering. "I saw my first dead body the other day," she says. "It was surreal." When a Humvee got hit outside the Green Zone (once Saddam Hussein's preserve, now headquarters for the

U.S.–led coalition), killing the gunner and wounding four others, Jennifer's team had to break up traffic and get the body out. "I keep thinking about that scene," she says. "I fully accept that this is a life-threatening situation. But I love my job. I wouldn't change it for anything in the world."
—*Photos by Stephanie Sinclair*

Portrait of the Artist as a Young Woman

❖

Photos by Melissa Farlow

To really see Caity, née Caitlin, Kennedy, it helps to ignore certain things that make her a fairly typical 21-year-old art student. The ring in her lip. The tattoo of a thundercloud on her back (that she designed herself). Her hair, which has been brilliant crimson and canary yellow, but at the moment is natural brown with reddish highlights. Her clothes, culled from yard sales and the racks at the Salvation Army. "Malls are draining," Caity says. "Too many people and too much stuff." She prefers to scavenge for art supplies and the occasional piece of furniture: "I frequently find very useful things looking through trash. People throw away all sorts of things." She goes to bed in the middle of the night and sleeps until midday. To describe her room in the house she shares with four other girls as "messy" would be a gross understatement. An old sofa serves as her bed. The floor is littered with books, sketches, and whatever clothing isn't spilling out of all the open dresser drawers. Remains of the week's meals congeal in unwashed dishes on a table. Her eating habits do not model the nutritional pyramid. "I'm a vegetarian. Mostly I eat tomatoes, cheese, carrots, and corn, which is very good for you. Oh, yes, and cookies and coffee, too."

What makes Caity sensitive, occasionally iconoclastic, and much more serious than she seems is not so readily visible. There's her merit scholarship from the prestigious Rhode Island School of Design (RISD). Her thoughts on conformity: "I do worry about what people think, but not like in high school, where everybody is so concerned with looking the same and so awkward trying to be something they're not. I kind of treated those days like a sociology experiment." Her passionately liberal politics: "I watched the whole Democratic convention and was really impressed with Barack Obama. Bush is a megalomaniac. He thinks he has very important things to do, like meddle in people's marriages and love lives, which aren't his job."

Then there are her views on religion and spirituality. "Do I go to church? Hell no! I went once or twice with a friend and was so bored that I pressed on my eyes really hard so I could see colors and balloons and things. What I find comforting is the Goddess Theory. It's about the Mother Earth spirit where the Earth is a being and when we die our atoms are dispersed and grow into something else. So I am made of other people and things, and I may make a flower. I like that idea of continuing to be

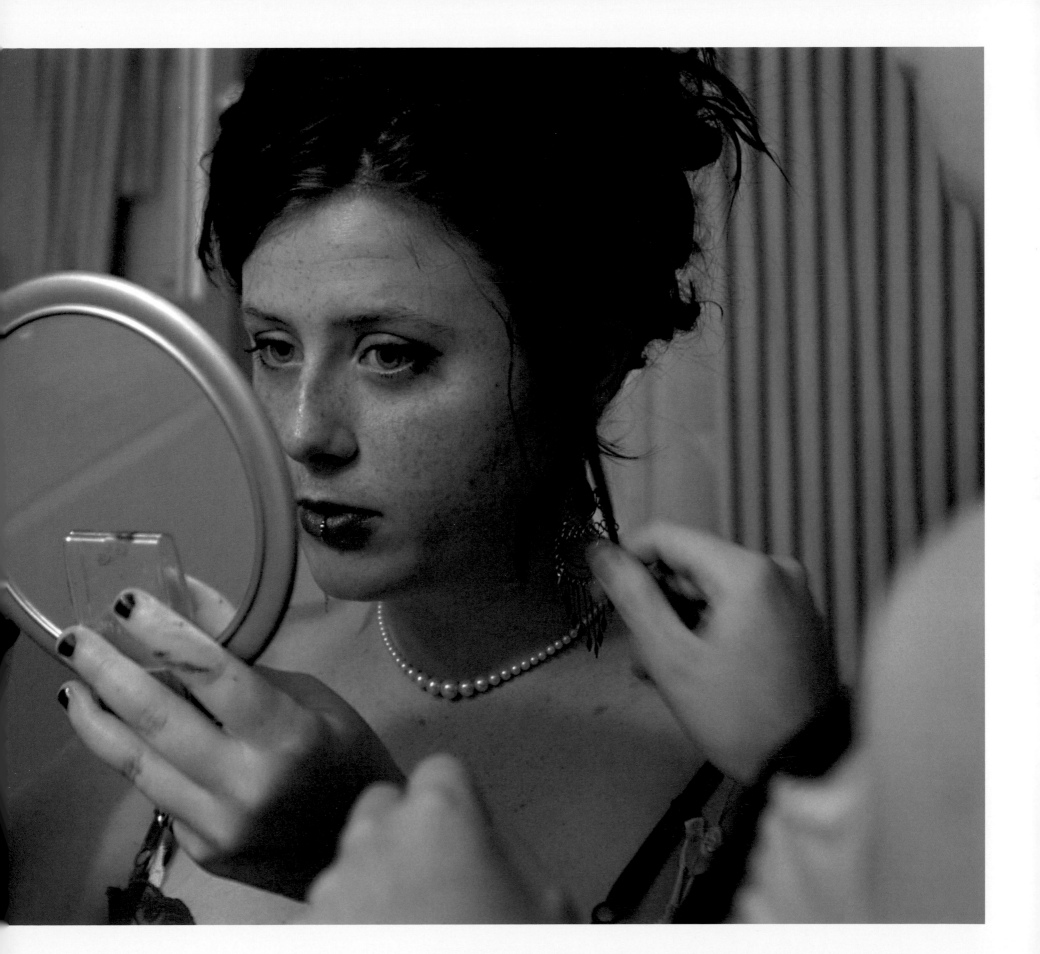

Caity Kennedy, an art student at RISD, puts aside her paint-spattered jeans to get dolled up for a costume party she is attending with her roommates.

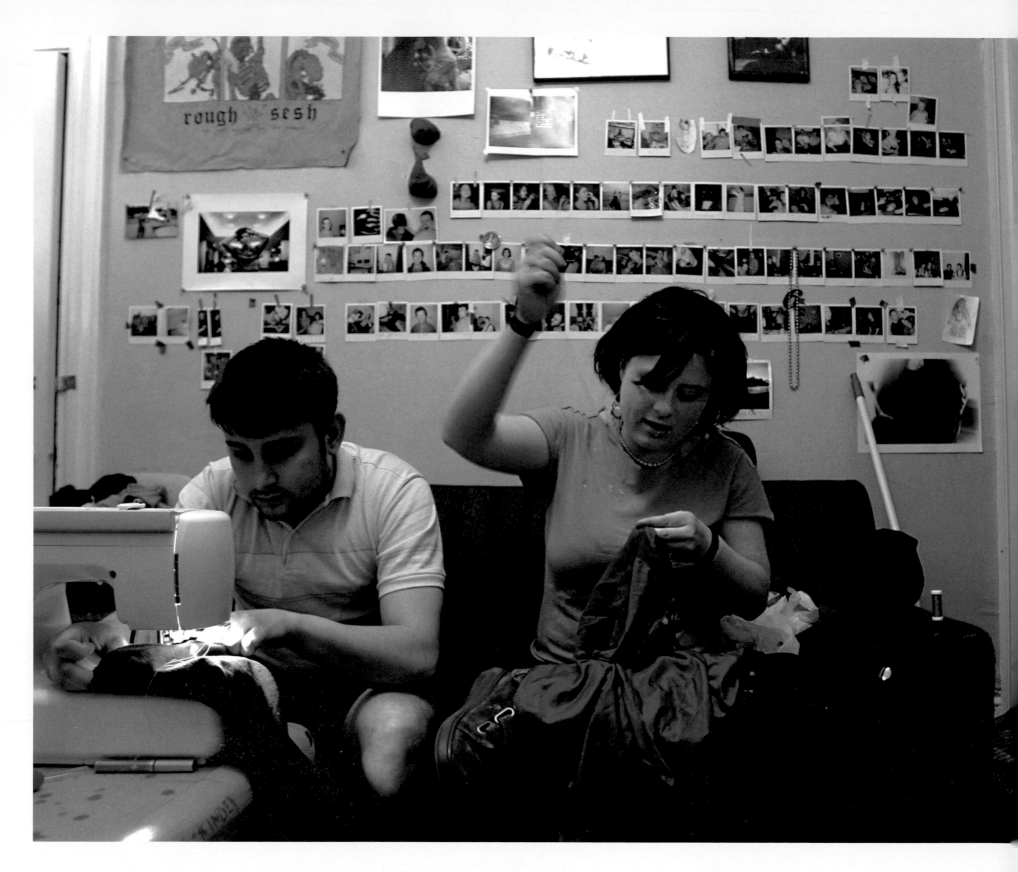

Caity and her friend Sean Hilts put the finishing touches on their outfits for tonight's party.
Kansas-born Caity has been sewing for years—another expression of her "need to make things."

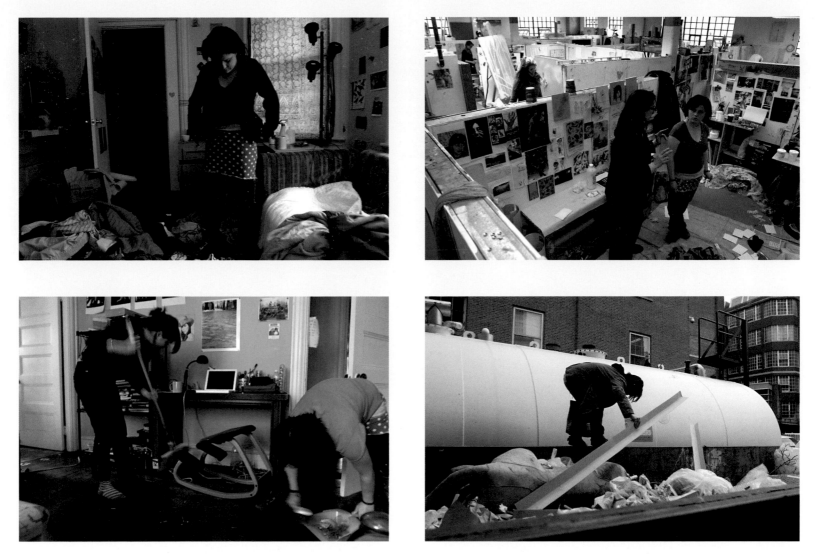

part of the earth. I think religion is a lot of rules, but spirituality is reverence for something bigger than you."

Caity loves her siblings, never hated her mother, and considers her parents her friends. She's grateful for their support. "They've started paying my student loans, but once I get out of school, the loans are my responsibility—and I want them to be. My parents aren't getting anything from this." She'd rather have coffee with John Edwards than Brad Pitt, though she wouldn't mind meeting Kevin Spacey or Johnny Depp—"but he'd have to wear his outfit from *Pirates of the Caribbean*." If she could have dinner with three of the world's greatest artists, she'd choose Wayne Thiebaud, Duchamp, and Miró or Manet. Her own work—grand-scale, detailed ink drawings on sheets and blankets, combining surrealist and symbolic elements—doesn't resemble any of theirs, but she's still experimenting: "I can't possibly expect to find my own artistic direction at 21. I just know I have a need to make things."

She's had that need since she was a little girl in Lawrence, Kansas—a pocket of liberalism that racked up the highest percentage of Ralph Nader voters in the country in the 2000 presidential race. She can't remember a time when she didn't want to be an

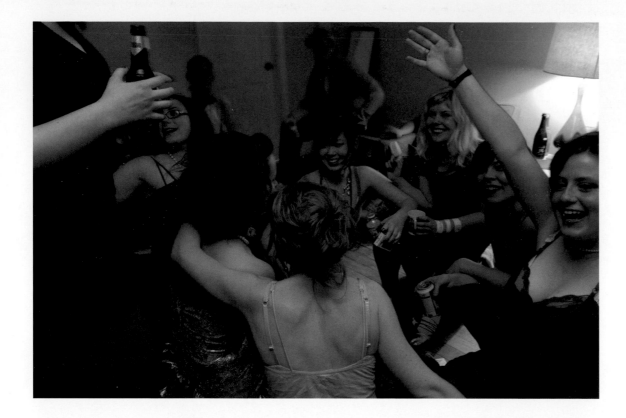

artist. By her senior year in high school, she was taking almost all art classes: "I didn't want to waste time with subjects that didn't interest me." When she wasn't making things, she was reading: "I was really, really shy. I wasn't willing to put myself up for rejection. I pretty much waited for people to come to me." She went to her prom with her art girl-friends. She still parties with groups, and has yet to go on what she'd call a real date.

One of Caity's good friends affectionately describes her as "laid-back and weird. She can be all 'la-la-la,' but then she gets this Cheshire cat grin, and she won't tell you what's going on in her mind." She's more likely to write her thoughts in her copious notebooks and journals, like the one she kept on a recent trip to northern Spain. She spent three weeks trekking the arduous Camino de Santiago trail, and kept a detailed diary with observations about whatever struck her, like the carvings way at the tops of cathedrals that artists made just for the sheer glory of the work, since nobody could see them from the ground.

Like Dorothy, she loves her native Kansas, but isn't ready to go back. "After graduation I want to be nomadic for a couple of years, just do odd jobs and see the West and the South and then go back to grad school. It would be beautiful if I could support myself with my art, but it's not likely. I'd just like to keep making things and maybe have moderate success. I want to be happy."

Poised to embark on her uncharted journey into adulthood, the young artist is in no hurry. "I know where I came from, because I've been there," she says. "But I don't know where I'm going, and I'm rather glad, because there would be nothing to discover."—C.S.

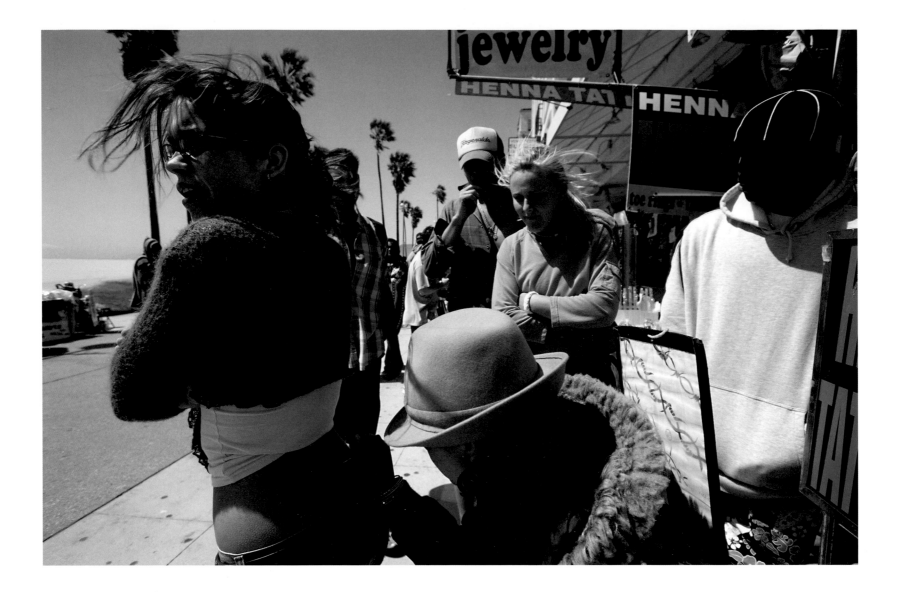

Almost Famous. When Mandy Musgrave, then 16, arrived in Los Angeles from Orlando, Florida, two years ago with dreams of acting, she nabbed the first part she auditioned for—a spot on Nickelodeon's *Drake & Josh*. She delivered one line: "Hey, Drake, looking cool."

She thought getting more roles would be a cinch. But she didn't land another part for six months. Besides the two weeks her mom stayed to help her settle in, she faced the dry spell alone. "At first I thought, 'All right: no parents, no rules.' But I realized that was no nothing," Mandy recalls. "I'd go to sleep crying. I was lonely."

The slump finally passed. She landed a few one-time spots on TV sitcoms like *Malcolm in the Middle*, then a recurring role on *Days of Our Lives*. This fall, she'll be starring in Nickelodeon's *South of Nowhere*, a show about two high schoolers, one a good girl, the other a bad one played by Mandy. "I don't know why I'm always cast as the bad girl," she says.

On April 8, Mandy sifted through photos of potential co-stars with her producer (*right*) and stopped in Venice for a henna tattoo (*above*). "My father would kill me if I got a real one," she giggles.

For a "bad girl," Mandy speaks well of her parents. "My family always believed in me. They didn't push me. They backed me up." —**Photos by Erica Berger**

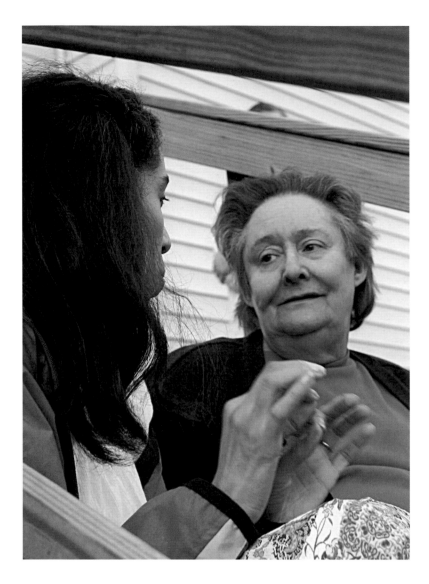

Reunited. Everything about my life so far as a photographer felt like a rehearsal for April 8. I had photographed my subject, Vikki Marshall, 23 years before. Taking pictures of her again reminded me how much images evolve: If we really care about the people we photograph, we better dip back into their lives from time to time.

Vikki is now a 31-year-old mother of two, and has been deaf since birth. I first met her and her mom Carol in 1982 in a battered women's shelter in Pittsburgh, where I was researching abused women for a photography book about domestic violence. There,

I heard about Eddie, the boyfriend with mean eyes. Vikki was nine when she saw Eddie break down the door in the apartment where she was hiding with her mother. She also saw him smash her mother's nose and ribs, but she was helpless to scream. She didn't even know what a scream would sound like.

Vikki was lucky in one way: She spent several years with loving foster parents who instilled in her a sense of self-respect. Later, she moved to Minneapolis because it was "far enough away," worked as an emergency room technician, and raised her two children.

Then one day by chance she saw the photograph

I had taken of her in my book, *Living with the Enemy.* Looking at the image of herself for the first time, she was filled with anger. She sent me an email. "How dare you photograph me? I was just a child—you had no right!" She had a point—I had published a picture of her without making any attempt to interview her.

We continued to email and talk, and we eventually became friends. In late March, Vikki wrote to say she had to confront her demons—she planned to meet her mother again for the first time in seven years, in Pittsburgh on April 8. I asked if I could go with her.

The day of the reunion was difficult for both mother and daughter. Vikki was determined to tell her mom she loved her, which she had never done before, and to forgive her mother's decision to stay with the man who had caused so much heartache in their family over two decades. And Carol had to confront what she had lost—the loss of trust, and respect, and of so many years.

I know enough about photography to say a single photograph can change people's lives in a million ways. Vikki's lesson for me has been profound. Every person I photograph has something to say, and I must learn to listen. —*Photos and text by Donna Ferrato*

Off the Streets. Lorena Macias, 23, always knew she would get a job doing homeless outreach. "I was homeless when I was younger," she explains, "and I decided that when I got old enough I was going to give back. Now I'm back on my feet." She works as a direct-care counselor for Denver's Urban Peak agency.

Lorena is a single mother of four. Her eldest child, age 9, stays with Lorena's mother, and she drops off her 2-year-old twins and 4-year-old with a babysitter every day before going to work. After stopping at a downtown homeless shelter, she hits the street, often the 16th Street Mall area, with a backpack, handing out "simple things like deodorant, toothbrushes, and tampons, and also things that might lower risk of disease, like condoms and bleach kits," to homeless teens and adults.

Asked how she turned her life around, Lorena recalls, "I used every program possible that I could. I used one housing program after another. I took baby steps and made myself aware of everything that was available to me." —*Photo by Judy Walgren*

Role Model. She dubbed herself "Sister" because people can't tell from her name whether Haero Dizaye is male or female. And being female is part of her statement. Haero, 28, does what some would say no good Muslim girl should: get onstage and spit hip-hop poetry in English, Kurdish, and Spanish to a deejay's beat.

"Lots of people trip out when they see me perform. The visual is so far off from what they've heard about Muslims," says Haero. Born in Iraq, she came to the United States as a baby, and began wearing a *hijab* (head scarf) as a badge of pride while in college.

"Other Muslims say women aren't supposed to be in public and that music's a sin. I say, if it wasn't meant for me to do, I wouldn't be inspired to write and rhyme." On a weekend night, she'll adorn her hands with henna tattoos before hitting a Los Angeles club and going head-to-head in a freestyle battle, usually with the fellas.

"A lot of times guys don't think I can do it. They think I'll choke. But I'll get out and represent! My message to girls out there: Stick to your guns, don't sell yourself out. You don't have to show your body and talk about sex to make it. We have to value ourselves for others to value us."—***Photo by Peggie Peattie***

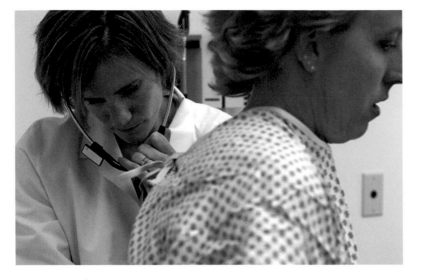
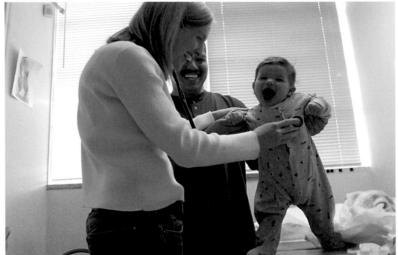
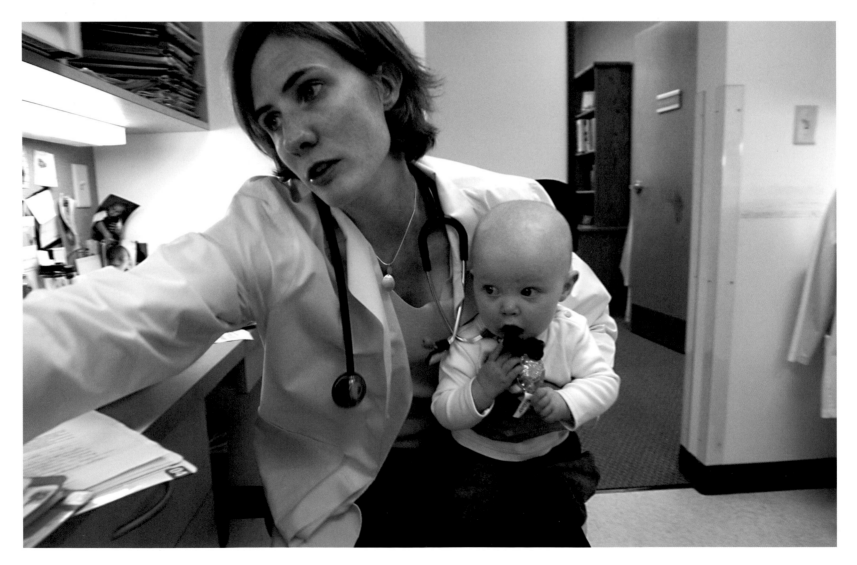

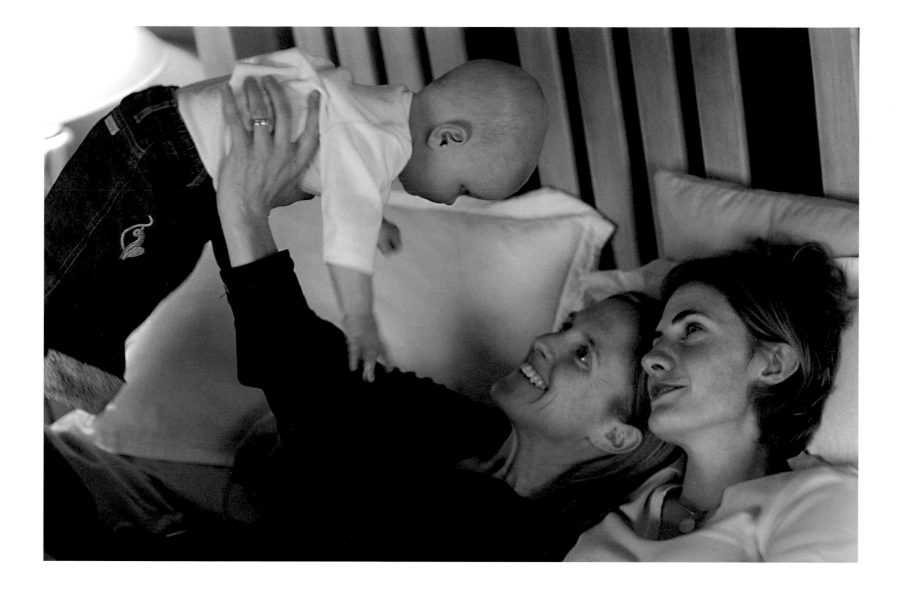

Family Practice. Doctors Michelle Drury and Marcie Lavigne relied on med-school know-how to calm their patients' new-parent anxiety. Until they had a baby of their own. "It's been eye-opening," says Marcie (*above, at right*) of their 5-month-old daughter, Rowan Drury Lavigne. "I have a lot more empathy for my patients now that I know babies don't develop by the book."

"I used to think, 'It's just an ear infection, nothing to get upset about,'" Michelle, 31, agrees. "But for a parent, it is a big deal. Having Rowan has made me a much better doctor." The two family practice physicians met as med students in the Midwest before moving to Boulder, Colorado, where Marcie joined a private practice and

Michelle works at a community health center. "We were emotionally ready by the time we decided to start a family," says Marcie, 30. "One thing about same-sex couples is that our babies are very planned and wanted." They chose a donor, and Michelle got pregnant on the first try.

"I was there every second of the pregnancy," says Marcie. "I did feel a little left out in the breast-feeding stage. I thought, 'This is how dads feel.'" Rowan sometimes goes into the office with Marcie. "I spend so much time with her, I'm as attached as if I'm the birth mom." Which she'll be next year, when the couple plans Baby No. 2.
—Photos by Joanna Pinneo

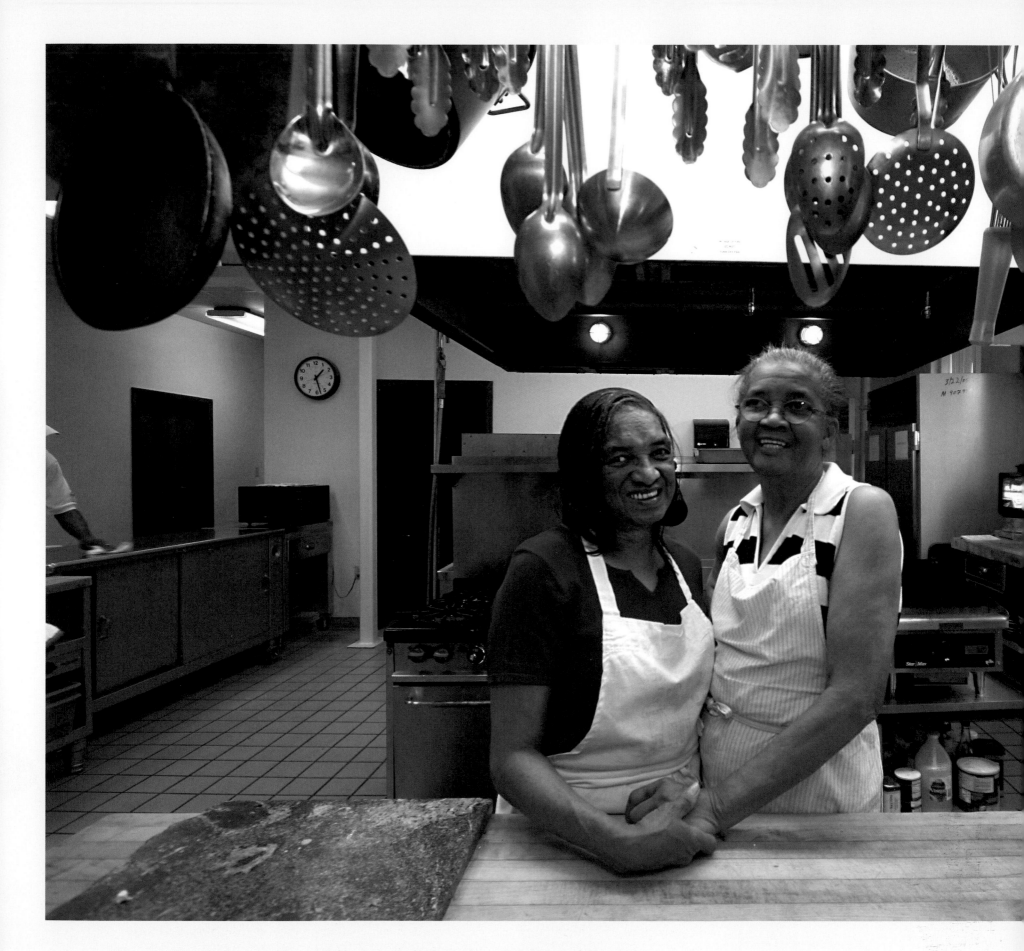

Sisters Ann Harris (above, at left) and Sylvia Scott rent kitchen space at Christ Episcopal Church,
in Little Rock, Arkansas, where they now run the catering service their mother started in 1963.

Soul Sisters

❖

Photos by Dixie D. Vereen

Ann and Sylvia…Sylvia and Ann. It hardly matters who goes first. The two sisters are as interdependent as the flour and butter in the roux they whisk in their catering kitchen. They were raised in a big white house by powerful women who nourished them on propriety, self-sufficiency, and devotion to family. Their widowed grandmother, Anna Peterson, called "Ma Pete," stayed home and managed her five lively grandchildren, while their mother, Ma Pete's widowed daughter Mildred, went out to cook in the kitchens of the elite white families of Little Rock, Arkansas, catering their fancy parties to support the household. If she ever felt degraded or insulted riding to work in the back of the bus, she never discussed it with her daughters.

"We always ate good and looked nice," Sylvia, age 67, says. "Mama brought leftovers home from all her parties—enough to share with our friends—and her clients gave us the clothes their kids had outgrown." Proper manners were required, rules were followed, elders were respected, and chores were done without bellyaching. "If we misbehaved," Sylvia recalls, "Ma Pete would tell Mama at night after work, 'Your ladies been fighting.' Then Mama would call us out of bed in our nightgowns, give us a sermon, and like as not take a little switch to our legs." In the safe confines of this matriarchal kingdom, Mildred's girls finished high school and started their own families. When Ann's brief marriage fell apart, she left her job as a short-order cook and moved back home, adding her two toddlers to Sylvia's four. Sylvia was always a single mother. The sisters functioned best as co-parents, raising their children without much male influence.

In 1963, Little Rock's Woman's City Club, then a whites-only, hoity-toity private establishment, broke precedent and, despite some flak from a local paper about hiring a Negro, invited Mildred to run its tearoom. She asked her daughters—then in their twenties—to join her, and that marked their official entrance into her business. By the time Mama retired two decades later, Ann and Sylvia had moved smoothly into her place as pillars of the Little Rock social scene. In the supermarkets where they buy their supplies, chic ladies spring from checkout lines to smother them with howdy-dos and hugs. When someone in a wealthy old family dies, the first call goes to the undertaker, and the second to Ann and Sylvia.

In the large professional kitchen at Christ Episcopal Church where Ann and Sylvia rent space these days—working without helpers, thank you—the TV is quietly tuned to Sylvia's soap operas, and the food processor sits unused in a corner. The sisters learned to chop by hand, and still do. A tin box crammed with recipes and the cookbooks near it are rarely opened. "We *are* the *Joy of Cooking,*" Sylvia quips. Without words, they operate in perfect synchrony. "We think alike," Ann explains, "and never get in each other's way. We know exactly what needs to be done. If Sylvia finishes something and I'm on the phone, she'll pick up whatever I was doing to help me out."

Sylvia plans the menus and garnishes the platters. Ann, now 69, is chief cook: "I reckon if it tastes good to me, it's going to taste good to others." She is also the caretaker, admonishing Sylvia to sit and rest when she thinks her sister is overdoing it. Then Sylvia counters with, "No, you can't do everything. You go sit down." "After the party's over," Sylvia says, "we'll hug each other and go 'Whew!'"

In today's chicken-glazed-with-kumquats-on-a-bed-of-pistachio-flavored-rutabaga world, Ann and Sylvia have stuck with down-home cooking—their fried chicken is a favorite—and such time-consuming dishes as carved watermelon baskets filled with melon balls. They don't use pre-fab foods, and they don't take shortcuts. But it's not only their cooking that keeps customers from one generation to the next coming back. "We just enjoy people," Sylvia says. "When we cater a party, everybody is back in the kitchen, laughing with us." That includes Bill Clinton, who liked to banter near the stove when they did parties at the Governor's Mansion, so he could be the first to get their can't-eat-just-one sweet rolls hot out of the oven. "I think our customers stick with us because we're plain, down-to-earth folks," says Ann. "I try to read just enough news so I can start a conversation with someone standing around alone. Maybe I only know one or two sentences, but that's enough to get 'em going."

Lately health problems are slowing them down just a bit; they're catering more

In preparation for catering a local cocktail party, the sisters share a laugh with hostess Kristi Barton (above left), *and Ann puts her final touches on the buffet* (above).

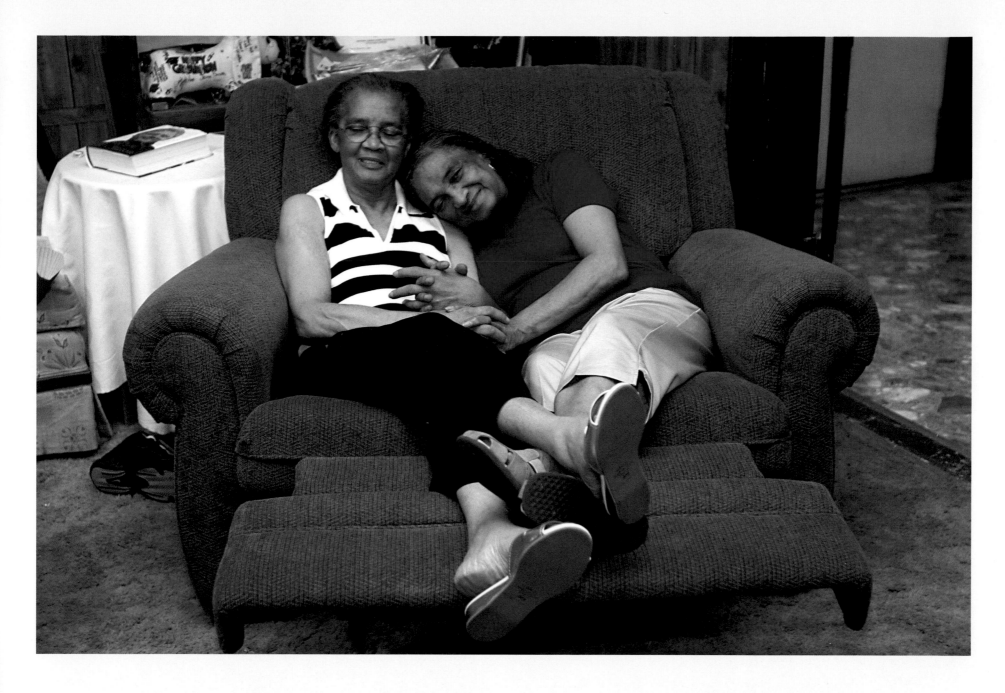

At the end of a long day, the sisters relax in the home they've shared for 43 years (above), where every Sunday they cook dinner for their many children and grandchildren.

luncheons and fewer elaborate parties, but they haven't eliminated the big dinner they host for their kids and grandchildren every Sunday after church. While Sylvia sometimes needs the help of oxygen to breathe, it doesn't keep her out of the kitchen. "We've been so fine for so long," she says. "Now the asthma's got me so I can't just flow like I used to."

For almost all their lives, Ann and Sylvia have lived together, parented together, worked and worried together, had their hair done together, and prayed together, always knowing there was someone in the bedroom down the hall to trust and depend on. "We've had a really good life," Ann says affectionately, planting a kiss on her sister's cheek as Sylvia echoes, "We certainly have! What would I be like without Ann? She is a really good person." —*C.S.*

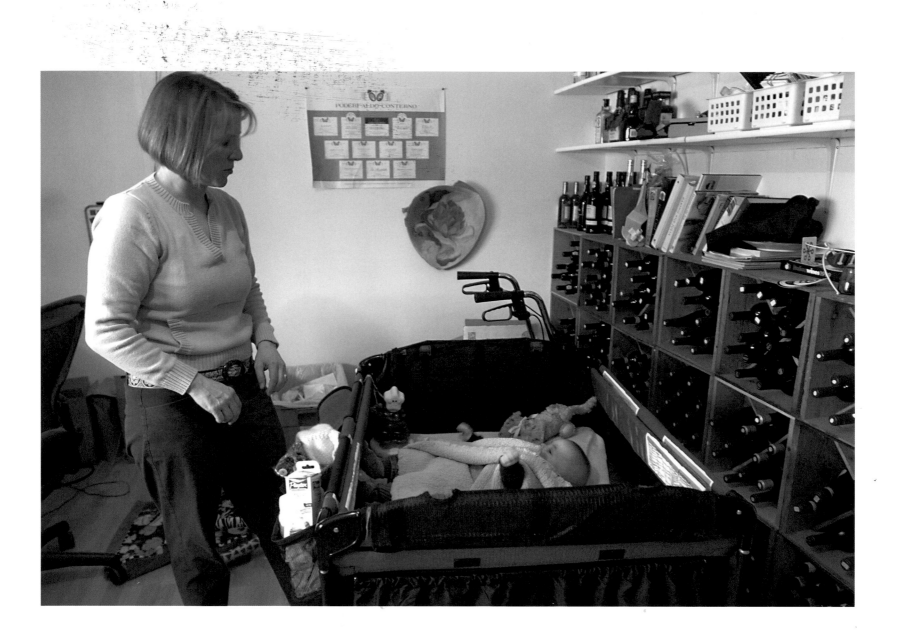

Feeding Time. Five years ago, Holly Smith was already a star chef in Seattle. She wasn't really thinking about having a child or launching a new restaurant of her own. She'd written up a business plan, but hadn't found the space she wanted. And kids were something that was going to happen later.

But, the 38-year-old now realizes, "The best things happen when I stop looking." Her life changed on the day she spotted an old-house-turned-restaurant for sale on Juanita Creek. She opened Café Juanita, featuring the cuisine closest to her heart, northern Italian, in 2000. And just a few years later, she was pregnant with Oliver, who is now 6 months old.

The restaurant is a family affair. Oliver spends at least six hours a day there, dividing his time between watching mom whip up her signature dishes and playing downstairs with his dad. Holly's husband, Mike, telecommutes for a nonprofit, sharing his workspace with the wine cellar. Holly dashes downstairs every hour to "open up my chef coat to breast-feed the baby."

Holly's long hours at the restaurant do take their toll. "I don't think it's ever going to feel perfect. I come home, and he's asleep. I miss a lot of his nights." But she has no regrets. "Oliver is the best thing I've ever done," Holly says. "I used to crumple up the reviews, but now I want to save them for him." —*Photos by Barbara Kinney*

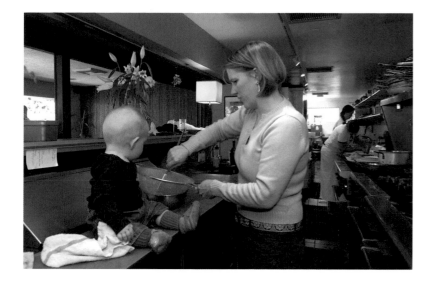

Diva Mom. In many ways, mezzo-soprano Denyce Graves is a typical international opera star, constantly jetting to opera houses and concert halls in the United States and Europe from her home in Leesburg, Virginia.

Yet when she gave birth to her daughter, Ella, eight months ago, she didn't slow down. She just added the baby's luggage to her own and took her along, often with her own mother (*above,* at right) in tow. "I realized that because I was so seldom home, I had to make home wherever I happened to be," Denyce says.

Denyce, 41, grew up in Washington, D.C., and recalls listening to the gospel music her mother allowed, but secretly wanting to be at friends' houses to hear the latest Michael Jackson record. Later, at Duke Ellington School of the Arts, she heard a recording of Leontyne Price singing Puccini arias. "I'd never heard opera, never heard anything like that, then or since," says Denyce. "From that moment, I knew what my purpose was."

Now Ella is in her mom's dressing room on performance nights and underneath the piano during informal rehearsals at home. "She likes to sing along with me when I do my vocal exercises.

"Ella has given birth to me, not the other way around," Denyce says, with a trace of wonder in her voice. "I love being a mom." This diva is clearly delighted with her new starring role. —*Photos by Alexandra Avakian*

133

Major Courage

❖

Photos by Susan Biddle

NOVEMBER 12, 2004—THE DAY ARMY NATIONAL Guard Major Tammy Duckworth lost her legs—started off routinely enough. She awoke at 3 a.m. and reported to the tactical operation center at Camp Anaconda, near Balad, Iraq. By midmorning she was at the controls of her Black Hawk helicopter, ferrying troops and supplies throughout the countryside. As she flew back to base camp at 4 p.m., almost done for the day, a rocket-propelled grenade tore through the copter floor and exploded in the cockpit, instantly severing her right leg just below her hip.

Tammy's training clicked in, obliterating fear and pain. "My only thought was to save the others," she says. "We were losing power, and I had to get us safely on the ground. I didn't know who else had been hit. I gripped the controls, consumed with trying to land without crashing." When the craft touched down—guided by her less severely hurt co-pilot, Dan Milberg—Tammy passed out. As she was pulled from the copter, her left foot was dangling from her one remaining leg. Doctors in Baghdad amputated it at the shin but managed to salvage her badly injured right arm.

She never was afraid of dying; she had made her peace with that. What she wasn't prepared for was the pain, too strong for morphine to conquer, so intense that even her hair follicles ached. She endured by counting to 60 over and over and over, moving from minute to minute. But don't even think of calling her a hero. "I'm a survivor," she clarifies. "Dan, who saved my life, the men who dragged me and dropped me and picked me up and dragged me some more to the medevac, the doctors who took care of me—they're the heroes. What I don't mind is being a role model for a kid who might be looking for something to become."

Now that the worst is behind her, now that she's walking with canes, adjusting to her prostheses and determined to get back into her copter and fly again, the word she keeps coming back to is "lucky." Lucky that her civilian job is waiting whenever she's ready to return. Lucky that friends from the National Guard are making her home in

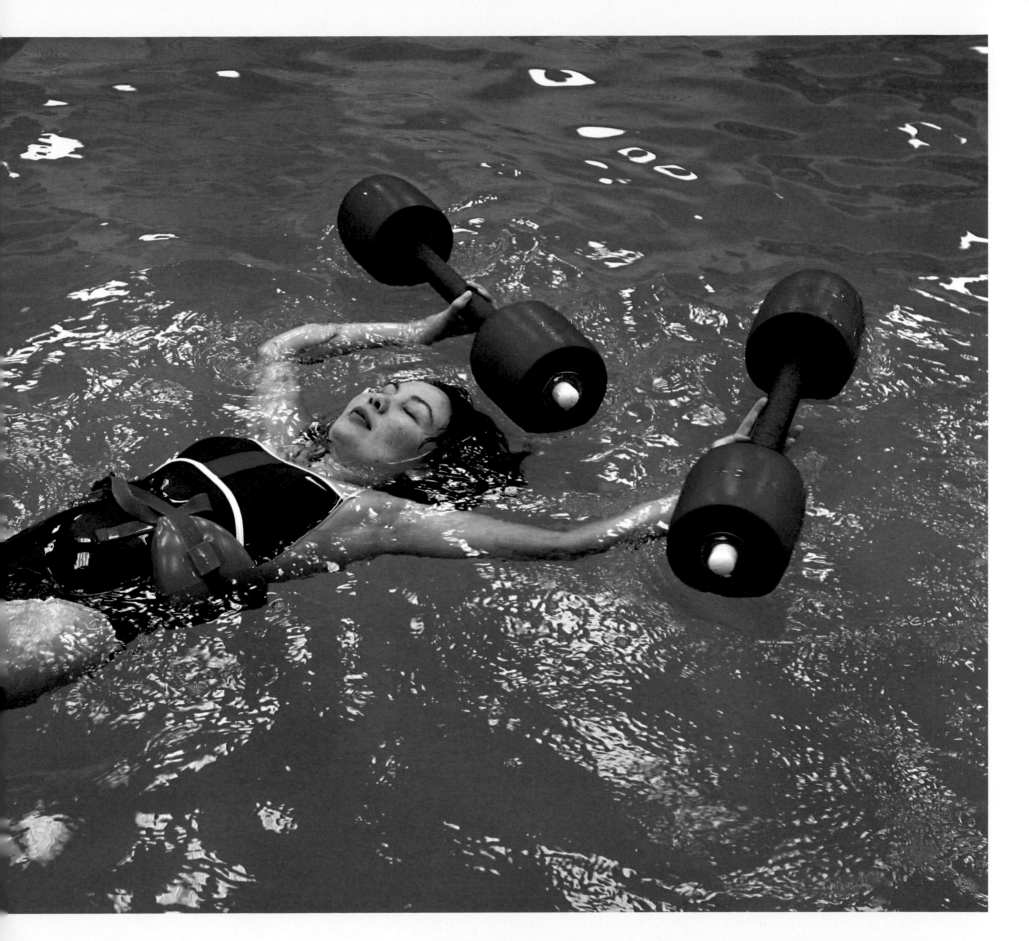

Major Tammy Duckworth does five hours of exhausting therapy each day to restore movement to her damaged arm and strengthen the muscles that support her leg prostheses.

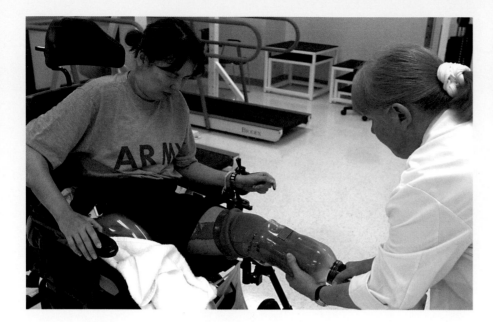
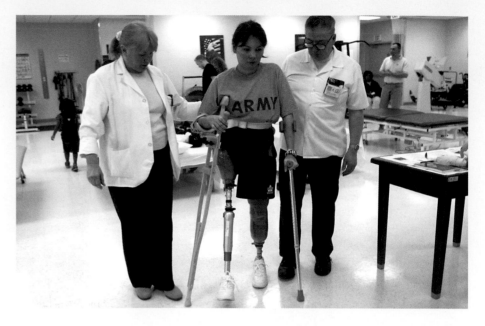

Chicago handicapped-accessible. (They joked that if she didn't send the key, they'd break in.) Lucky that well-wishers chipped in nearly $18,000 for the construction materials. That doctors could graft a muscle from her rib to fix her damaged arm. That both her legs weren't torn off above the knee, in which case she might never have walked again. Lucky she isn't blind, thanks to her optometrist, who'd prescribed her extra-thick glasses to protect her from shrapnel. Lucky she came back alive.

In the midst of the noisy arguments about the war in Iraq, it's sometimes easy to forget that hundreds of thousands of men and women have volunteered to serve their country, and are willing, if necessary, to give their lives in the process. Tammy Duckworth is one of them.

For the first half of her life, she lived primarily in Southeast Asia, where her American father, a soldier decorated for his service in Vietnam, worked for United Nations development programs, moving his Thai wife and their children from one assignment to another. While Tammy's younger brother hated the lifestyle—in three years of high school, they lived in five different cities—it suited her adventurous spirit. "I love trying new things, learning about the local culture. When I travel, I eat street food everywhere and just carry my Imodium."

Ultimately, living abroad taught her to appreciate what it means to be American. "With money, you can enjoy a great life in those countries," she says, "but there's no real freedom. When I came back to the States, I was amazed at what people took for granted—how they can speak out against the government, how cops are held accountable for their actions. There is so much this country gives you that we don't even realize, and I wanted to step forward and give something back. People serve their country in different ways—they volunteer at church, work with battered women. My way was the honor of wearing a uniform."

While working toward a master's degree in international affairs at George

The biggest obstacle to Tammy's goal of walking unassisted has been creating a comfortable high-tech prosthesis with a computerized knee that can be attached to the five remaining inches of her right leg. "Using what little limb I have to operate the leg," she says, "is like trying to control an entire broom by holding onto two inches of the handle."

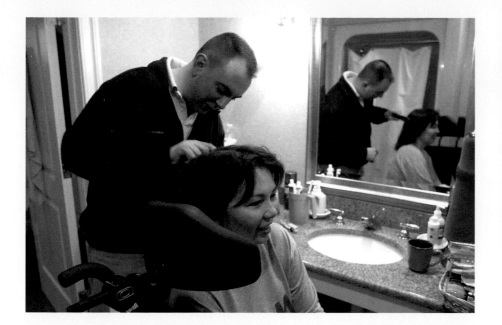

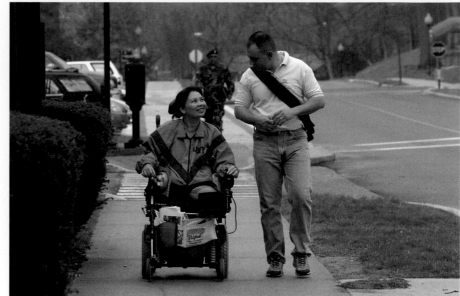

Tammy's husband, Bryan (above), gave up his job and moved to Washington to care for her during her year at Walter Reed Medical Center. While she sometimes complains he's too protective, he says, "I know this is going to be an inconvenience for the rest of her life, but it won't change our relationship in any significant way. When she woke up, I saw the same woman I married in her eyes."

Washington University, she found that friends whose values she shared all seemed to be in the National Guard. She joined the ROTC as a way to test her interest and commitment. It stuck—and she met her husband, Bryan Bowlsbey, a computer specialist who jokes that *he* kept his maiden name. Their connection was instant, and electric. "We met at a Georgetown club and talked for 12 hours nonstop. I have never gotten my fill of her," he says. "She is the most intensely interesting and aggravating woman I've ever met."

They settled in Chicago, where Tammy took a job with Rotary International working with their clubs in East Asia, and began courses for a Ph.D. in human services. The couple both joined the National Guard, although in different units. They decided that having children wouldn't jibe with Tammy's military aspirations, which soon included piloting helicopters. "Flying was the only combat job open to women," she explains. "Nobody wants to get blown up or shot at, but I decided if I was going to be a soldier, I didn't want to take fewer risks than men. I wanted to be equal. I am just as much a soldier as the guy next to me."

When the rocket-propelled grenade hit, Tammy's life changed forever—and yet in many ways, it didn't. "I'm very good at compartmentalizing," she says pragmatically. "I don't worry about what I can't control, and I deal with what I can fix. If I don't get back to where I was, the guy who fired the RPG at me wins. And what a slap in the faces of everyone who worked so hard to save my life if I don't take the gift they've given me and do the most I can with it."

So she expects someday to retire with Bryan to Hawaii. She'll go to the beach in a bikini and prostheses with painted toenails. "I came by my scars honestly. I'm not going to hide them," she says. Meantime, she's sporting T-shirts emblazoned with quips like "Hey dude, where's my leg?" and "Lucky for me he's an ass man." When people ask what happened to her, she's got her answer ready: "I was in a bar fight. You should see the other chick." —*C.S.*

137

Animal Farm.

Photographer Karen Kuehn falls asleep to the sound of frog ribbits and owl hoots. She awakes each morning to the howl of coyotes, the "meows" of neighbor Lida's peacocks, and the brays, honks, clucks, barks, and whinnies of the animals on her own farm in rural New Mexico.

"I work, and I have an 11-year-old son," she says, "so the animals are extra responsibility. But I'm a Virgo, which is the sign for domestic animals. My whole life is based on them."

Karen, 45, made a living for 15 years as a high-profile photographer in New York, on assignments for publications like the *New York Times Magazine, Travel &*

Leisure, and *Interview.* But in 2001, she and her son moved to the country, near Peralta, New Mexico. "I wanted to raise my son in an agrarian community," she explains. "I'm a nature girl myself, and didn't want us to be compressed by city living."

With the move, the rhythm of their daily life changed dramatically. "We spend our days making art, gardening, baking, caring for animals, and riding horses and motorcycles," says Karen (*near right,* with eggs), who is still in high demand as a commercial and journalistic photographer, but is also starting to do more artistic work.

Her community has changed, too. In New York, she notes, her closest neighbors were the drug addicts who

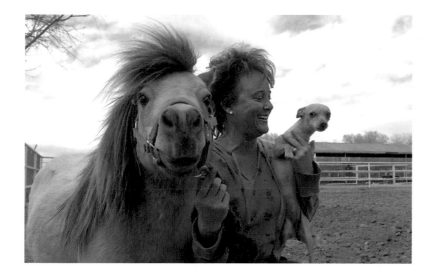

camped out on her front stoop. Now her neighborhood includes Debbie Connors the farrier (*left*, trimming the hooves of Karen's donkey); Valerie Holliday (*above top*), who raises mini horses; agility-dog trainer Judy Carr (*above right*); and Patty Gallegos (*right*), who keeps alpacas and pigs.

"I'm surrounded by incredible women," she marvels. "We all share this passion for animals. Women relate to animals differently than men—we see them less as tools, yet we are fearless with them. My friends and I get tremendous pleasure from sharing our lives with them." —*Photos by Karen Kuehn*

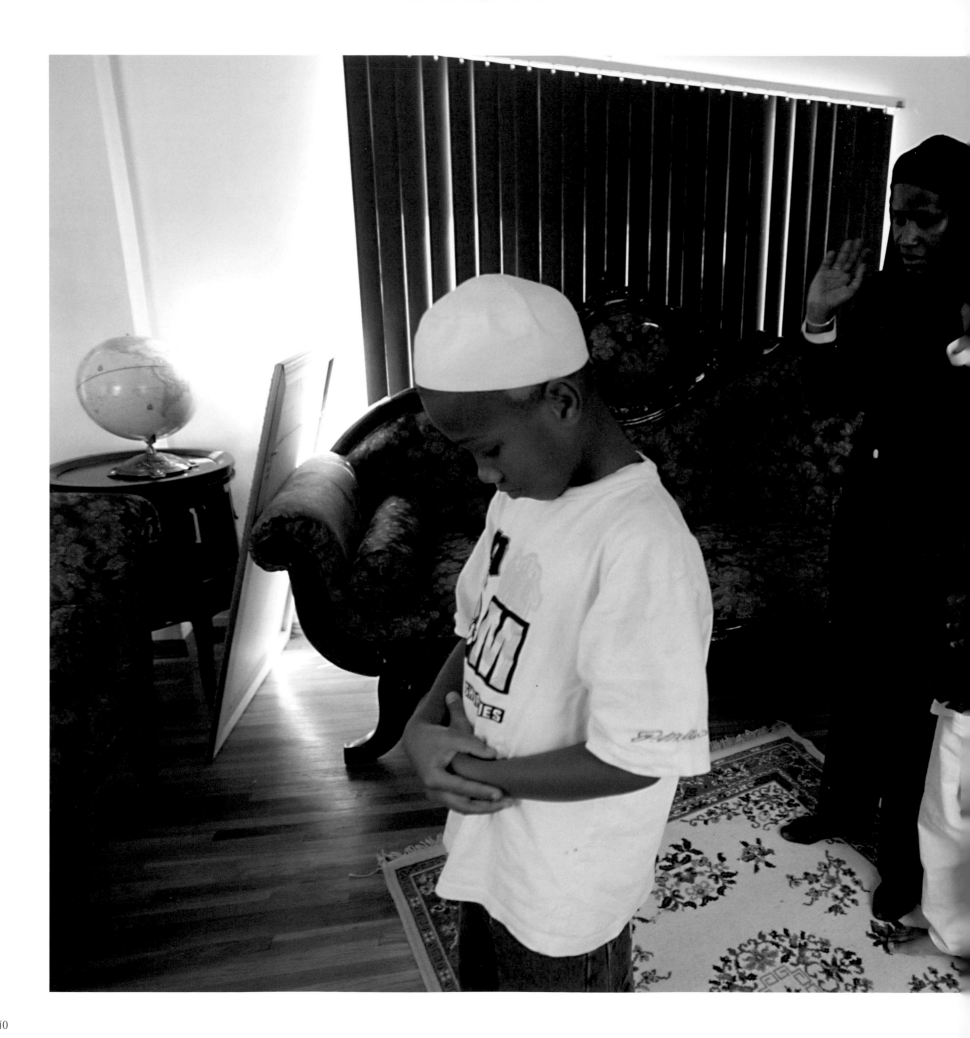

Facing East. "The Prophet Mohammed says, 'Paradise lies at the feet of mothers,'" quotes Janiece Hameed, citing a treasured ideal from the ancient faith of Islam she has been practicing for 20 years.

"Muslim women in America are liberated," says Janiece, 46, a mother of six and the author of the book *Women in Islam and Contemporary World Issues*. Though raised as a Methodist in Miami, Janiece found inspiration in the messages of the Koran, and went on to marry a Muslim man whose melodious prayers she took as a calling. "I would hear him in the middle of the night and wonder what he was saying," she recalls. "It sounded so peaceful."

After she converted, she and her husband founded and still work for the Black Contractors Association, a nonunion trade organization in San Diego. She also raises the couple's six children in the faith. Ismail, 15, and Idris, 10, lead the *salaat* prayer (*left*), one of the five they do each day.

Janiece's pride rubs off on other members of her diverse community. "I could be wearing an Ann Taylor suit and a headwrap and men say, '*Assalam alaikum*, sister.' They know I'm a Muslim woman, and they treat me with respect." —*Photos by Peggie Peattie*

My Mother.

My Mother. Spending the day photographing my mom, Elizabeth, on April 8 was a real eye opener for me—amazing in many ways, gut-wrenching in others.

My mother has Alzheimer's disease. The challenge of watching her living out her day, from sun-up to sundown, 12 full hours, was an emotional roller coaster. Every time I planted a kiss on each of her cheeks, she provided a smile. She sometimes looked at me with great wonder as if trying to remember or recognize me (*near right top*). But she never did seem to connect even when I called her "Mom" or "Squeak" (my nickname for her),

or told her I was her daughter. While I am beginning to get used to it, I still wonder, "Where did my mom go? Is she trapped inside or is she actually gone?"

I still see glimpses of her essence. She is stubborn. She will certainly speak up for herself when she doesn't like something. She still likes to comb her own hair. She still likes to be well dressed and still prefers skirts to pants.

Mom was a singer years ago and later returned to school and became an interior designer. She and my dad, who was an architect, were married 53 years before he died in 1995. Mom was one (continued on following page)

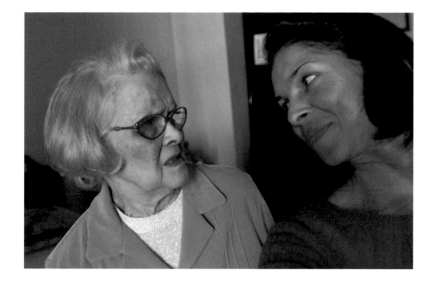

(continued from previous page) of 11 children and is the only one still living. Her mom lived to be 105. Mom is a survivor. Her feistiness and stubbornness are what have brought her this far.

A year ago, I had to face that she is unable to live independently, or even in assisted living, and needs constant supervision. The staff and caregivers (*far right*)

at Montgomery Place in Hyde Park, Chicago, are an amazing group of women. They run a tightly structured ship and yet manage to allow their patients to exercise and satisfy their curiosity. While they deal with the extraordinary challenges of caring for those with severe dementia and Alzheimer's, they all still have personal lives of their own—their own families, their own daily world of highs and lows. They are in a field that requires

tremendous patience, and as I watched them in their
routine, I was comforted by their skills, kindness, and
common sense.

The story of my mom and the caregivers of
Montgomery Place is a story of the American woman.
We work, play, and care hard. The combination is
the elixir of life.

—*Photos and text by Jeanne Moutoussamy-Ashe*

Generations. In response to an invitation on the *A Day in the Life of the American Woman* website, many readers nominated inspirational American women to be included in this book.

We chose Louise Hartwig, (*above*, third from left), secretly nominated by her daughter Kylee Baumle (fifth from left), who describes her mom as "remarkable." Kylee wrote, "My mom thinks she is just a normal woman, but I assure you, as will others in her community, she is not."

Louise, the 70-year-old grandmother of two (Kara, left, and Jenna, fourth from left), is an avid mountain biker, golfer, and interior decorator, as well as a champion fundraiser for public-garden projects in the picturesque town of Van Wert, Ohio. She also checks in on her 90-year-old mother, Virginia (second from left), who lives just a mile away.

On April 8, Louise's busy schedule included her daily morning workout, followed by a round of golf with her granddaughters, time spent planning her latest fundraiser, and a few hours doing volunteer gardening at the First United Methodist Church. She did manage to take a little time out to pose for this portrait in front of her house, with all four generations of her family's women present—along with her husband, Fred, on the sidelines.
—*Photo by Sarah Leen*

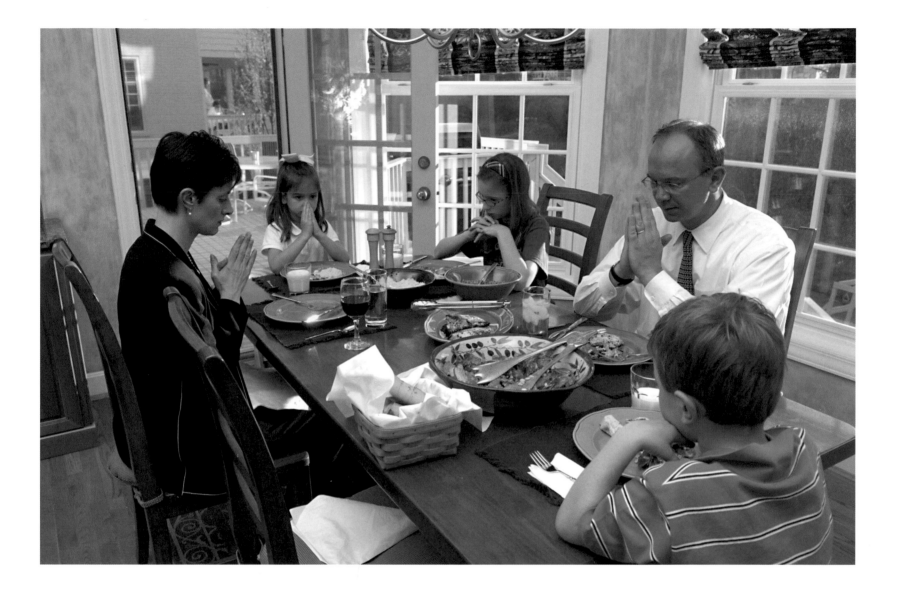

Second Shift. "I try to make it feel as though we're not as busy as we actually are," says Lauren Thaman Hodges, 42, speaking of the daily balancing act she and her husband, Tom, perform as parents of three active kids (Bebe, 6, Victoria, 11, and Jack, 5, *above*) in a two-career household.

As an executive research scientist in Cincinnati, Ohio, Lauren often works ten-hour days at the office only to return home for late-night conference calls to overseas clients, but she always makes time for family dinners at 7 p.m. "I grew up in a very traditional household," she recalls. "We always ate as a family and talked about our days, and to me that's really important."

And so is keeping up with her children's academic and extracurricular activities, which includes lecturing to science classes at her daughters' school and attending swim meets for all three. "We focus on the top priorities," Lauren explains. "I've learned that it's okay to bring store-bought cupcakes to the school party—it's not okay not to show up." *—Photo by Pam Spaulding*

Hog Heaven. Julie Gauman thinks nothing of hauling around a 200-pound slab of beef or of carving up a thousand-pound carcass. The owner of Western Way Custom Meats in Moriarty, New Mexico, Julie does everything from dealing with clients—local farmers, ranchers, and county-fair prizewinners—to butchering and wrapping the meat.

"Every one of my customers takes pride in their animals. I'm gonna give it everything I have, too," says Julie (*left*, with a black eye from a softball game the night before). She slaughters the animals herself, quickly and humanely, using a retractable bolt or, for lambs and hogs, a .22 handgun.

Julie, 32, learned her trade at her rural high school, which offered an unusual elective. "Our school had a slaughter and processing floor right in the building," she recalls. "So I took a class in slaughter." She liked working with livestock, and the physicality of the work appealed to her. Although she'd originally planned to be a veterinarian, Julie became a butcher instead.

"It's not the gory chaos people expect," she insists. In fact, despite the bloody nature of her job, Julie doesn't consider herself particularly strong-stomached. "I can barely stand to watch *ER*," she says with a laugh.
—*Photo by Karen Kuehn*

Tamale Tia. "Just by watching my mother, I learned to make tamales," says Irma De Los Santos, 65, who now makes up to 150 tamales a day. "We are very well-known," she says, "but I have never advertised. It's all word-of-mouth." The customers who come to her door to pick up their tasty orders include local doctors and judges, and others from as far away as California and Paris. "People say they've never tasted tamales like I make them," the señora boasts.

Irma's parents ran a restaurant in Cotulla, Texas, where she spent every day after school. Irma went to work for the civil service, but cooking was in her blood.

"I would get done with work and stay up until 2 a.m. making tamales," she says. "In 1994, I got laid off and never went back."

These days, headquarters is her own kitchen in Laredo. She cooks in advance, she says, "so when I sit down to do my tamales, I have everything ready." The tamale queen has ten grandchildren, four of whom come over every day after school. "I fix them lunch," she says with a wink, "whatever they want. I have always kept my family very close." Photographer Penny De Los Santos—Irma's niece by marriage—would certainly agree.
—*Photo by Penny De Los Santos*

Dance Partners. In 1988, after living in California for 26 years, Leiola Oliver came home to Hawaii with her husband and eight children. They acquired homestead land on Kauai and imagined a quiet retirement, unaware that their then-8-year-old daughter, Mi Nei, would become an award-winning Tahitian dancer, and lead the family into a business producing hula shows at local resorts and tourist destinations.

Leiola, once a dancer herself, drove the young Mi Nei and her sisters "from one end of the island to the other" for lessons and performances. "It's good that my kids picked something I enjoyed. That made it easy for me to get into it," says Leiola.

After Mi Nei (*above*, in yellow skirt)—who is now 25 and the 2004 Miss Garden Isle—won a dance competition in her teens, she was besieged with job offers. But instead, Mi Nei started her own dance production company, and enlisted her family's help.

Now Mi Nei's brothers and teen sisters dance in the shows, her older sister takes care of the costumes, and her father operates the lights and collects flowers for the leis. Leiola, 58, sews together the leis, grass skirts, and other costumes, using fabrics imported from Tahiti. "Sometimes I struggle with my kids," she confesses, "but I appreciate everything that we have."

—*Photos by Barbara Ries*

The Queen of Bluegrass

❖

Photos by Karen Ballard

RHONDA VINCENT IS WAILING. HER RICH, THROATY VOICE CAN BARELY KEEP PACE WITH her fingers as they fly over the mandolin strings, picking out "Muleskinner Blues." A week back, Rhonda and her band played to a standing-room-only crowd, but today they're getting about as much attention as a lounge act in a smoky bar. Only two 5-year-olds are on the dance floor; the rest of the guests on this riverboat cruise—a bit of corporate back-scratching for Rhonda's sponsor, the Martha White flour company—are drinking and talking, clueless to the fact they're being entertained by the Grammy-nominated five-time winner of the International Bluegrass Music Association's Female Vocalist of the Year award.

"My daddy taught me long ago, you treat every crowd the same, no matter how big or how little," Rhonda, 42, says during her break. "The most miserable situation can turn into a blessing." Just then, a man walks up, compliments Rhonda, and says he'd like to book her at a chain of clubs he owns. The told-you-so look on her face says it all.

The woman dubbed the "New Queen of Bluegrass" by the *Wall Street Journal* grew up in a big, extended musical family that played bluegrass every night after dinner. Rhonda was 3 when her parents heard her singing harmony on "Happy Birthday to You" and promptly added her to the family act, playing fairs and festivals. When she was 8, her father stuck a mandolin in her hands. "Here's G, B, and D," he said, showing her the chords. "You're gonna play this for two hours every Saturday night from now on."

Growing up, she didn't roller skate or play sports because her father worried she'd hurt her hands. All through school, she missed parties and sleepovers because she was onstage every weekend. She studied accounting at Northeast Missouri State College, but quit just short of graduation, to pursue her music. On Christmas Eve 1983, she married a bandleader who'd booked her to play a few years earlier with his group. Now he's her manager. "Herb is an amazing man who's allowed me to pursue my musical dream," Rhonda says. "He knows I'm always coming home to him. He's the one I love."

After their daughters, Sally and Tensel, now 16 and 18, were born, Rhonda stayed on the road, while Herb took care of the kids. "He had his way of reminding me that, like

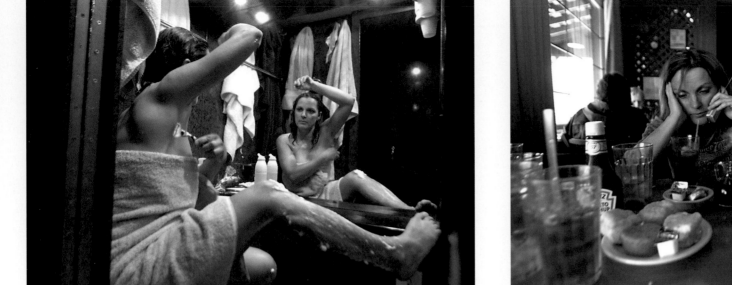
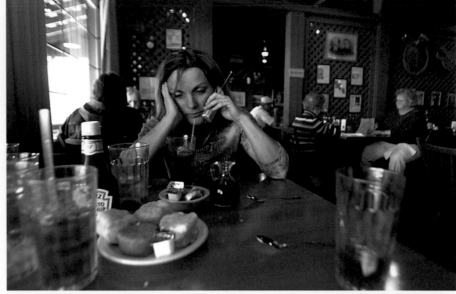

Life on the road for Rhonda means getting up-close and personal in her 45-foot-tour bus, where she shares one bathroom with the four members of her band (far left). After the overnight trip from Wisconsin to Waterford, Michigan, she checks in on her family from a local diner, and conducts business on the sofa that opens at night into her bed (left bottom).

Rhonda's daughter Sally (right) sometimes joins her onstage for weekend performances. Sally has an added incentive to visit the band on tour—she is dating fiddle player Hunter Berry.

my daddy said, 'One monkey don't make a show,'" says Rhonda. "I'd come home and there'd be 25 loads of laundry and an empty woodbox for me to fill. I'd think, 'Gosh darn, can't he fill this up?' But he wanted me to get a dose of reality. At home, I'm just a wife and mom."

Even while she's away, Rhonda focuses on her family. "When the fans and the music are gone," she says, "that's who's left." Summers when the girls were little, she took them on the road; as they got older, she brought them along on European tours. "I was just out for ten days and had a spare 12 hours, so I flew back home to Missouri," she says. "I grab precious moments wherever I can." (Neither daughter plans a musical career. Sally sometimes sings onstage with Rhonda, but she starts college this fall to study pharmacy.) "When I plan vacations," Rhonda says, "I look to put us in situations where we have to talk, like in a compartment on an overnight train. I love cell phones, because the girls know I'm only a call away. Yeah, there's things I probably missed with them. But I'm proud that I've raised independent children who are good Christian women. I'm okay with how I've done it."

Rhonda's current success has been four decades in the making. In the early '90s, after years of performing with her parents, she was lured to Nashville by a producer who tried to turn her into a "chick" country singer. "Those were my musical college years," she recalls. "I worked with the best of the best, learned about microphones, recording studios, contracts, attorneys, songwriting. It was very intense." But her two country albums did poorly, and her expenses opening for big country stars exceeded her earnings. Approaching the millennium in debt and at a crossroads, she decided to chuck Nashville and go back to her base.

She put together her own bluegrass band, the Rage, and finally everything clicked. Her diehard fan base grew as bluegrass, popularized by the film *O Brother, Where Art Thou?,* moved into the mainstream; her contemporary, anything-but-hillbilly style began to earn her crossover radio play. "I'm getting grandfathers at my shows," she says proudly, "saying they're here to listen to me play, and their granddaughters are here to see what I'm wearing."

Five years ago, Rhonda was touring in a Suburban hooked up to a trailer, making an occasional appearance on *Prairie Home Companion.* Now she logs 300 days a year in a 45-foot bus with eight bunk beds and a single bathroom, which she shares with the four guys in her band. "Used to be if somebody offered us a job, I took it," Rhonda says. "Now I'm on overload, and trying to cut back to 100 dates a year. But I'm grateful I can do what I love."

She's booking gigs two years ahead through her New York agency. Sponsor Martha White is building her a brand-new bus. Rhonda has music videos, a DVD, top-selling CDs, and a shelf of awards. "I didn't plan this, and I don't know where it will go," she says. "I just seized whatever opportunity came along. I am surely the luckiest girl in the world." And as stars go, one of the most down-to-earth. Not long ago, Rhonda was in New York to appear on *David Letterman* with Dolly Parton. "We were squeezed into a town car," she says, laughing. "I'm leg-to-leg with Dolly, and all I can think of is, 'Gosh, I didn't shave my legs.'" — *C.S.*

Rhonda talks to fans after a show at Highland Lakes Community College, near Detroit. "People are surprised that I go out and sign after every show," Rhonda says. "I think part of our success is that we're very one-on-one."

Miami Heat. "We went to Miami Beach to spend some time with friends, relax, and recharge," says Gina Bonavita about her 32nd birthday trip with half a dozen girlfriends—all professional women from Boston and New York. "Since we were all single, meeting men was just an added bonus.

"It was the perfect trip from the moment we got there," gushes Gina. Her first surprise: The room she was sharing with her friends was upgraded to a suite with two sundecks. Enjoying their unexpectedly luxurious accommodations, the posse took its time getting dressed that night. "We were crimping each other's hair and saying, 'That looks good, that doesn't look good.'"

In no time, they met a group of five men—single, 26-year old-professionals who had moved to Miami from Argentina, Chile, Puerto Rico, and Venezuela. "We were just hanging out together," Gina recalls, "and they said, 'Do you girls want to learn salsa dancing?'"

Back in the suite, the men threw on a merengue CD and everyone danced. "We were all so excited," Gina says, "We each had a guy and they were all good-looking." Later in the weekend, "They showed us around town. It was all good clean fun."

One of Gina's friends told her later, "I have been around the world. But I cannot get that Miami trip out of my head." —*Photos by Colby Katz*

Singles Scene. There are a million lonely hearts in the naked city. Why does it sometimes seem so hard to get them together?

In recent years, a host of new tools has been added to the dating arsenal, including online personal ads, "speed-dating," and modern matchmaking. And for those who still prefer to meet face-to-face, a new crop of parties targeting older singles may help.

In Manhattan, Gotham Parties hosts monthly gatherings that attract the stylish over-40 set to dances and soirées at some of the city's most sophisticated night spots. At this year's Spring Fling party (*above*), singles mingled while dancing to samba music, enjoying cocktails, and sampling spicy hors d'oeuvres.

One Gotham party regular noted it was refreshing to be out among people her own age. "There are plenty of places to go out when you're in your twenties or thirties," she says, "but when you get older, there aren't as many ways to meet each other."

Although finding that elusive spark continues to be a challenge, partygoers Ed Amira and Marian Greenberg—while disconnected when this photograph was taken—were at least sharing a booth by the end of the evening. —*Photo by Jill Freedman*

Girls' Night Out. When girls just want to have fun in New York's East Village, they stand in the long line to get into the cavernous Webster Hall nightclub for a rocking, high-spirited dance party every Thursday night. The fun lasts into early Friday morning.

Onstage, gorgeous guys with buff, glistening bodies, their family jewels discreetly covered, bump and grind to the giddy shrieks and laughter of a predominantly female audience. The crowd is straight and racially mixed, with no other agenda but to let loose and have a good time. Disco blares from the sound system; the air reeks of sweat and perfume; the dance floor pulses with the exuberance of gyrating couples in tight jeans.

"It's all crazy, slightly risqué, but basically innocent," says photographer Mary Ellen Mark. She chose to shoot here "because I love the life and energy of the place. It's such a visual scene.

"I'm really interested in pictures that make a social comment. This is about how young, middle-class working women go out and party. How men enjoy dancing for women. How everybody is putting on a big show acting sexy and suggestive but not being bad," says Mark. "I see it as a kind of performance art. Nobody takes it seriously. I just love the spirit and the good humor."
—*Photos by Mary Ellen Mark*

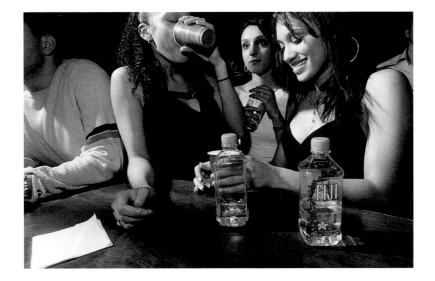

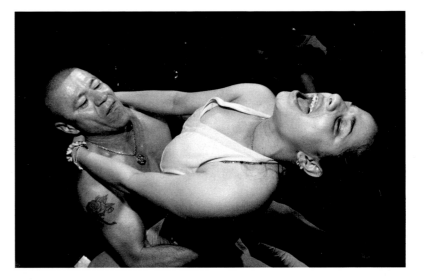

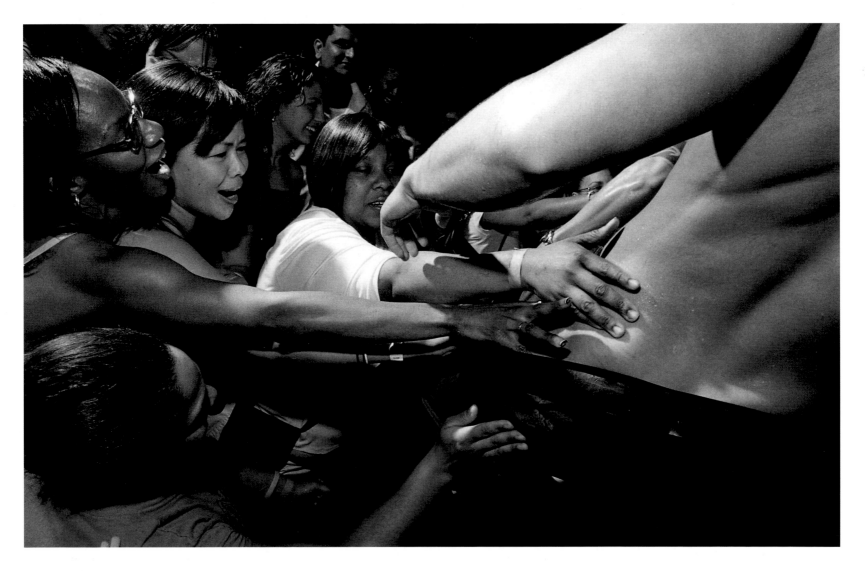

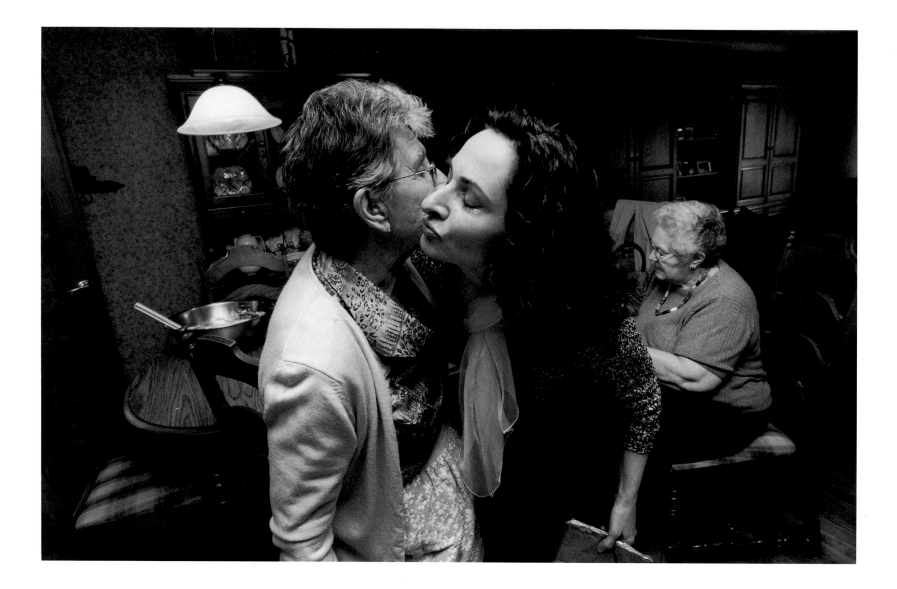

Comfort Food. A wedding, a baptism, or patriarch Uncle Sam's 78th birthday—the occasion doesn't matter. When the Bellos gather, "Chaos reigns, everyone talks at once, teasing is ceaseless, and we have lots of laughs," says Gina Bello, with her family in Nyack, New York.

And, she adds, plenty of good food. "We make everything from scratch," says Gina. "Today's society is too rushed and stressed. Many people choose shortcuts. But nothing is as delicious as homemade Italian food."

Bello family affairs attract at least 25 people and span several generations, from Gina's 82-year-old mom, Augusta (*above*, with Gina), to four-year-old Sam. Everyone treasures the family traditions, like making homemade manicotti (*near right*), and retelling the old stories, like the time Uncle Tony came home from work so exhausted he collapsed on the pasta drying on his bed.

"All my life, I've never felt alone because I have such a big family," says Gina, who lives in Manhattan, within relatively easy reach of most of her family, who are scattered throughout New Jersey and New York.

At 42, Gina sees her role changing. Having lost her beloved father, Michael (also a good cook), five years ago, she savors family time even more. "The torch is being passed to my generation to take over lots of the coordinating and cooking," she says. "I realize we're not going to have the elders around forever."

—Photos by Brenda Ann Kenneally

The Art of Living

❖

Photos by Stormi Greener

You'd think that at 86, Ruth Duckworth would have plenty of time to kick back and spend a few hours talking about her life. Hardly. She's got the Chicago opening of her retrospective coming up, a show of 83 works spanning five decades that's traveling to seven American cities over the next two years. She has to put the finishing touches on some pieces she's selling at SOFA, the big contemporary spring art fair in New York. A large wall hanging that was commissioned for a private home awaits completion. Ruth is anxious about retaking her driver's test—required every other year in Chicago after age 81; failure would mean the loss of her precious independence. There are the 70-odd plants and trees to tend in the light-filled, sparely furnished living room of the old pickle factory she remodeled into her home and studio. Her outdoor garden needs attention, too, after a long winter. But frankly, all five feet of Ruth wouldn't know what to do if she weren't so busy. "The reason for working," she says, "is not to be bored with life."

And what a life it's been. "I started out in Hamburg, Germany, on the wrong foot," Ruth says. Her mother, pregnant and stricken with Spanish flu, was medicated with vast quantities of red wine. Ruth somehow survived, but she was born so tiny that she was better suited to a shoebox than a cradle. "The doctor advised Mother to lock me a room alone and keep me absolutely quiet so I could grow. It was the *worst* possible remedy," Ruth says. "You don't learn to bond with anybody."

Small and sickly, she spent many days in bed. She wasn't much of a scholar. "My three sisters and my brother were brilliant, and I was only good at art. My older sister called me 'stupid little one.' I think in a way it inspired me to prove myself."

When Hitler rose to power in 1933, Ruth, who'd attended evangelical schools, was informed by her sister that their father was Jewish. Her Christian mother had never thought it worth mentioning; the Nazis felt differently. "Our dear friend, the mayor of Hamburg, committed suicide because it was preferable to a concentration

Ceramic artist Ruth Duckworth bought this abandoned pickle factory in a run-down neighborhood more than 20 years ago. She soon sacked her architect and designed the studio and living quarters herself.

camp," Ruth says grimly. Her father's parents had been in England on business when he was born, so he was able to obtain British citizenship for himself and his children and get the whole family out of Germany by 1936.

In wartime England, Ruth enrolled in art school, studying painting and sculpture. After graduation, she found work as a puppeteer. But she felt guilty about not contributing to the war effort, and took a job in a munitions factory. Nightmares of

heaps of bodies killed by the bombs she was building pushed her into a nervous breakdown and several years of psychoanalysis. "I learned how the loneliness of my early life affected me," Ruth explains. "I wasn't even aware how angry and depressed I was. That began to go away, and I felt more self-confident." While still in analysis, she married, took in a nephew when she couldn't have children of her own, and concentrated on her sculpture.

Frustrated by chiseling pieces nobody bought, Ruth switched to clay in 1955, and discovered her métier. Refusing to stick to traditional, functional wheel-thrown pots, she created objects reflective of her sculptural training, and turned the ceramics world on its ear. Her work sold; her name spread. But as her reputation grew, her marriage suffered. In 1964, the University of Chicago invited her to teach for a year. Her husband joined her after six months and announced that their marriage was over. Loneliness and sadness swept over her again. "I became a workaholic," she says.

Ruth settled in America in part because she'd brought her two dogs over from London and couldn't bear to quarantine them for six months in order to go back. "I could also see that working here could be more stimulating," she says. "I became a citizen when Reagan stood for president, so I could vote against him. My agent doesn't like me to say that, because all my big collectors are Republicans."

Today, Ruth Duckworth is an eminent figure in the art world; her works range from small, delicate porcelains priced from $7,000, to abstract ceramic wall murals that sell for upwards of $25,000, to soaring bronze public sculptures, like the one purchased by the Greek government to represent the United States at the 2004 Olympics. "I realized I was famous," she says in an offhand way, "when I had a big exhibition in Rotterdam in '78, and all over town there were banners and posters with my name. That was a thrill. I love that there are people who love living with my work. That's very, very important to me."

Solitary by nature, Ruth has been on her own for almost 40 years. She lives in a serene home (no dishwasher or computer) that, like her art, is largely devoid of color. She has traveled the world, socializes with a network of women friends, and has neighbors checking in on her, along with two assistants a few days a week. Those who know

Ruth was nervous on the way to take her bian-nual driver's test (left). *Being able to drive and shop for herself, to dine out alone* (right) *or have a cup of tea in the quiet of her own space are all part of the freedom that Ruth treasures. "When I took my driving test this year," she says, "I told the woman all I want is to stay independent and keep my mobility."*

her are awed by her spirit and work ethic. "Perseverance is terribly important," she says, "along with patience, talent and luck—meeting the right people to help you." In her case, that would be Thea Burger, her agent of 23 years.

Ruth is passionate about the environment, and gives liberally to charities that support animals, ecology, needy children, and liberal politics. She consults psychics and believes in reincarnation, which she hopes will eventually bring her some of what she has missed this time around. "In my next life," she says, "I would like to have one child, be happily married, and work for someone like Jane Goodall. I would like to make a powerful difference for a cause I love."

Though she's pondering a trip to Egypt next year, she admits that aging has slowed her a bit. Five years ago, after she broke her leg while in the Antarctic to study the colors of ice for a mural, she yielded to a cane and installed an elevator. "I'm slightly deaf, and my memory for what I did yesterday is appalling," she says. "I'm trying to age gracefully and not complain, but it's more difficult than I thought it would be."

Asked how she'd like to be remembered, she looks surprised. "It would be something just to be remembered at all," she says, a little wistfully. "I really don't have any expectations. I guess I'd like people to think I did beautiful things. That I had an influence. That I might be an inspiration to younger women."

With that, she's off. They're adjusting the night lighting on a new bronze-and-granite sculpture of hers on the campus of Northeastern Illinois University, and she's got to drive over and supervise. Then it's a cup of cocoa, a sip of Kahlúa, and to bed. Tomorrow, there's work to be done.—*C.S.*

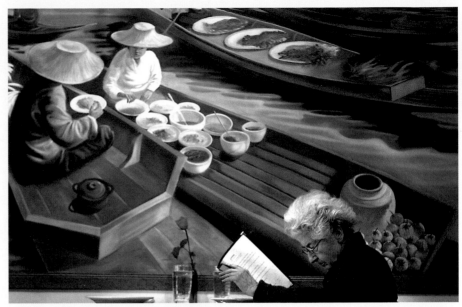

About the Photographers

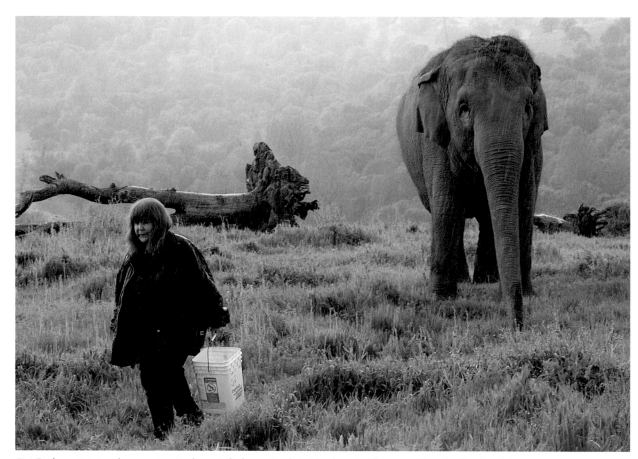

Pat Derby maintains three sanctuaries for retired show animals in Northern California. —Photo by Carolyn Cole

Lori Adamski-Peek has covered ten Olympics for *Newsweek* and Kodak. She was the United States Ski Team staff photographer from 1983 to 1989, and her work has earned her top honors from *Ski* magazine, *American Photo,* and the New York Deadline Club. Her work has also appeared in the *New York Times Magazine, Business Week, Outside,* and *Sports Illustrated for Women,* among other publications. She is based in Park City, Utah.

Kathy Anderson has been on staff at the New Orleans *Times-Picayune* since 1981. She has won an Associated Press regional award, and Picture of the Year and monthly clips contests from the National Press Photographers Association (NPPA). Her work has appeared in publications including the *New York Times, People, Time,* and the *Los Angeles Times.*

Nancy Andrews, currently the director of photography at the *Detroit Free Press,* has received numerous awards, including White House Photographer of the Year and NPPA Photographer of the Year. Formerly a *Washington Post* staff photographer, she has published two books of her work, most recently *Partial View: An Alzheimer's Journal,* released in 1998.

Alexandra Avakian has spent the past 20 years covering international political events, including the uprising in Haiti in 1986, the Palestinian intifada from 1987 to 1995, and the Armenian earthquake in 1988. Her work has appeared in *National Geographic,* the *New York Times Magazine, Newsweek, Life, Paris-Match,* and the *London Sunday Times Magazine.* She is based in Washington, D.C.

Karen Ballard is the recipient of eight White House News Photographer awards, and was Vice President Dick Cheney's official photographer for his first 100 days in office. She was recently awarded a fellowship from the International Center for Journalists to conduct photojournalism workshops in Eastern Europe. Formerly on staff at the *Washington Times,* she is now a freelancer based in Washington, D.C.

Erica Berger has been a staff photographer at the *Miami Herald* and *New York Newsday.* Her work on breast cancer has earned her a New York Newspaper Publishers Association Distinguished Community Service Award, and is included in the book *We're All in This Together: Families Facing Breast Cancer,* published in 1995.

Susan Biddle began her career as a Peace Corps photographer and later worked at the *Topeka Capital-Journal* and the *Denver Post.* She is currently a staff photographer at the *Washington Post,* where she has worked since 1997.

Robin Bowman's photographs have appeared worldwide in publications including *Life, Le Figaro, Travel & Holiday, Forbes,* and *Time,* and she has received several awards of excellence from Communication Arts. Her upcoming book is a study of the American

Anne Gonzalez (at left) and Becky Roeher spend the cocktail hour browsing Internet personal ads. —Photo by Lois Raimondo

teenager captured in black-and-white Polaroid portraits, and her work is part of the International Polaroid Collection. She is based in New York.

Carolyn Cole received the 2004 Pulitzer Prize for Feature Photography, awarded for her coverage of the civil crisis in Liberia. Her combined work from Liberia and Iraq earned her the title of newspaper photographer of the year for 2004 from both the University of Missouri Pictures of the Year, and the NPPA. She is currently on staff at the *Los Angeles Times*, and is based in New York.

Jamie Lee Curtis has starred in more than 50 movies and television shows, including *Halloween*, *A Fish Called Wanda*, and *True Lies*. She is also the author of six bestselling children's books, most recently *It's Hard to Be Five*. She is an avid photographer and uses a Leica M6.

Anne Day's work from Miami, Haiti, South Africa, and the former Soviet Union has appeared in *Time*, *Newsweek*, the *New York Times*, the *Washington Post*, *Fortune*, and *Vogue*. She covered Namibian independence and the release of Nelson Mandela for Reuters, and has photographed classical American architecture for four books published by W.W. Norton.

Penny De Los Santos, currently working on assignment for *National Geographic*, was a staff photographer at the *San Jose Mercury News* before returning to her native Texas in 2002. Her work has appeared in numerous publications including *Time*, *U.S. News & World Report*, *Mother Jones*, *Sports Illustrated*, *Latina*, and *Paris-Match*. She has received grants from the National Geographic Photographic Division, Kodak, and Canon USA.

Cheryl Diaz-Meyer is senior staff photographer for the *Dallas Morning News*. She won the 2004 Pulitzer

Artist Lisa Adams has created a personal sanctuary to help inspire her creativity. —Photo by Lara Jo Regan

Prize for Breaking News Photography with fellow staff photographer David Leeson, for their images depicting the invasion and aftermath of the war in Iraq. She also received the 2004 Visa d'Or Daily Press Award for her photographs from Iraq. A native of the Philippines, Diaz-Meyer has traveled on assignment to China, Guatemala, Kuwait, Bahrain, Indonesia, and Iraq.

Melissa Farlow has worked on assignment for *National Geographic* for the past 14 years. Her recent subjects for the magazine have included Kentucky Thoroughbred horse country, Olympic National Park, and a biography of Frederick Law Olmsted. Her work has been featured in *National Geographic's Best 100 Photographs* and *National Geographic's Best 100 Wildlife Photographs*.

Donna Ferrato is known for her groundbreaking photographs of domestic violence, published in her book *Living with the Enemy*. She is the founder of the Domestic Abuse Awareness Project, which through exhibits of her work and other activities has raised more than $500,000 for victims of abuse. Her recent book *Amore* explores love and intimacy.

Deanne Fitzmaurice was awarded the 2005 Pulitzer Prize for Feature Photography for her story on a maimed Iraqi boy. She has been a staff photographer at the *San Francisco Chronicle* for 16 years, and her work has appeared in publications including *Time*, *Newsweek*, *Sports Illustrated*, the *New York Times Magazine*, and *People*. In 2002, the Bay Area Press Photographers Association named her Photographer of the Year.

Sharon Holte enjoys the early-morning quiet at her lakeside home near Duluth, Minnesota. —Photo by Rosemarie Sheggeby

Natalie Fobes is a co-founder of Blue Earth Alliance, a nonprofit foundation dedicated to helping photographers pursue stories about endangered environments, threatened cultures, and social issues. She was a finalist for the Pulitzer Prize, received an Alicia Patterson Foundation Fellowship, and has won more than 200 other awards for her photography and writing. Her work has appeared in publications including *National Geographic, Geo, Travel Holiday,* and *Smithsonian.* She is based in Seattle.

Jill Freedman's six books include *Firehouse, Circus Days,* and *Street Cops.* Her most recent, *Ireland Ever,* contains introductions by Frank McCourt and Malachy McCourt. Her numerous awards include an Alicia Patterson Foundation Fellowship, a Leitz Medal of Excellence, and both individual and group grants from the National Endowment for the Arts. She was named an Honorary Fellow of the Royal Photographic Society in 2001.

Stormi Greener began her photojournalism career at the *Idaho Statesman* in 1975. She then joined the *Minneapolis Star Tribune* as a staff photographer, where she has been for the past 28 years. She has done extensive foreign coverage of refugees in Vietnam, Cambodia, China, and many other countries. She is a two-time Pulitzer Prize finalist, and her work has garnered numerous photographic

awards, including the Canon Photo Essayist Award, the Robert F. Kennedy Photojournalism Award, and a World Press Photo Award.

Lauren Greenfield has published her work in two critically acclaimed books, *Girl Culture* and *Fast Forward: Growing Up in the Shadow of Hollywood.* She has received many major awards and grants, including the 1997 Infinity Young Photographer Award from the International Center of Photography, the Nikon Sabbatical Grant, and the 1999 Hasselblad Grant. Named one of the 25 most influential photographers working today by *American Photo* magazine, Greenfield is a member of the photo agency VII.

Lori Grinker began her photographic career while still a student at Parsons School of Design in New York, documenting the rise of then-13-year-old boxer Mike Tyson. Her numerous grants and awards include the W. Eugene Smith Fellowship, the Ernst Haas Grant, the Hasselblad Grant, and the World Press Photo Foundation Prize. She has published two collections of her work, *The Invisible Thread: A Portrait of Jewish American Women,* and most recently, *Afterwar: Veterans from a World in Conflict.*

Carol Guzy's work has earned three Pulitzer Prizes and three Photographer of the Year awards from the NPPA. She began her career at the *Miami Herald,* then moved to the *Washington Post,* where she has been a staff photographer since 1988.

Gail Albert Halaban's photographs have appeared in the *New Yorker,* the *New York Times Magazine, Fortune, People,* and *Details.* Her work has been included in exhibitions and group shows throughout the United States. She holds an MFA from Yale, and has lectured and taught at UCLA, Yale, and Pasadena Art Center, where she is currently on the faculty.

Katharina Hesse holds a graduate degree in Chinese studies from the Institut National des Langues et Civilizations Orientales in Paris. After receiving her degree, she settled in Beijing, and freelanced for *Newsweek* from 1996 to 2002, both as a reporter and a photographer. Hesse received the 2003 NPPA award for magazine portraits.

Catherine Karnow, based in San Francisco, was born and raised in Hong Kong. She has covered Australian Aborigines, Bombay film stars, Russian "Old Believers" in Alaska, victims of Agent Orange in Vietnam, and high society in Greenwich, Connecticut. Karnow's work has appeared in *National Geographic, National Geographic Traveler,* and *Smithsonian.*

Colby Katz is a graduate of NYU's Tisch School of the Arts, and contributes to the *New York Times, Newsweek, Tokion,* and the Associated Press. Her current project is a series of photo-essays on subcultures, including comic and animé groups. She is based in Fort Lauderdale, Florida.

Brenda Ann Kenneally lives and works in Brooklyn, New York. Her work has appeared in the *New York Times Magazine, Rolling Stone, Teaching Tolerance, Newsweek,* and *L'Express.* She has received two NPAA awards, a Nikon Sabbatical Grant, and a World Press Photo award, among other honors. She is a also a regular contributor to the *Fortune News,* an in-prison magazine published by the Fortune Society, an organization that helps prisoners transition to life in mainstream society.

Barbara Kinney was one of four personal photographers for President Bill Clinton, from 1993 to 1999. She received a World Press Photo first place award in 1996. Her work has been published on the covers of *Time* and *Newsweek,* and in publications

including *George, U.S. News & World Report, Life, People,* and *Paris-Match*. She has served as a picture editor and photographer at *USA Today*, and is currently a picture editor at the *Seattle Times*.

Melody Ko is currently on staff at the *Eagle Tribune* in North Andover, Massachusetts. In 2004 she received an NPPA award for Spot News, and she has been a photographer and producer on numerous documentary films, most recently *Life at the End of the Road*, about Punta Arenas, Chile.

Karen Kuehn lives on a farm in New Mexico, where she shoots black-and-white film, tends to her garden, and raises her son. In her other life as a New York-based editorial and advertising photographer, her work has appeared in magazines including *Interview, Elle, Newsweek, Life, People,* and *New York* magazine.

Sarah Leen is a photographer and picture editor for *National Geographic*, living by the Chesapeake Bay in Edgewater, Maryland. Her assignments have

included the Kamchatka peninsula in Siberia and the Mexican volcano Popocatepetl. A book of her work, *American Back Roads*, was published in 2000. She and her husband, Bill Marr, are partners in Open Books, LLC, a book-packaging and design company specializing in photographic subjects.

Melissa Lyttle is currently a staff photographer for the *St. Petersburg Times;* she was formerly on staff at the *South Florida Sun*. Her work has been recognized by the NPPA, the Southern Short Course, the Atlanta Photojournalism Seminar, and the Alexia Foundation.

Mary Ellen Mark is the recipient of numerous awards and grants, including the John Simon Guggenheim Fellowship and the Matrix Award for outstanding woman in the field of film/photography. She has published 14 books of her work, most recently *Twins*, released in 2003. A contributing photographer to the *New Yorker;* she has published

Dozens of women descended upon Massachusetts' Eastover Resort for Spa Girls Weekend. —Photo by Gail Albert Halaban

photo-essays and portraits in such publications as *Life,* the *New York Times Magazine, Rolling Stone,* and *Vanity Fair.*

Jeanne Moutoussamy-Ashe has published four books of her work, most recently *The African Flower,* released in 2001. Her photographs have appeared in publications including *Life, Ebony, People,* and the *New York Times*. She is the director of the Arthur Ashe Endowment for the Defeat of AIDS, and is currently working on a fifth book entitled *Goodbye Comes Before Hello*. She is based in New York.

Farah Nosh graduated in 2002 from the Western Academy of Photography in Victoria, British Columbia. Three months later, Nosh—a Canadian of Iraqi descent—moved to Iraq, where she was based for 11 months. She was one of the few Western freelance photographers based in Baghdad under the regime of Saddam Hussein. In March 2005, Photo District News chose Nosh as one of the top 30 emerging photographers.

Amber Novak is a photographer and writer based in Austin, Texas. She is a regular freelance photographer for the *Austin American-Statesman* and *County* magazine. Her body of work includes portraits and interviews with more than 20 Mexican women photographers. She is also an adjunct instructor at

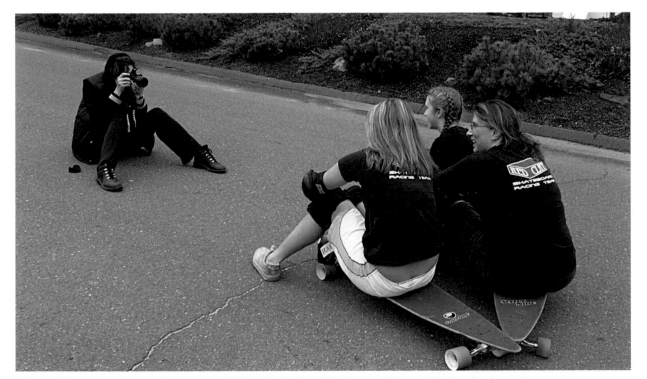

Photographer Anne Day rose at 4:30 a.m to catch Lisa Woodward and daughters at their morning skateboard practice.

Champion surfer Kim Hamrock is accompanied by her daughters on a morning trip to the beach. —Photo by Peggie Peattie

the University of Texas at Austin, where she teaches magazine and newspaper photojournalism to undergraduate students.

Peggie Peattie spent two years at Ohio University on a Knight Journalism Fellowship, teaching and earning a master's degree in visual communication, before joining the *San Diego Union-Tribune* in 1998. She was named Greater Los Angeles Press Photographer of the Year five times in a row, and she has won several honors from the NPPA, including first place for feature story photography.

Keri Pickett has published three collections of her work, most recently *Saving Body & Soul: The Mission of Mary Jo Copeland*, released in 2004. Pickett has received numerous grants and fellowships, from the National Endowment for the Arts, as well as the McKnight, Jerome, and Bush foundations, and is based in Minneapolis.

Joanna Pinneo, founder of www.grrlstories.org, received a Nikon Sabbatical Grant to continue her work documenting girls coming of age, and exploring the rites of passage many girls experience. She was the recipient of the Alfred Eisenstaedt Award in 1998.

Lois Raimondo has been on staff at the *Washington Post* since 1999. Previously she was the chief photographer for the Associated Press bureau in Hanoi, Vietnam. Her work has appeared in numerous international magazines, including *National Geographic, Smithsonian, Life, Newsweek, Time, Paris-Match,* and *Der Spiegel.* She received an Alicia Patterson Foundation fellowship in 2004.

Lara Jo Regan is a frequent contributor to *Time, Newsweek, Life, Entertainment Weekly,* and *Premiere,* and has received numerous awards including Pictures of the Year and the World Press Photo of the Year Award. However, she is perhaps best known for her whimsical photos of her dog, Mr. Winkle, which have appeared in bestselling photo books, cards, and calendars. She is based in Los Angeles.

Barbara Ries has won awards from the NPPA and the White House News Photographers Association, and has been a finalist for the Pulitzer Prize. In her

20 years as a photographer, her work has been featured in books and magazines including *Time, Newsweek, Fortune,* and *U.S. News & World Report.* She has worked as a staff photographer at *USA Today,* and is now based in San Francisco.

Susie Post Rust has been working as a freelance photojournalist since 1990. Her work has appeared in publications including *Life, People, U.S. News & World Report,* and *Newsweek.* She has spent a year as a professional-in-residence at Western Kentucky University, and has been on the faculty of Duke University's Center for Documentary Studies.

April Saul has been a staff photographer at the *Philadelphia Inquirer* for the past 24 years. In 1997 she received the Pulitzer Prize for Explanatory Journalism. Her photographs have also won the Robert F. Kennedy Journalism Award, and many Pictures of the Year, Society of Newspaper Design, and World Press Photo honors.

Dr. Anne Rosenberg and project co-creator Sharon Wohlmuth take a break from their shoot day at Anne's farm.

Stephanie Sinclair was on staff at the *Chicago Tribune* for five years before leaving to cover the Middle East for Corbis, and is currently based in Beirut. Her work from Iraq was recently on exhibit at the Peace Museum in Chicago. She is the editor and publisher of an award-winning independent online magazine for women photographers called Photobetty.com.

Jan Sonnenmair is a freelance photojournalist currently living in Portland, Oregon, and was formerly a staff photographer at the *Dallas Morning News*. Her photographs have appeared in magazines such as *Life*, *People*, *Newsweek*, and *Time*. Her work on a collaborative project addressing children with AIDS won the 1993 Budapest Award for Photo Essay from the World Press Foundation. She has also received a Visa d'Or award at the Visa pour l'Image international photojournalism festival.

Pam Spaulding has been on staff at the Louisville, Kentucky, *Courier-Journal* for the past 33 years. She is a graduate of Ohio State University with a BA in photography, and is the recipient of a Neiman Fellowship from Harvard University.

Ann States is a self-taught photographer with a degree in painting and drawing from the University of Georgia. For more than 15 years, she has produced images for national publications, including *Business Week*, *People*, *Forbes*, *Newsweek*, *Time*, and *TV Guide*. She lives in Atlanta.

Joyce Tenneson is the author of 10 books, including the bestseller *Wise Women*, released in 2002. She has received the International Center of Photography's Infinity Award and been named Photographer of the Year by the Women in Photography organization, among other honors. She was recently voted among the ten most influential women in the history of photography in a poll conducted by *American Photo* magazine.

Vicki Valerio has been a staff photographer at the *Philadelphia Inquirer* since 1979. She was part of the *Inquirer* team that shared a Pulitzer Prize in 1980 for coverage of the Three Mile Island nuclear disaster. She has also contributed to the *Evening Phoenix*, the *Philadelphia Daily News*, and Gannett Rochester Newspapers.

Dixie D. Vereen was a founding staff member of *USA Today* in 1982, and still works there today, as both a photographer and front-page designer. She has also been on staff at *Newsday* and the *Philadelphia Inquirer*, and her freelance work has appeared in numerous magazines including *National Geographic* and *U.S. News & World Report*. She is based in Arlington, Virginia.

Véronique Vial has authored eight books, including *Women Before 10 a.m.*, *Men Before 10 a.m.*, and *An American in Paris: The Cordial Traveler Inside Guide*. The French-born Vial is the exclusive backstage photographer for the famed circus troupe Cirque du Soleil; her collections of accompanying images include *'O' Cirque du Soleil at Bellagio*, released in 2001.

Ami Vitale is an independent journalist now living in Italy, who for many years was based in New Delhi. Her photographs and stories from events in Europe, the Middle East, and Africa have appeared in publications including *Time*, *Newsweek*, *U.S. News & World Report*, *Business Week*, the *Guardian*, the *Telegraph Sunday Magazine*, the *New York Times*, the *Los Angeles Times*, and *USA Today*.

Judy Walgren has received numerous awards, including the Award of Excellence from the Robert F. Kennedy Foundation, the Harry Chapin World Hunger Award, and the Barbara Jordan Award for reporting on people with disabilities. She is currently a staff photographer at the *Rocky Mountain News*, where she continues to cover socially relevant issues

Guide Audrey Wilkinson shows hikers tortoise habitats in Utah's Moki Canyon. —Photo by Lori Adamski-Peek

in Colorado, the United States, and the world. She is based in Denver.

Diana Walker's collection of White House and Washington photographs, *Public & Private: Twenty Years Photographing the Presidency*, was published by National Geographic Books in 2002. She has received numerous awards from the World Press, the White House News Photographers Association, the NPPA, and the International Photographic Council of the United Nations. She is based in Washington, D.C.

Sharon J. Wohlmuth spent more than 20 years as a photojournalist and editor for the *Philadelphia Inquirer*. Her numerous photography awards include a shared Pulitzer Prize for the *Inquirer*'s coverage of the Three Mile Island nuclear accident. Her work can be viewed online at www.sharonwohlmuth.com. She is the co-author of the bestselling book series *Sisters*, *Mothers & Daughters*, and *Best Friends*.

Principal Essayist

Carol Saline's journalistic career spans more than three decades. She is a senior writer at *Philadelphia* magazine whose extensive honors include a National Magazine Award, considered the Pulitzer of the magazine world. Information about her seven previous books is available at www.carolsaline.com.

Project Team

Created by:
Sharon J. Wohlmuth
Carol Saline
Dawn Sheggeby

Producers
Lewis J. Korman
Matthew Naythons

Creative Director
Thomas K. Walker

Director of Photography
Acey Harper

Assignment Researcher
Jody Potter

Project Logistics Manager
Amanda Behrins

Project Intern
Dawn "D.B." Bard Davis

Project Website
Peter Goggin, ISL Consulting

EpiCom Media
Lewis J. Korman
Robert Gottlieb
Matthew Naythons
Dawn Sheggeby
John Silbersack
Shelley Schultz

Photo Editors
Lisa Berman, *Vanity Fair*
Bobbi Baker Burrows, *Life*
Karen Frank, *More*
Laurie Kratochvil, *In Style*
Michelle Molloy, *Newsweek*
Karen Mullarkey
Christine Ramage, *People*
Michele Stephenson, *Time*
Miriam White, *Parade*

Principal Essayist
Carol Saline

Staff Writers
Cynthia Cotts
Carolyn Murnick

Text Editors
Sandy Hingston
Colleen Paretty

Contributing Writers
Susan E. Davis
Sabrina Rubin Erdely
Katherine Kam
Roxanne Patel
Chiori Santiago
Evantheia Shibstead

Copy Editor
Magdalen Powers

Photo credits for images of
 photographers at work:
Page 6, *top* — Rebecca Drobis;
 bottom left — Stephanie Sinclair;
 bottom right — Mitch Soileau
Page 173, *bottom* — Linda Brinkley
Page 174, *bottom* — John Thompson

Very Special Thanks
The project team wishes to express their heartfelt gratitude to all those at Bulfinch Press whose enthusiastic support made this project possible — especially Jill Cohen, Michael Sand, Karen Murgolo, Matthew Ballast, and Alyn Evans. Many thanks to Ellen Levine of Trident Media Group who helped bring this group together, and to Lynn Goldberg and Angela Baggetta Hayes, our publicity team at Goldberg, McDuffie Communications.

Additional thanks to Cory Baron of Children's Hope International; Joe Foley, videographer; Marcel Saba of Redux Photos; Heidi Schaeffer of PMK/HBH; and Johanna Rose Walsh, event planning.

Essay Credits

Flower Power, pg. 10, Katherine Kam
Granny Heart, pg. 14, Chiori Santiago
Danger Woman, pg. 16, Evantheia Shibstead
The Shape of Success, pg. 18, Carol Saline
Border Patrol, pg. 22, Roxanne Patel
Taking Care, pg. 26, Cynthia Cotts
Circle of Friends, pg. 28, Carol Saline
Homecoming, pg. 30, Katherine Kam
Native Voices, pg. 32, Chiori Santiago
Call of the Wild, pg. 34, Cynthia Cotts
Leaving the Office Behind, pg. 36, Carol Saline
Skater Mom, pg. 40, Carolyn Murnick
Fighting Chance, pg. 42, Carol Saline
A Day with Jamie Lee, pg. 44, Susan E. Davis
Healing Hands, pg. 48, Carolyn Murnick
Boa Instructor, pg. 49, Carolyn Murnick
On My Street, pg. 50, Carolyn Murnick
All About Mee, pg. 52, Carol Saline
Red Hattitude, pg. 56, Carolyn Murnick
Wedding Belles, pg. 58, Carolyn Murnick
The Last Dance, pg. 59, Carolyn Murnick
Going to the Chapel, pg. 60, Evantheia Shibstead
Military Engagement, pg. 62, Roxanne Patel
Support System, pg. 66, Colleen Paretty
Moved by the Spirit, pg. 68, Carol Saline
Late Shift, pg. 72, Colleen Paretty
Small Miracles, pg. 74, Sabrina Rubin Erdely
New Sheriff in Town, pg. 76, Cynthia Cotts
Law and Order, pg. 80, Carolyn Murnick
Piece by Piece, pg. 81, Carolyn Murnick
Starting Over, pg. 82, Roxanne Patel
A Healing Heart, pg. 86, Sharon J. Wohlmuth
 with Colleen Paretty
Live Wire, pg. 92, Carolyn Murnick
A Home of Her Own, pg. 93, Cynthia Cotts

Classical Beauties, pg. 94, Katherine Kam
Faith in the Heartland, pg. 98, Sabrina
 Rubin Erdely
Home on the Range, pg. 100, Cynthia Cotts
Built for Speed, pg. 102, Carol Saline
Love Goes On, pg. 106, Susan E. Davis
In the Green Zone, pg. 110, Cynthia Cotts
Portrait of the Artist as a Young Woman, pg. 112,
 Carol Saline
Almost Famous, pg. 118, Evantheia Shibstead
Reunited, pg. 120, Donna Ferrato
Off the Streets, pg. 122, Cynthia Cotts
Role Model, pg. 123, Carolyn Murnick
Family Practice, pg. 124, Chiori Santiago
Soul Sisters, pg. 126, Carol Saline
Feeding Time, page pg. 130, Cynthia Cotts
Diva Mom, pg. 132, Colleen Paretty
Major Courage, pg. 134, Carol Saline
Animal Farm, pg. 138, Susan E. Davis
Facing East, pg. 140, Carolyn Murnick
My Mother, pg. 142, Jeanne Moutoussamy-Ashe
Generations, pg. 146, Carolyn Murnick
Second Shift, pg. 147, Carolyn Murnick
Hog Heaven, pg. 148, Sabrina Rubin Erdely
Tamale Tia, pg. 149, Cynthia Cotts
Dance Partners, pg. 150, Cynthia Cotts
The Queen of Bluegrass, pg. 152, Carol Saline
Miami Heat, pg. 158, Cynthia Cotts
Singles Scene, pg. 159, Carolyn Murnick
Girls' Night Out, Pg 160, Carol Saline
Comfort Food, pg. 162, Evantheia Shibstead
The Art of Living, pg. 164, Carol Saline